THE BOOK OF
NATURE
Photography

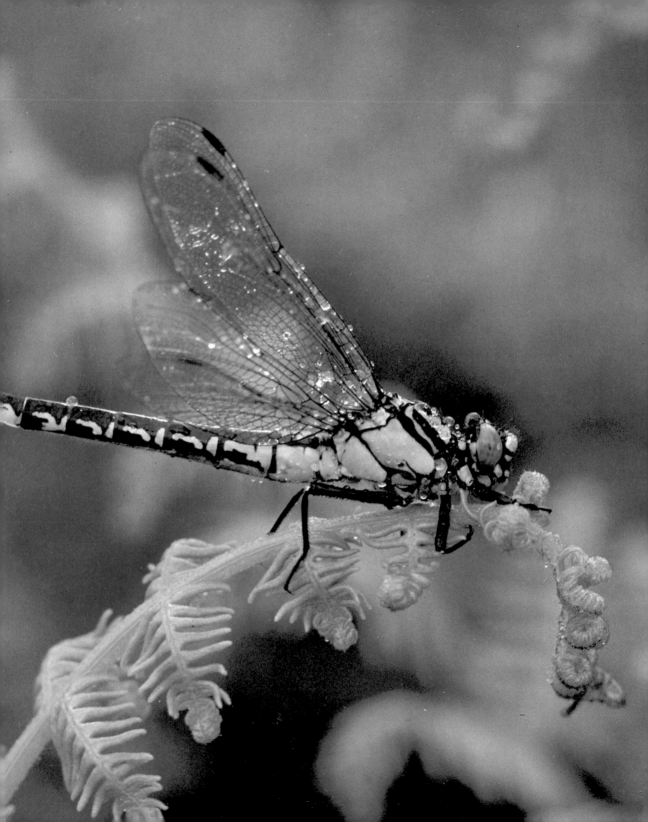

THE BOOK OF
NATURE
Photography

Text and photographs by

Heather Angel

Alfred A. Knopf

The Book of Nature Photography was
conceived, edited and designed by
Dorling Kindersley Limited,
9 Henrietta Street, London WC2

Project Editor
Lindy Newton
Art Editor
Pauline Faulks
Designer
Julia Harris
Managing Editor
Jackie Douglas
Art Director
Roger Bristow

Library of Congress Cataloging in
Publication Data
Angel, Heather.
 The book of nature photography.
 Includes index.
 1. Nature photography. I. Title.
TR721. A528 1982 778.9'3 81-48106
ISBN 0-394-52467-5 AACR2

Typesetting by BAS Printers Limited,
Over Wallop, Stockbridge
Reproduction by Dot Gradations Limited,
Chelmsford
Printed and bound in Italy by
A. Mondadori, Verona

Contents

Introduction

A passion for nature photography can be aroused in so many ways. You may be a keen photographer who finds in the natural world a rich supply of material for all types of photography. Perhaps you are inspired by the way that light and shadow can change a view completely, for even a static landscape presents a constantly changing image to challenge the photographer. Alternatively, you may want to record some of the endless variety of forms to be found in nature. At the other extreme, you may, like myself, have come to nature photography through an involvement in biology or an interest in natural history.

Now that photography dominates my working life, it is hard to believe that I took it up entirely by chance. When I was working as a marine biologist, I needed pictures to illustrate some lectures, and so began photographing seashore life. I still prefer to photograph marine life whenever I have the opportunity, but I very quickly decided not to confine myself to this specialized field in which the outlets for picture sales are very limited. Now I am prepared to tackle any subject anywhere in the world. This inevitably involves a great deal of hard work and a fair number of disappointments. When something works and I achieve a seemingly

Interactions ▷
While photographing protea flowers in South Africa, I spotted a sugarbird and quickly switched to a long lens to record a natural backlit study of a plant and its pollinating agent.

A harmonious landscape ▽
It would be difficult to capture a more striking picture of Arizona's Painted Desert landscape. I chose a 200mm lens on the Nikon to record the shot toward the end of the day.

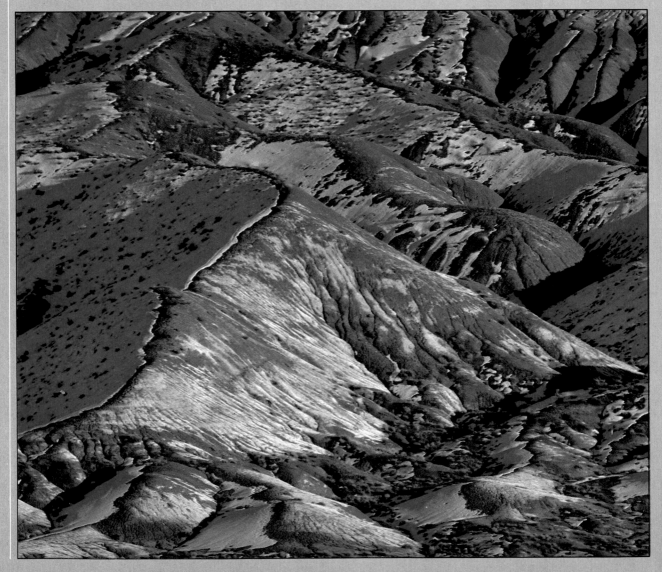

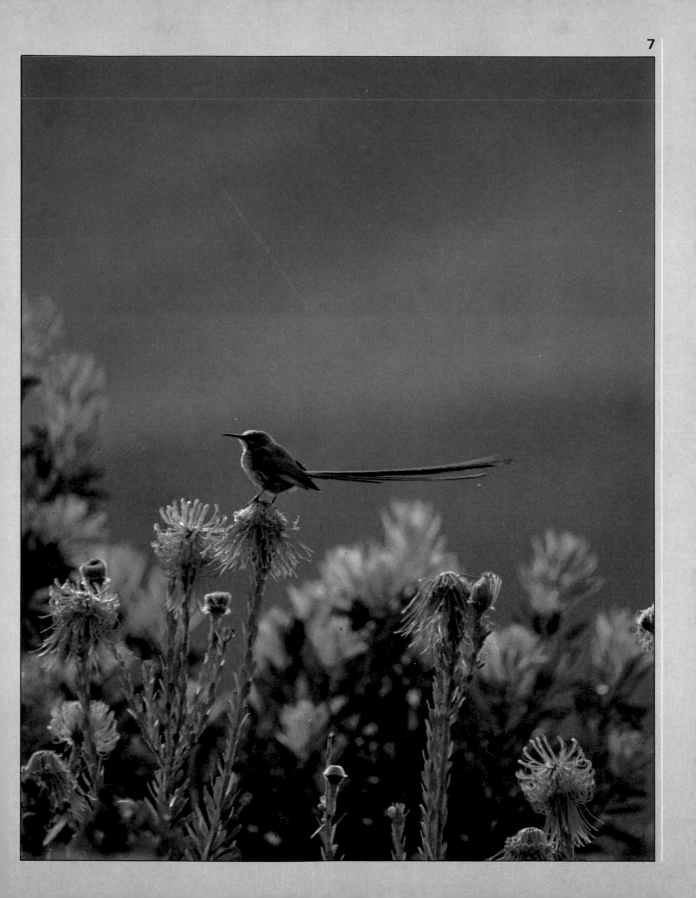

impossible picture, it is like a shot of adrenalin which spurs me on to the next goal.

Whatever route has led you to become a nature photographer, you will inevitably find that, to achieve satisfactory pictures, you will eventually have to combine to some extent the different approaches. It is only sensible for a naturalist who wants to take useful pictures of the natural world to learn the technical photographic skills that will allow him or her to do this. On the other hand, the photographer who decides to specialize in nature will achieve authentic pictures only if he or she takes the trouble to learn something about the subject beforehand. All nature photographers will find that their work benefits from careful planning and, more especially, from keeping reasonably detailed records (see p. 164).

Every photographer aims to develop a particular style or signature; indeed photography is more enjoyable when tackled with a specific goal in mind. It is always worth studying and assessing the work of other nature photographers in books and in exhibitions, not so much as models to be imitated, but as stimuli for your own photographic ideas. A nature photograph can mean quite different things to the photographer, to a picture editor, to a competition judge, or to the general public. For this reason, there is no point in trying to please others by your photography. Only by experimenting with techniques, and developing those that are successful, will you be able to evolve a style that is fresh and unlikely to become stuck in the stereotype of other people's expectations. My own aim is to produce pictures that

Lighting the landscape ▽
Late one evening, as I was driving along in New Zealand, I passed some lines of young poplar trees spotlit by the setting sun so that they glowed in the somber shadowy landscape. I doubt that I would have looked twice at this scene if I had been driving toward it from the opposite direction at the same time of day.

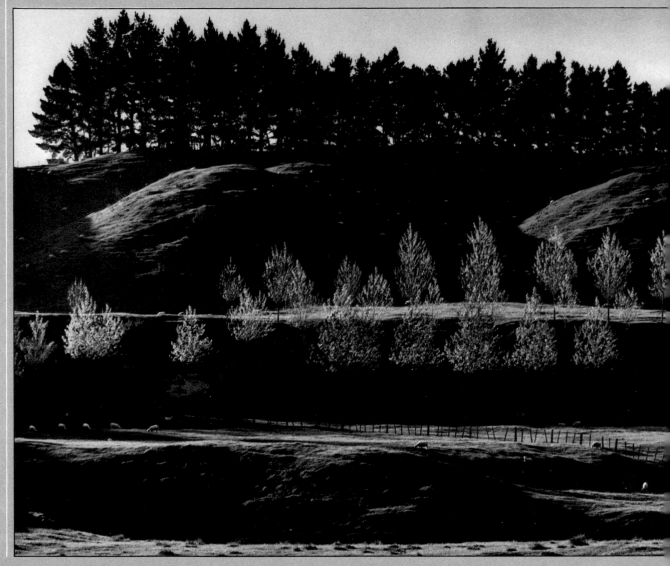

are biologically truthful and that are at the same time exciting images that will communicate to others my appreciation of the natural world.

What makes a good nature photograph is difficult to define. It is perhaps the ability of the photographer to anticipate, to react quickly, and, above all, to develop a flair for seeing a picture where one does not obviously present itself. For example, it is not difficult to fill the frame with a sharp image of a butterfly feeding on a flower by mounting the camera and one or two flashes on a single unit. On the other hand, it requires a certain amount of flair and courage to experiment by taking a moving subject with a slow shutter speed or by framing the subject, so that it occupies only a very small part of the frame, and thereby accentuating the vastness of its environment. By such experiments, which of course are not always successful, you can change a mere photographic record into an exciting visual concept that can have the added bonus of suggesting further ideas.

Nature photography has evolved considerably since the days of the early pioneers working more than a century ago. When the Kearton brothers were working at the turn of the century, it was a major effort to carry in the field their "miniature" camera — a hefty half-plate model — with heavy lenses, tripod, and sensitized plates and holders. The slow speed of their emulsions meant that long exposures were obligatory, and so action shots of animals were almost impossible. Nowadays, an individual can carry single-handed a tripod, cameras, lenses, and enough film for several days' work. Recent technical advances have given us lenses with

Modeling a close-up ▽
Lava is extruded from the earth in many different forms. I found some meringue-like formations on an extensive lava field in the Galapagos. Long-since cooled and solidified, they have resisted weathering in the dry equatorial climate for decades. Their starkness, without any suggestion of plant life, was strengthened by the hard cross-lighting. Because I wanted to emphasize the barren terrain, I used a tripod, which allowed me to stop the lens right down and bring the frame sharply into focus.

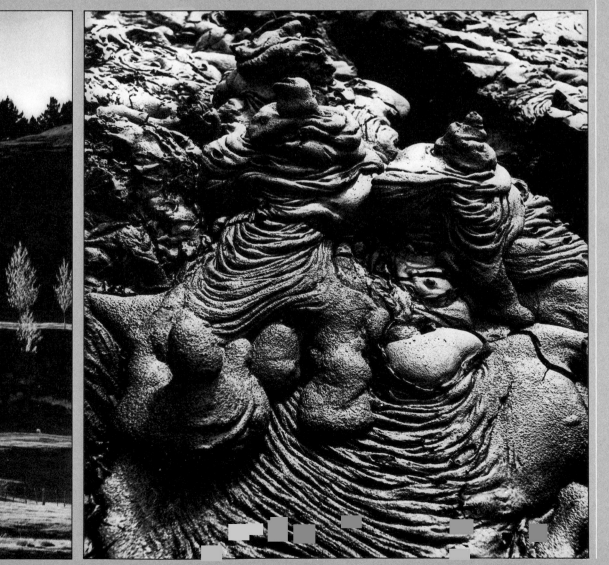

high resolution, fast films, lightweight electronic flashes, and through-the-lens metering.

The simplest way to begin photographing nature is to work outdoors, locally, with the minimum of equipment, preferably concentrating on a single technique such as landscapes, or close-ups, or using long lenses. Then, as you learn to master one technique, you can gradually expand the range of your expertise.

Throughout this book, emphasis is placed on the necessity for a good knowledge of your subject which, in nature photography, is more important than elaborate and expensive equipment. However, your lenses must have good resolution, and the camera mechanics and electronics should be reliable enough not to let you down after you have trekked miles into a wilderness area. I took the majority of the images in this book using basic camera systems — albeit with a wide range of lenses. Rarely did I use sophisticated equipment, although in many cases relatively cheap accessories aided the exposure. You will find no examples of pictures taken with gimmicky effects, such as starburst filters, because I feel that they distort the natural image too much.

Most of your work will, of necessity, be done in the field, and you will find basic information on planning a field trip on p. 147. Some of my field photography is minutely planned, so that I know not only the time of year and the location, but also the time of day when a certain animal will be active. Other fieldwork is carried out on a speculative basis, when dramatic lighting or an interesting biological phenomenon, for instance, has motivated me

Life among the ashes ▷
My first instinct was to fill the frame with this pine seedling bringing new life to the burnt ground, but I realized that much greater impact was to be gained by including its surroundings to emphasize the vastness of the charred land.

Living together ▽
The natural home of clown fishes and sea anemones is among the coral reefs in tropical seas. However, I took this picture in a marine aquarium, using electronic flash to freeze all movement of the fishes sheltering among the tentacles.

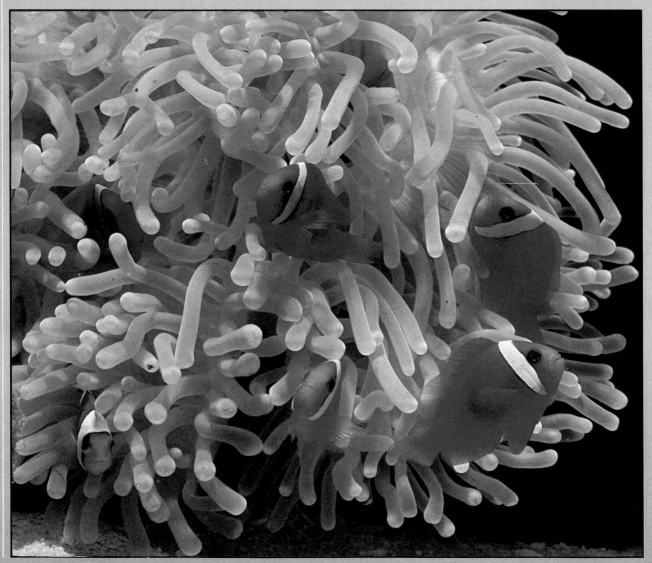

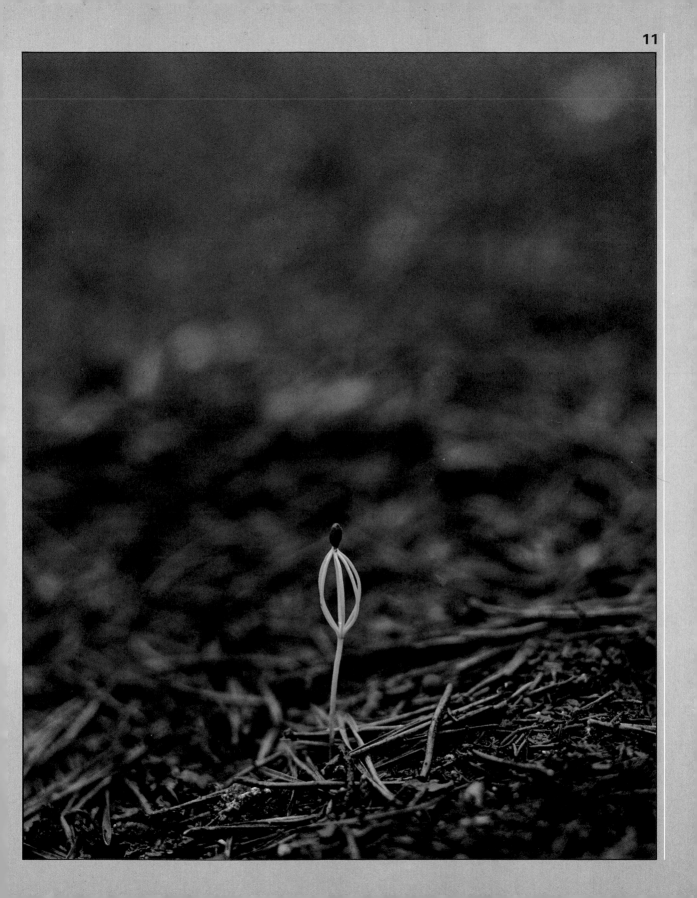

to expose film. When planning a field trip, try to allow for more than one visit to an area in a single season. Nature photography can be most exciting and rewarding, but it can also be intensely frustrating when adverse weather conditions make field photography impossible for another year. The nature photographer should never forget that the welfare of the subject comes before everything. A photograph achieved by trampling a delicate habitat is no better than a hunter's trophy of a stuffed head hung over the mantelpiece.

Sometimes you will find that, perhaps because of unsuitable conditions in the field, it is possible to achieve the desired picture only by arranging a set-up in the studio. While for many animals, such as small aquatic life, working in a studio may be the only way of taking high-quality pictures, and the basic equipment that you will need for your studio is described on p. 160. Most of us rarely have the opportunity to travel to distant countries for the sake of photographing an unusual specimen, and, when this is the case, the zoo can be an acceptable alternative, as long as you do not try to pass off such photographs as having been taken in the wild. The work of a nature photographer is valid only if it is honest. I believe that to photograph a stuffed bird or mammal in a natural setting, pretending that the subject was alive, produces a visual lie that throws doubt on the rest of that photographer's work. An experienced naturalist will easily recognize the unnatural posture of a stuffed animal, but it will mislead the naive observer. Sadly, such pictures have been published and will go on being

Dissecting a forest ▽
In the highland region on the main island of Santa Cruz in the Galapagos, the endemic sunflower trees (*Scalesia pendunculata*) form an eerie evergreen forest which thrives in the mist-shrouded hills. Using a wide-angle lens, I was able to produce an exciting image by looking up at the canopy pattern of the fine branches radiating from the solid trunks festooned with epiphytic mosses.

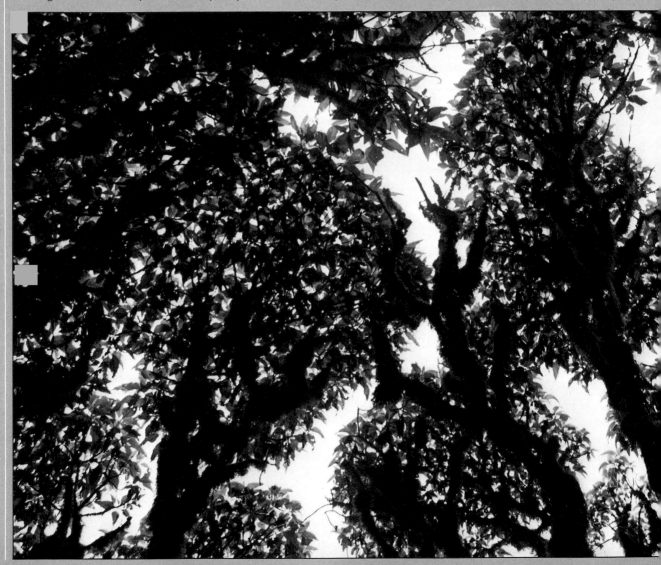

published as long as the people who select them know very little or nothing about the subject.

As well as suggesting possible approaches to the different aspects of nature photography, this book is concerned with techniques for both fieldwork and studio work, with emphasis on those that I have found particularly useful. The line drawings throughout the book function as cameos showing how I took specific color and monochrome pictures. They should be treated as guidelines for solving a variety of problems, and not as techniques to be followed slavishly.

When I started to take photographs, I used an equal amount of color and monochrome film. Today I tend to photograph in monochrome only when I see a particularly striking image suitable for the medium. A successful monochrome print will, more often than not,

depend on a strong combination of light and shadow enhancing the subject; whereas contrasting colors will automatically separate shapes — even in a single plane. I have always felt that monochrome pictures can lack important information, because color plays such a vital part in the survival of life on Earth. For example, the significance of the colorful courtship dress of birds of paradise would be lost completely in a monochrome print.

There are advantages to be gained by using monochrome film, however: its greater latitude allows for less critical exposures in low lighting, and the unit cost per frame is a fraction that of color. The use of black and white film also makes it possible to be creative in the darkroom. Indeed, the results obtained by some expert printers can bear little relation to the

Simplifying a close-up ▽
A honeybee was so intent on feeding from a fleabane flower that I was able to come quite close, with a standard lens and extension tubes attached to the camera. The back rim-lighting helped to focus attention on the bee, which, like the flower, was well separated from its background by the use of differential focus.

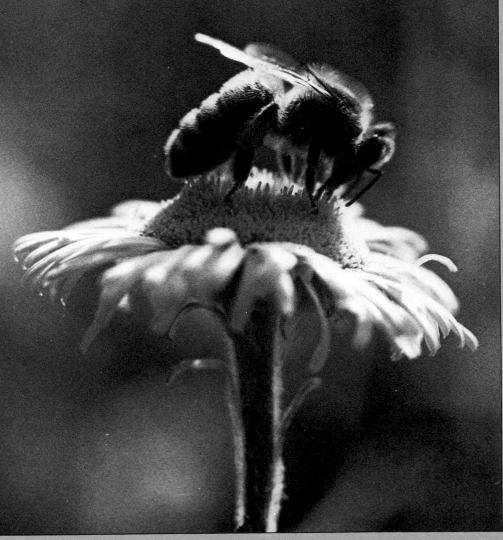

original negative after they have masked and dodged parts of the image, and perhaps super-imposed images from other negatives on the same piece of paper.

Some nature photographers favor composing their pictures in the darkroom or the studio by using a 2¼ square format, which they then mask down to fit a 35mm format. This approach is merely a substitute for buying a longer-focal-length lens. I feel that a picture is best composed through the viewfinder after the right lens and viewpoint have been carefully selected. While such techniques can be useful on occasion, I believe in general that they are not an important part of the nature photographer's repertoire, and so in this book I have tended to concentrate on photographic rather than dark-room techniques.

Following the development of the motor drive, with which you can build up, over a series of frames, the pattern of movement or of a behavior, it might seem that the still photo-graph has become redundant as a means of capturing action. However, aiming to tell a story or freeze a moment of time in a single frame is a very worthwhile exercise. It is the ability to capture this precise moment that can lead to the success or the failure of a still action picture; indeed a successful picture can reveal a moment of time much more graphically than can a series of pictures. A still picture of a static subject can be equally dramatic if you take care with the composition and the lighting.

In none of the captions to the photographs in this book will you find the full exposure details given. This omission is deliberate, because I

Capturing the moment ▷
The earth star (*Geastrum triplex*) dispersing its cloud of microscopic spores is one of my most popular pictures. Two electronic flashes behind the fungus highlighted the moment of dispersal, while a front flash filled in the shadows.

A design in miniature ▽
I used a bellows extension on the Nikon and a single small flash to show up the individual yellow, black, and white scales on the underwing of a male orange tip butterfly. The scales are reproduced here at twenty times life size.

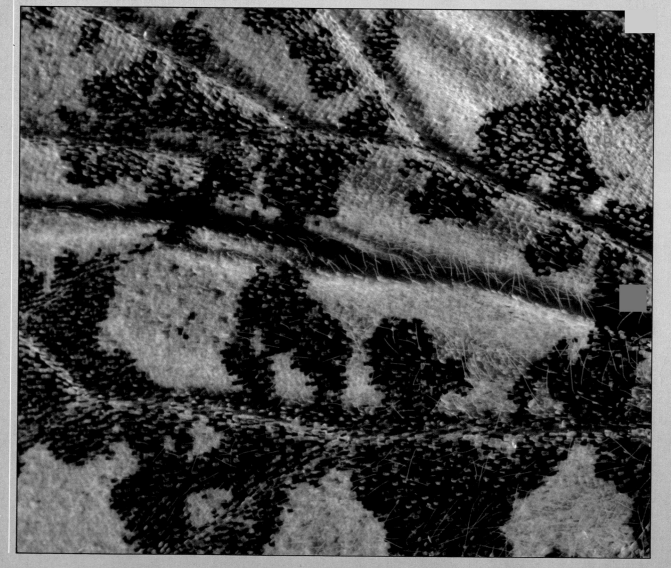

never record my exposure nor am I convinced that it can be of much use to other photographers, who are very unlikely to encounter the same subject under identical lighting conditions. What is more significant is that I used a long exposure, or a high-speed flash, or a small aperture to produce a particular effect.

Once you have learned to handle the camera instinctively, and have developed a variety of techniques, you will find that the most important aspect of your photography is the interpretation of an image. The way in which we see and then interpret a subject is highly individual. If a photograph is to communicate, it must cut through a tangle of individual likes and dislikes by containing sufficient elements of esthetic appeal, while still retaining authenticity. Depending on your motivation for taking the photograph, you should aim to strike a balance between these two criteria. No-one can fail to be impressed by high-speed flash pictures illustrating animal or plant movement that is too fast to be discerned by the naked eye; but it is often the simplest of natural images that are most evocative and long-lasting. They may appear deceptively simple, yet their very simplicity is a tribute to the seeing eye and the insight into the subject's habits which have combined to produce the perfect mix of image size, camera viewpoint, color reproduction, lighting, and background.

However you choose to interpret the natural world, you should always strive toward achieving the best-possible pictures. Only by so doing will you gain full enjoyment while doing justice to the beauty of life on Earth.

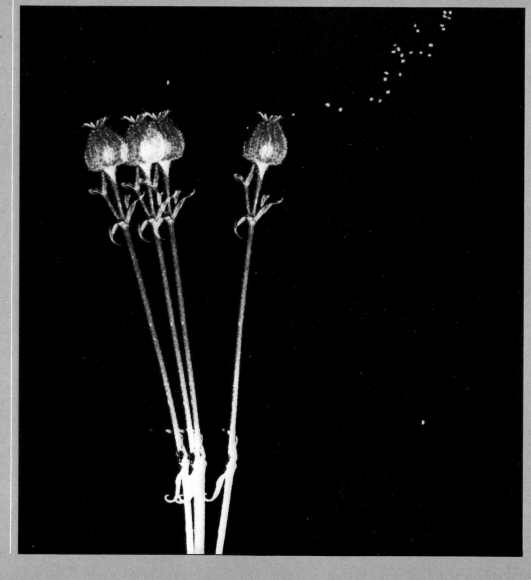

◁ **Multi-image**
To show the way in which seeds are dispersed from the dry capsule of a red campion, I used a repetitive stroboscope light, set at a rate of eight flashes per second, in a darkened studio. I used an exposure of 1/2 sec to take the picture on Tri-X film double rated to 800 ASA after my assistant had jolted the fruiting stem.

ART IN NATURE

Shape and form

The Earth's natural landscape, the living world, and even weather systems, all display an infinite variety of natural shapes. Aerial views reveal exciting shapes of meandering and dendritic rivers, coral reef atolls, glaciers, and lava flows. From ground level, you can observe lightning forks, cloud patterns, sand dune waves, natural arches, stacks, eroded pinnacles, and limestone pavements. A journey below ground reveals a world of caverns, stalagmites, and stalactites; while beneath the sea the intricate beauty of coral reefs can be seen. Remarkably few basic forms make up plants and animals, whose shapes are based on the circle, the mirror image, the spiral, and the polygon.

No special techniques are required for photographing natural shape and form. An observant eye and careful composition are all that is needed. Precise framing is important, because so often you can lose the impact of the main theme by including distracting and superfluous borders. Low-angled lighting is essential for conveying the form of a three-dimensional subject in a two-dimensional photograph. This is why landscape photographers so often favor working early or late in the day, when low-angled sun casts strong shadows which enhance the molding of the landscape. Isolation of the subject, either by throwing the natural background out of focus or by introducing an artificial background, helps to emphasize a shape, which can be further enhanced by back rim-lighting. Silhouettes can be used to simplify shape still further.

Lighting from behind ▷
Sunlight shining behind a flowering Christmas cactus (*Zygocactus* sp.) inspired me to experiment with studio lighting to emphasize the intricate form of the flower. Two small tungsten halogen spotlights placed between the flower and the black velvet background, outside the field of view, allowed the backlighting to be viewed critically through the camera. Before taking the photograph, I substituted two small electronic flash units for the spotlights.

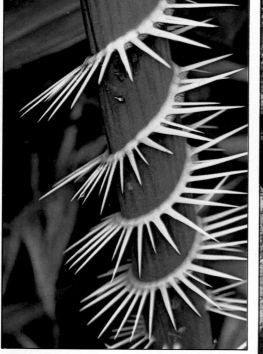

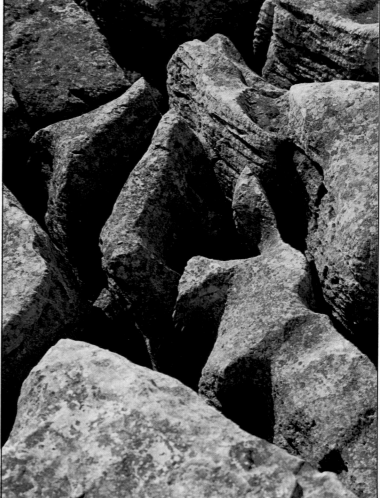

Spiky spirals △
As soon as I spotted this shrub in the Singapore Botanic Gardens, I visualized the tight framing of the spiral design to be gained by using a 105mm micro-Nikkor lens. To achieve the desired effect, I isolated a single stem by tying back some neighboring branches.

Natural sculpture ▷
Where limestone outcrops are exposed to the elements, they become eroded into striking natural sculptures. During a day spent walking over limestone pavement in Yorkshire, I was able to isolate these sculptured forms by viewing them through a 150mm Hasselblad lens.

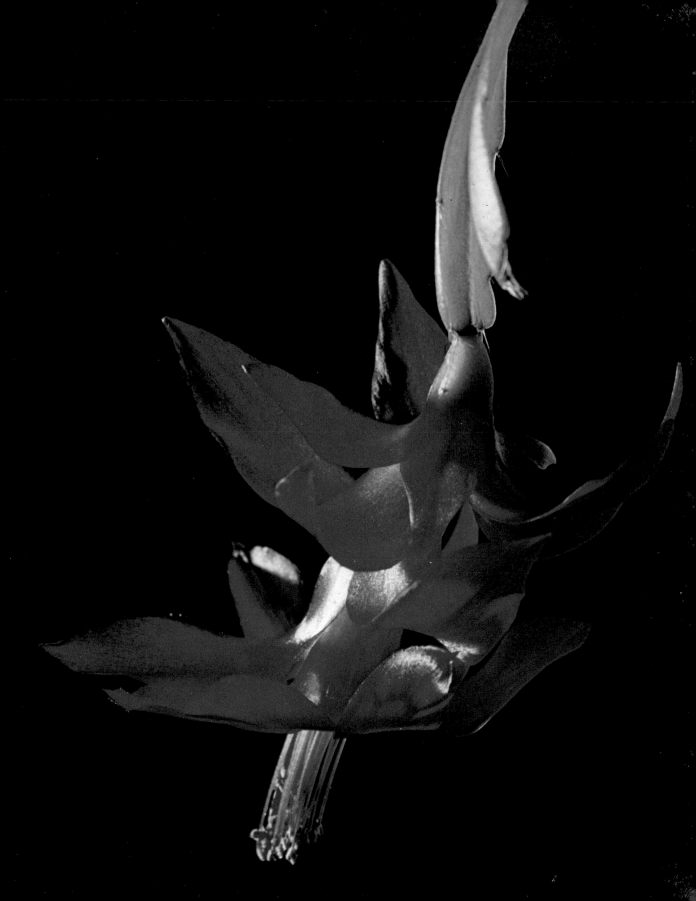

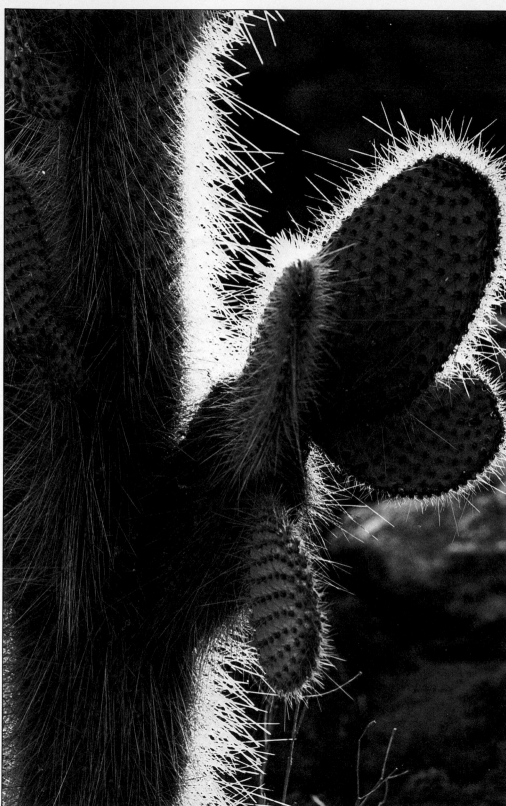

◁ **Rim-lighting for emphasis**
Natural rim-lighting of
subjects takes place when
the sun is low in the sky;
and it was at the end of the
day that I saw the spines of
this Galapagos *Opuntia*
cactus glowing against the
arid landscape. I metered the
sunlit part of the cactus
directly through the camera
by first walking round to the
opposite side of the plant. I
then opened up the lens by
one stop to allow for some
detail in the shaded part of
the cactus pads.

Spiral section ▷
One of the best-known
natural spirals is a snail
shell. This shell belongs to
another mollusc, a marine
cephalopod known as
Nautilus pompilius. I bought
this half section from a shell
shop and propped it up on a
black velvet backcloth with
small wedges of modeling
clay. I used dual-source
oblique lighting from behind
the shell by angling in two
small spotlights to shine
through it.

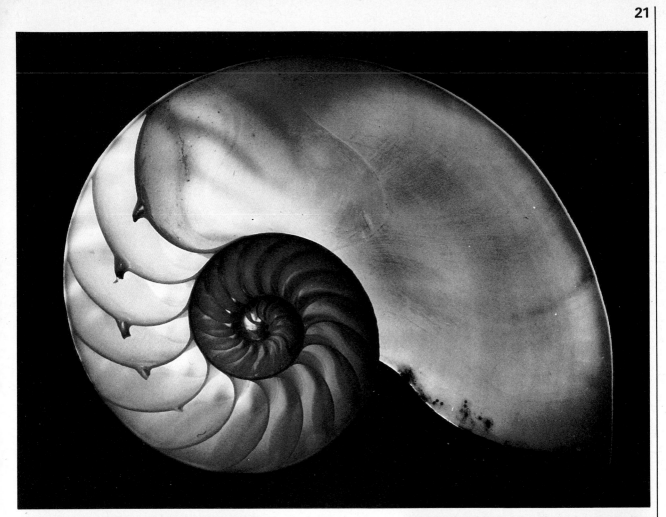

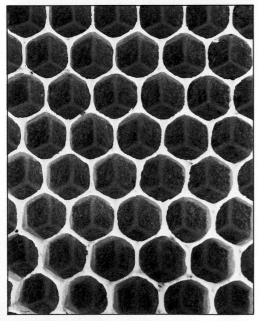

◁ **Natural polygons**
Each cell of a honeycomb is hexagonal and interlinks with its neighboring cells in strikingly exact symmetry. I took this picture of empty cells by supporting the camera directly above the comb on an overhead copying stand.

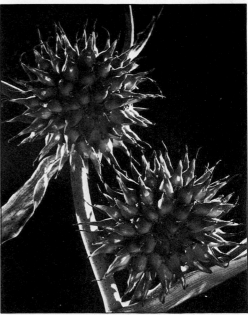

Spiky fruits ▷
I shone two spotlights on the back of these spiky fruits of branched bur-reed (*Sparganium erectum*) to highlight their structure, the spotlights fulfilling the same function as the sunlight in the picture of the cactus (far left). It is possible to emphasize the form of natural shapes by the use of precise lighting.

Seeing pattern

In the natural world, patterns abound, both on a large scale and most especially in close-up. Among the more conspicuous are the regular patterns based on an obvious symmetry.

Flowers such as daisies, roses, and poppies, and animals such as sea anemones, jellyfish, and starfish are all radially symmetrical organisms whose body pattern is based on a circle. Bilateral or two-sided symmetry, in which one side is a mirror image of the other, can be seen among the vertebrates — fishes, amphibians, reptiles, birds, and mammals — and in more elaborate flowers such as sweet peas. The facets of a fly's eye and the stress patterns on dried mud show repetitive polygonal designs. Other regular patterns occur when units of a similar size are tightly packed together, for example, in the arrangement of corn cob seeds.

The most successful pattern pictures are often quite simple images of portions of well-known subjects. The framing must be precise and so the choice of magnification is crucial for maximum impact. A macro lens, with its continuous focusing range, is ideal for quickly gaining the precise cropping required. Sharp definition of close-up patterns is achieved only by using a tripod and stopping down the lens.

Pattern pictures can be seen almost everywhere you turn — you can even find them in your own back garden. No great photographic skill is required, but it is useful to train your eye to select the portion from the whole. Seeing pattern is highly individualistic: this means that, given the same subject, it is extremely unlikely that any two photographers will interpret the pattern in the same way.

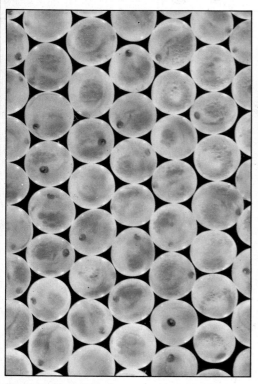

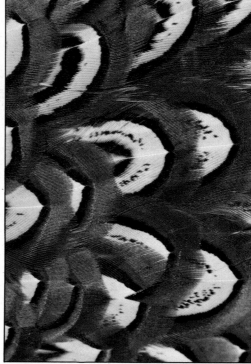

Regular packing pattern △
As I watched trout eggs being stripped from a fish at a hatchery, the way in which the eggs naturally packed together in the tray sparked off the idea for this studio picture. I first lined the base of a wooden box with black velvet. I then placed two small flash units inside the box so that they shone up through a central hole in the top of the box while remaining outside the field of view. I submerged the eggs in water in a shallow glass dish, which I placed over the hole in the box, so that they were transilluminated. I used a Hasselblad with a standard 80mm lens and 55mm and 21mm extension tubes to record this image life size.

Feather montage △
This picture of cock pheasant feathers, overlapping to protect the bird and keep it dry, was taken shortly after the bird had been shot. To illustrate fine detail in this close-up picture by available light, I used a 1/2 sec exposure so that the lens could be stopped down.

Radial symmetry ▷
The way that tentacles of sea anemones radiate from a central mouth is best shown on a square format. I put this dahlia anemone in a square aquarium, and used two small electronic flashes to make sure that the image was not blurred by movement. The picture was tightly framed for impact.

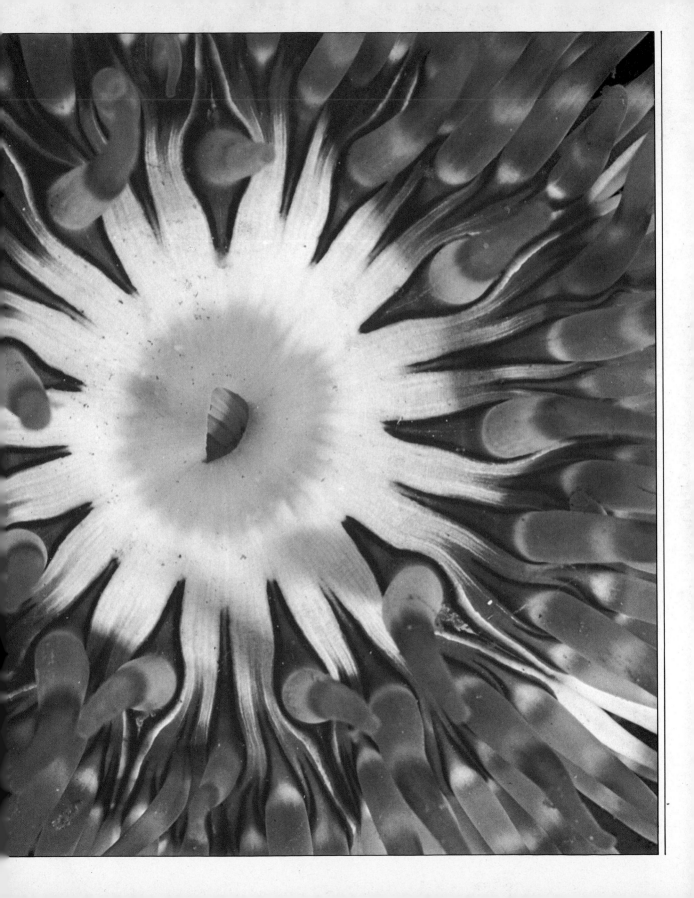

Highlighting texture

The surface character of a subject is known as its texture, and this can have varying degrees of roughness. Touch reveals texture most effectively but it can also be conveyed in photographs in which sun and shadow mold the texture of a landscape or when low-angled lighting picks out the surface features of small objects. Subtle texture on small subjects, such as encrusting lichens, can be enhanced in a photograph by grazing a light source across the surface so that the smallest bumps are revealed by their shadows.

In the natural world, texture is visible on the skin of many animals, on the surface of seeds and fruits, on the bark of trees, and on the shells of some molluscs. These textures do not exist simply to delight the artistic eye, but are biologically significant. For example, textured skin may help to protect an animal from desiccation or predator attack, while hooked seeds and fruits can hitch a ride on a passing animal and thereby be dispersed away from the parent plant.

When texture is shown in a photograph, the picture at once acquires a three-dimensional character, giving the impression that you can reach out and feel it. Strong texture, however, may detract from the impact of shape, form, and pattern, and so you must first decide which aspect to emphasize.

Scaly protection ▷
Chameleons are renowned for their ability to change color so that they blend in with their surroundings. For this studio picture, however, I selected an artificial black background to highlight the different-sized scales on the body, the leg, and the head and to illustrate the variety of textures that occur in one animal's skin.

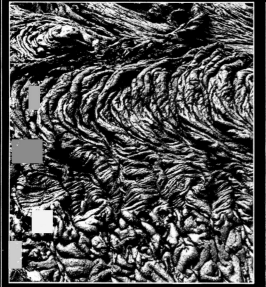

Texture enhanced by natural lighting △
I used a tripod when taking this detail of hardened lava from a huge outflow on San Salvador Island in the Galapagos archipelago Known as rope lava, it is formed by a surface skin developing on top of molten lava. The harsh equatorial lighting enhances the monochrome image of the rope-like texture.

Contrasting textures ▷
Low down on a sandy beach in Wales I spotted this stranded brittle star (*Ophiura texturata*) writhing on the sand. The swirling pattern created by the thrashing arms made a striking contrast to the texture of the rest of the beach I used a tripod to ensure precise framing and maximum depth of field.

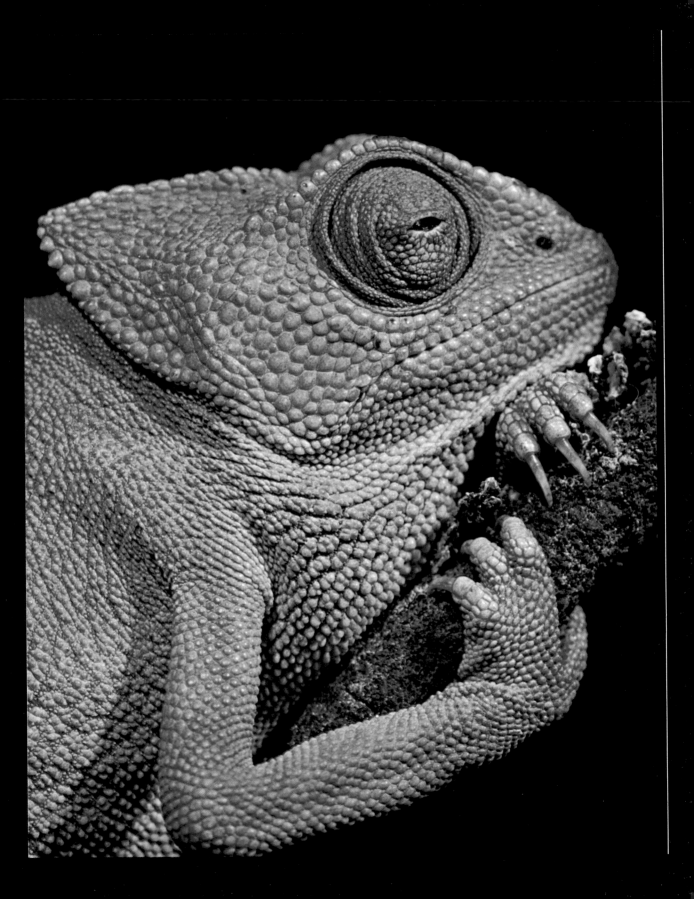

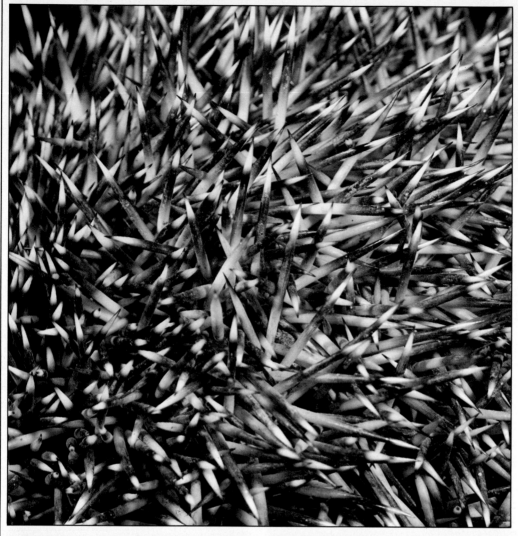

◁ Defensive spines
I took this picture as one of a series illustrating animal skins. The spiny coating of a hedgehog is a particularly good example of texture. When danger threatens, the hedgehog curls up into a ball and erects its spines in all directions, and this position presents a depth of field problem unless the lens can be stopped down. Because the hedgehog was alive, the spines were not static, so I used an electronic flash to freeze all movement as well as to gain increased depth of field.

Sculptured sandstone ▽
Sun, water, and wind have combined to produce these erosion hollows in a sandstone rock wall in the Valley of Fire in Nevada. Cracks in the rock have been enlarged by rain, then further eroded by sand blasting. I found that the texture of these natural sculptures showed up best early or late in the day when the sun was low. When I took this photograph, strong shadows from direct sunlight helped to emphasize the depth of the hollows as well as the texture of the rock surface. During the rest of the day I spent time selecting ideal viewpoints for the brief photographic sessions.

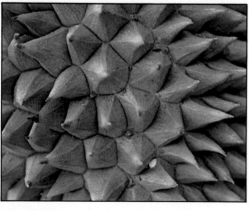

Armored fruit △
The spiny surface of the tropical durian fruit deters animals from eating it until it ripens. I spotted the fruit on a roadside market stall in Singapore. Because a storm was about to break and the light was fading fast, I used a tripod and a long exposure to gain the depth of field I required.

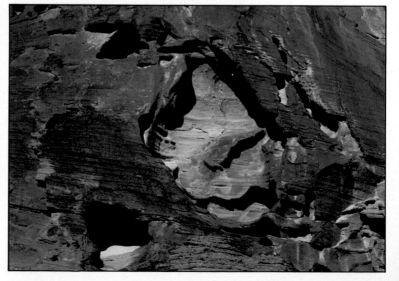

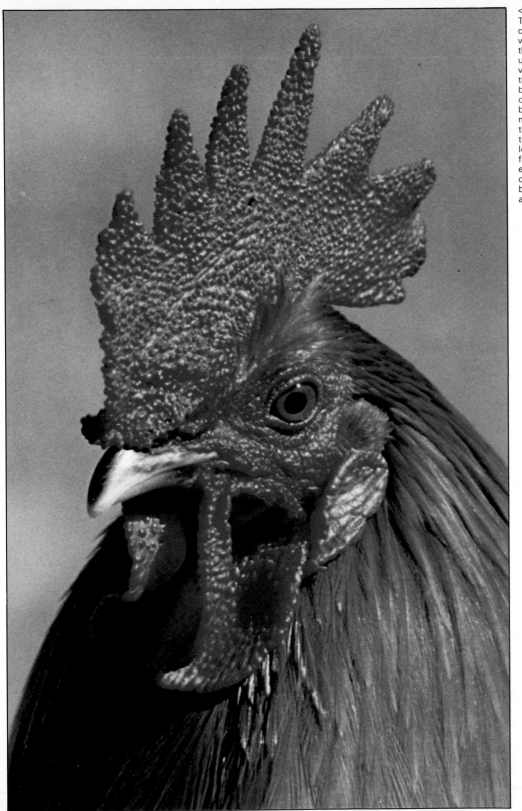

◁ **Dual texture**
The head of this bantam cock caught my eye as it was spotlit by sun early in the morning at a zoo. By using a 135mm lens, I could virtually fill the frame with the head, and throw the background completely out of focus. The texture of the bird's warty comb contrasts markedly with the texture of the feathers, and both are thrown into relief by the low-angled sunlight. Color film was essential to emphasize the texture and color of the cock's head, both of which are sexually attractive to the hen.

Abstract images

An abstract from nature may be created by photographic technique or by taking advantage of natural phenomena. Abstraction is either the over-emphasis of shape, pattern, or color or their distortion so that in the finished picture the original image is no longer obvious. Abstracts are therefore artistic rather than realistic creations.

Many fields of photography are exercises in abstraction, especially those based on elaborate darkroom techniques such as solarization, tone separation, and photo montages, for example. The natural-history photographer does not have to rely on such artifices to create abstractions but may have to look at subjects anew. The discerning eye will see how animals try to escape detection by disguising their shape and form with abstract patterns that disappear into the natural mosaic of light and shade. Another fertile source of abstract forms can be found in the effects of the physical world on the shape of the environment — for example, ripple patterns in sand, scour marks of water currents, bizarre forms of lava, swirl patterns in water, and wind-pruning of trees. Distortions may be caused by refraction through water or by inversions in the atmosphere producing mirages. Reflections may distort, especially if the mirroring surface is uneven. A rainbow is produced by a cloud of falling raindrops acting like a prism to split the white sunlight into its constituent colored wave-lengths. Rainbow hues are also produced by a thin oil film on the surface of water. Naturally occurring iridescent colors can be seen in mother-of-pearl shells and on some butterfly wings, while the surfaces of certain minerals iridesce when viewed in ultraviolet light.

The photographer can exploit these natural abstracts by isolating them from their context. You can do this by taking close-ups and deliberately omitting visual clues as to their origin. Alternatively, you can choose a form of lighting that emphasizes the abstract pattern or form but suppresses the aspects that orientate the observer; the elimination of all shadows, for example, may create a two-dimensional color pattern out of a highly textured three-dimensional subject.

You may choose to limit severely the depth of focus in your picture or to distort the perspective by choosing the ultra-short-focus fish eye lens. Or you may place distorting devices such as a colored filter, a soft-focus filter, a prism, a starburst filter, or a piece of curved glass in front of the lens. My own approach to nature photography is to reproduce the natural world as I see it. If this includes abstract images, I regard them as an exciting bonus, but I do not deliberately create abstracts.

Chance distortion △
This grab shot of a parrot fish was an unexpected bonus. The fish was swimming so close to the shore that I was able to frame it tightly with a 135mm lens. At the moment of exposure, the ripples distorted a portrait picture into a unique surrealistic shape. The odds of achieving such a chance shot would be increased by using a motor drive.

◁ **Iridescent colors**
The New Zealand paua shell (*Haliotis iris*) is renowned for its exquisite colors. Once any growths have been removed, the polished surface shimmers with blues and greens. I took this minute portion of shell by lighting it with a fiber optic, and was able to see the color mix changing as I varied the angle of the fiber optic to the shell.

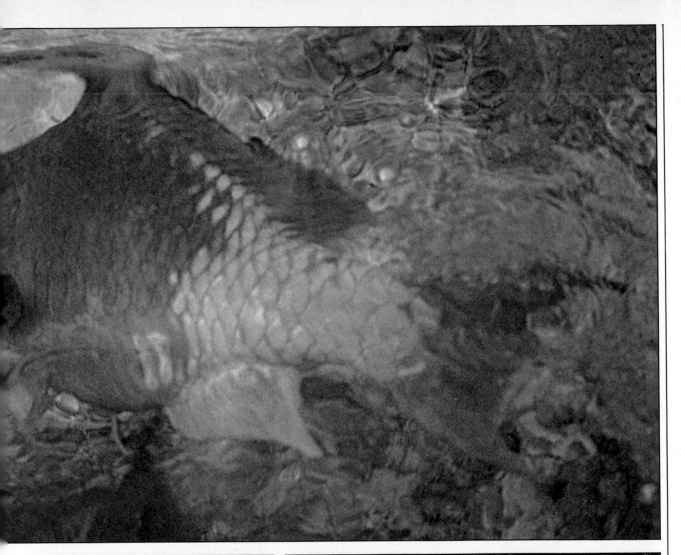

Living abstract △
This scribble mine is the work of a larva tunneling its way beneath the bark of an Australian eucalyptus tree. A forester slashed off the bark to reveal the dark mine contrasting so well against the pale wood. A 55mm micro-Nikkor lens gave me the precise framing I required.

Mineral abstract ▷
I saw this attractive abstract on a weathered rock platform of a New South Wales beach. The rock, still wet from the recently ebbed tide, was exposed to the air for only a few hours each day. It was the design made by the reddish iron deposit that made the rock photographically interesting.

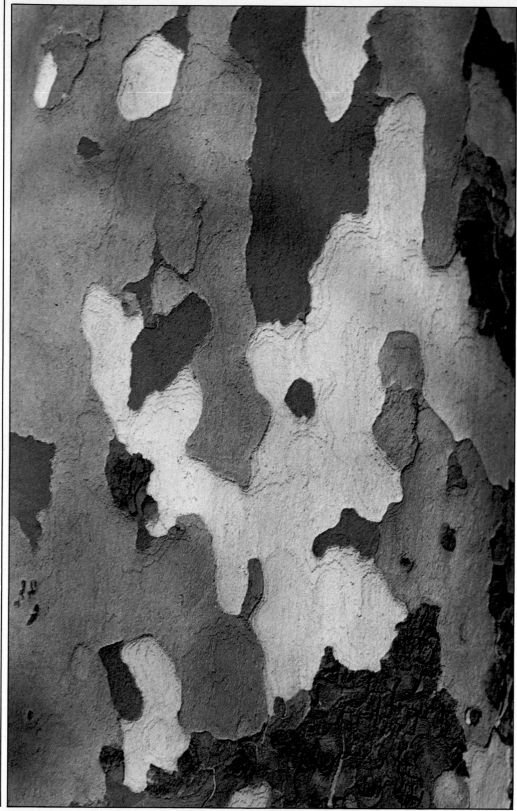

◁ **Flaking bark**
The bark of London plane trees (*Platanus* x *hispanica*) constantly flakes away in irregular patches, creating a natural abstract of old dark bark intermingling with the newly exposed creamy areas of fresh bark. In time, the latter darken as they are weathered by the elements and by pollution. The perpetual habit of bark-shedding allows the plane tree to rid itself of bark in which the breathing pores have become blocked by smoky pollutants. Using a monopod to support the camera momentarily, I took this picture with a 135mm lens.

Swirling water ▷
I had gone to an upstream site on this Scottish salmon river in the hope of taking photographs of the fish leaping up the falls. When this proved unsuccessful, I wandered back downstream and became mesmerized by the water swirling around in an eddy at the side of the river. I used a 250mm lens on the Hasselblad to isolate a portion of the river from the main swirling mass of white water. I took a number of frames, each of which was different.

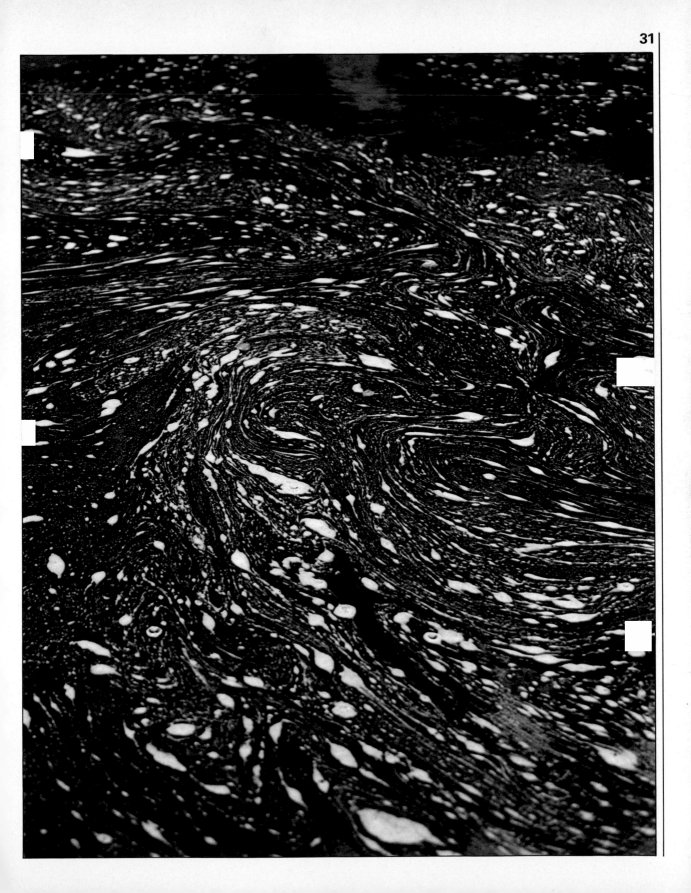

Reflections

Reflections in water, or even wet sand, can provide pictorial effects that lift an ordinary scene into one of exceptional beauty. Perfect reflections rely on the water surface being totally calm; any ripple or wave will distort the image. It is worth remembering that reflections depend on both the angle of the light source and the camera angle in relation to the subject, so it may be worth changing the angle of viewpoint to see how this alters the impact of the reflection. Reflections of objects or scenes are usually best when they are well lit, and this is achieved by taking the picture with the sun behind the camera. Views of reflected sunsets or silhouettes of dark shapes against bright skies are taken into the light.

The four water reflections shown here illustrate how natural reflections can be used to produce creative images; but reflections are not always welcomed by the nature photographer. As well as providing images that can be usefully exploited photographically, reflective surfaces can cause problems. For example, cats' eyes caught in the headlights of a vehicle gleam because of the reflective layer at the back of their retinas. Flash photography of animals at night sometimes unavoidably results in images of fiery-eyed monsters. The silvering of the bellies of some fishes creates real problems for both the underwater and the aquarium photographer. The angle of the flash to the fish's body is crucial, otherwise the light may be reflected straight back into the camera, resulting in over-exposure. Overcoming the problems of distracting skylight reflections on water and of lighting through reflective surfaces is dealt with on pp. 136–41.

The mirror image ▽
As I looked up from photographing spawning frogs in a canal, my eye was caught by this dramatic cloud reflection. The view was directly toward the reflected sun, but flare was eliminated by the rim-lit clouds creating a striking image which contrasted strongly with the dark water and the skeletal trees.

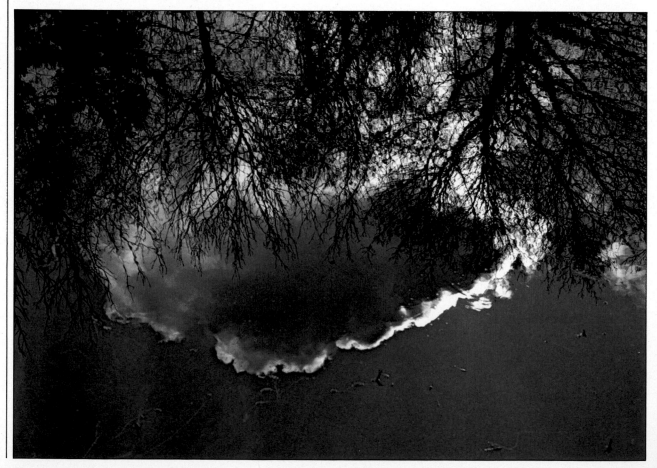

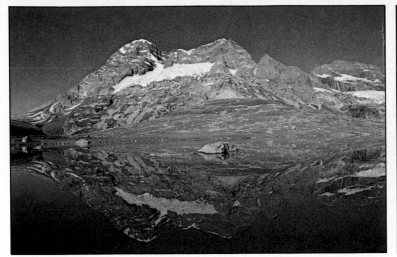

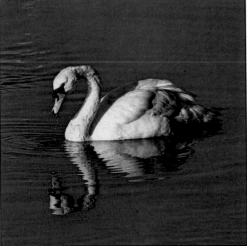

Mountain replica △
Reaching the crest of a mountain pass in Kashmir, I saw the sacred peak of Mount Haramukh mirrored in Lake Gangabal. In such remote areas where the air is pollution-free, perfect visibility can extend for miles in good weather.

Subtle sunset ▽
One clear mid-winter's day in the Scottish Cairngorms, I stopped beside a loch to photograph some snow-laden trees. Walking past the trees, I was drawn toward the small dark patch of open water and was fascinated to see the needle-like projections of ice growing out over the water as the temperature dropped. While I watched, the delicate hint of the setting sun appeared through the clouds. I quickly changed the 50mm lens for a 200mm lens, so that I could concentrate attention on the subtle colors.

Mirror distortion △
The reflections of waterfowl, especially of birds with white plumage, make ideal photographs. On ornamental ponds, where the surface can be disrupted by floating water plants, reflections are seldom seen. However, swans can often be found feeding in estuarine creeks. I had already prefocused my 400mm lens on this mute swan when a few drops of water fell from its bill and the radiating concentric ripples they caused distorted the reflection but created a dynamic abstract element in a static design.

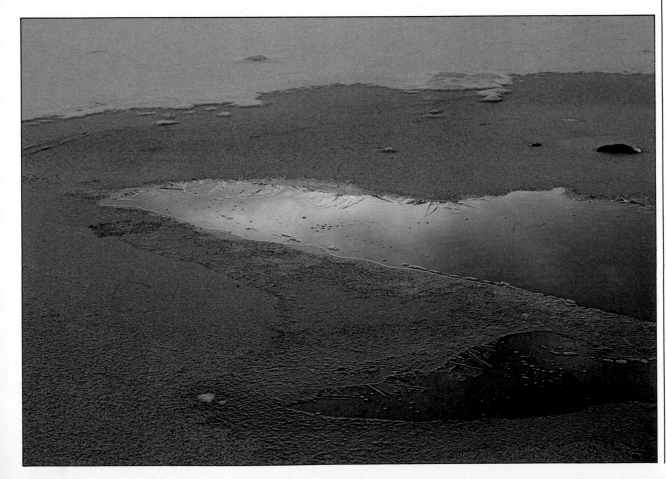

Nature's use of color

In the natural world, the range of colors and their combinations is infinite, and each makes a significant contribution toward the survival of a particular species. Brightly colored flowers attract pollinators, while attractive fruits lure animals to feed on them and thereby disperse the seeds from the parent plant. For much of the time many animals try to look insignificant, and there are many ways in which they conceal themselves. Most simply, animals blend in with the color of their surroundings. For example, many grasshoppers are the same green as the grass on which they sit, and many night-flying moths have drab upper wings that merge with the tree bark on which they rest by day. This cryptic coloration allows animals to escape the notice of predators or, in the case of some predators, such as crickets, frogs, and snakes, to avoid detection by their prey. Irregular blotches of light and dark color effectively break up the body outline of some amphibians, snakes, and fishes in the same way that camouflage clothing disrupts man's body outline so that it blends in with the vegetation during warfare or when out stalking mammals.

Photography of both cryptic and disruptive camouflage can present problems. If lighting or backgrounds are used to highlight the animal, it no longer appears insignificant, yet under natural conditions the animal may be so well camouflaged that it is virtually invisible.

Some small animals conceal themselves by resembling a natural inedible object. When at rest, several different butterflies and moths mimic dead leaves, a stick insect a twig, and some caterpillars even resemble bird droppings. At times, some animals use color and position to attract a mate, or to advertise the fact that their bodies would be distasteful to predators; others use fright displays, such as flashing false eye spots or bright splashes of color, to deter potential predators.

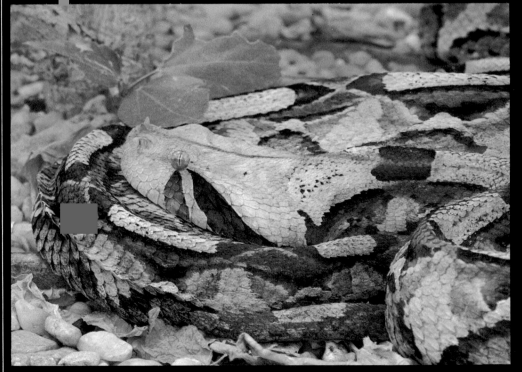

Hidden predator △
The blotched markings on the body of the gaboon viper (*Bitis gabonica*) help to camouflage the predator's body by disrupting its outline. This resting snake was safely confined behind a glass-walled vivarium in a South African snake park. I had to use a tripod for a fairly long exposure by available light, which filtered down into the enclosure from above.

Warning signal ▷
The spectacular red and black markings of this South American arrow poison frog (*Dendrobates histrionicus*) blatantly advertise its lethal toxin to would-be predators. I took this flashlit picture in my kitchen at a time when my studio was not functioning. I used an exotic pot plant both as a plausible background and to fill the frame.

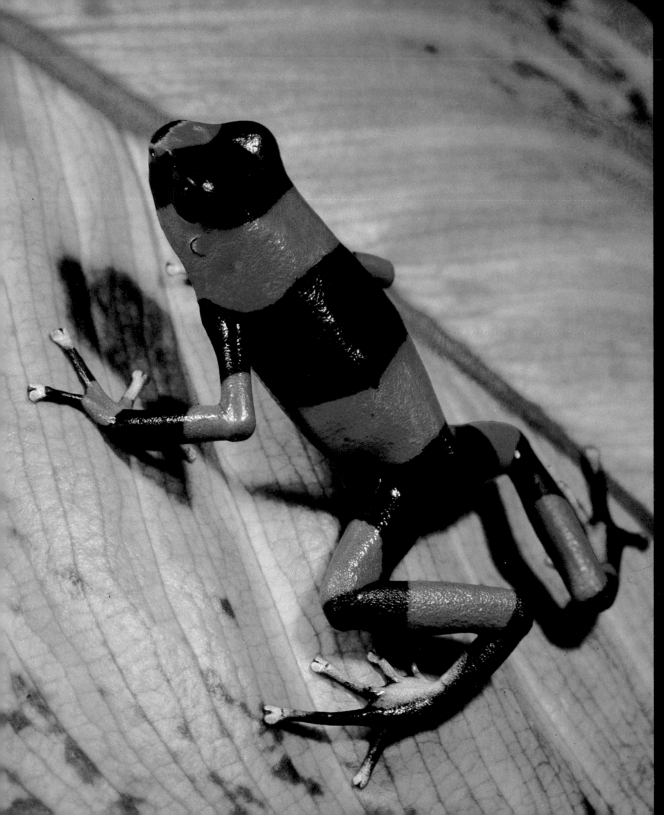

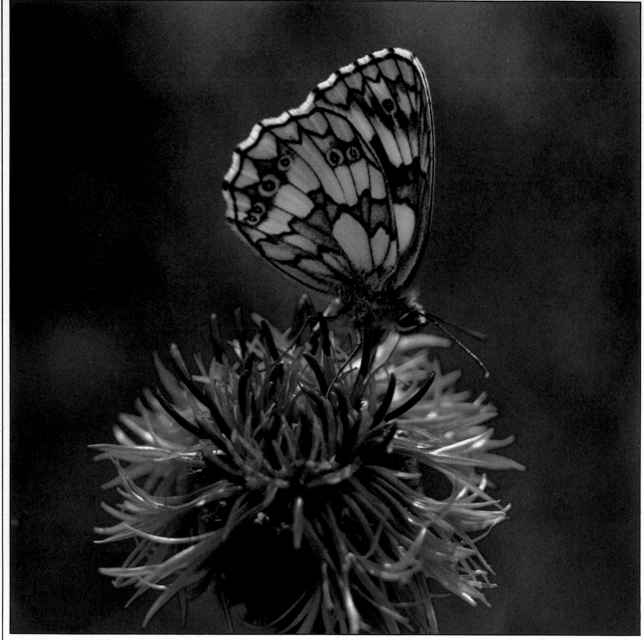

Attracting a pollinator △
A marbled white butterfly feeding on a greater
knapweed flower illustrates the relationship between a
flower and its insect pollinator. If you wish to photograph a
particular flower being visited by an insect, it is useful to
know not only the time of year that the flower is open, but
also the time of day, for not all flowers are open
throughout the day. By patient field observation you will
learn about the behavior of visiting insects. I used a
105mm micro-Nikkor lens for taking this picture by natural
light on a sunny day. For such ecological pictures, it is
much better not to fill the frame with the insect, but to use
a slightly smaller magnification, so that the flower features
quite obviously.

NATURE AND THE
CAMERA

Selecting a viewpoint

Selecting the viewpoint should be one of the first steps toward composing a picture; yet surprisingly few nature photographers give the choice of viewpoint more than a cursory thought. Merely holding the camera horizontally at eye level may be good enough for the grab shot, but it is scarcely creative. Admittedly, lying prone in a water-logged bog or carrying heavy equipment up mountains, just to seek the best viewpoint, demands an element of determination tantamount to masochism. However, without this sort of determination, there are occasions when it is difficult to achieve eye-catching pictures.

In a studio, the photographer can manipulate the set, move props around, and arrange the lighting. In the field, manipulation is usually restricted to the choice of viewpoint and the choice of focal length of the lens. Perspectives can be changed dramatically by even slight alterations in elevation. The lower your viewpoint, the more emphasis you are placing on the foreground, so that quite a lowly plant can be made to dominate a picture. A low-level camera can also be used to isolate plants against the sky.

Choose a high viewpoint, however, if you want to photograph a scene spread out before you. I have repeatedly climbed trees and deer stalkers' seats, or maneuvered my four-wheel-drive vehicle to where I could stand on the roof, to gain those few extra feet that allowed me to convert a mundane scene into one with pictorial impact. Even when you are satisfied with the proportions of sky to background and of background to foreground, you may still need to modify the camera position slightly. You could change the position of the subject in relation to its surroundings, or, by moving the camera a few feet to one side, you may be able to mask a distracting background with a tree or a rock. With care, you can create an interesting picture out of the most unpromising subject, simply by finding a viewpoint from where your composition is naturally framed and appears to have a feeling of depth.

Try not to look at everything merely from conventional angles. Babies lying on their backs are often fascinated by trees swaying in the wind, and details at ground level can make a great impression on little children. Simple images taken at a child's eye level can appeal by recalling that almost forgotten childhood experience of the outside world.

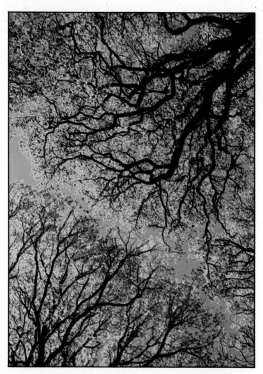

Framing the scene ▷
Viewpoint was crucial for this picture taken through a natural sandstone opening. A lower angle would have increased the proportion of the sky, while a higher angle would have obliterated the sky altogether. This was one of the rare occasions when I took the precaution of bracketing my exposures because of the enormous difference between the dark rock and bright sky.

◁ **Worm's eye view**
On only a few days each year can the mosaic pattern of a deciduous canopy flushed green with the new spring leaves be seen. I used a 150mm lens on a Hasselblad for this overhead view highlighted by the sun.

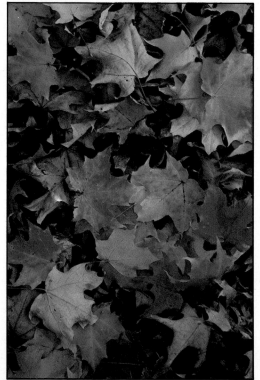

◁ **Bird's eye view**
I can never resist freshly fallen leaves on a forest floor. For this shot of sugar maple leaves, taken in the New England fall, I mounted a Nikon on my versatile Benbo tripod (above) so that the film plane was parallel with the ground. A 55mm micro-Nikkor lens ensured precise framing.

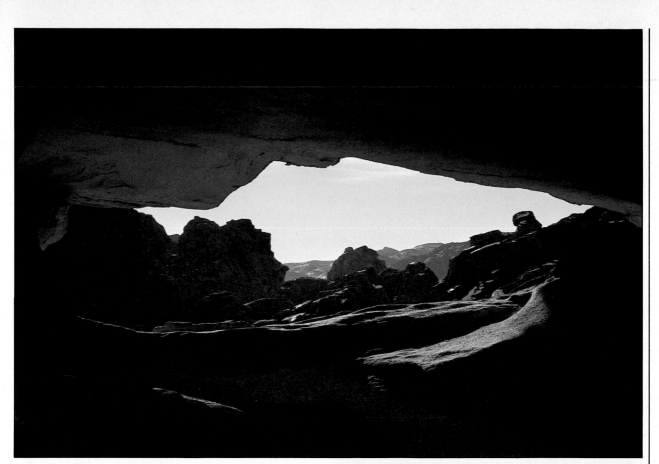

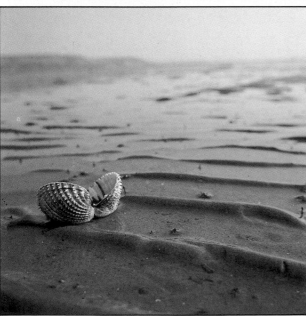

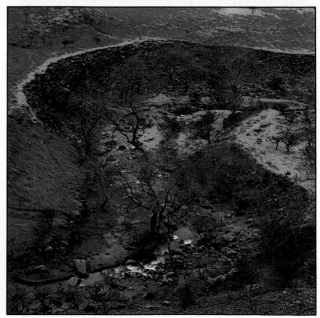

Wide perspective △
When I saw this pair of spiny cockle shells left by an ebbing tide on a sandy beach in Wales, I decided to use a low viewpoint and a wide-angle lens to emphasize the shells' isolation. I could only achieve the desired effect for this winter scene by lying prostrate on the wet sand.

Climbing high △
If it is not practical to take an aerial picture of a river in its landscape, look around for a natural high vantage point. I took this meander of a north Wales river after climbing a steep scree slope. The bare winter trees allowed a clear view of the river course.

Using wide-angle lenses

Choosing the correct focal length lens is every bit as important as selecting the right viewpoint. Most often a wide-angle lens is used to include a wide landscape within the frame when working from a restricted viewpoint. For the creative nature photographer, however, a wide-angle lens offers much more scope. Because it reduces the image more than does a standard or long lens, the wide-angle lens gives a greater depth of field for any given aperture. It also expands perspective so that foreground subjects appear large, whereas distant objects seem to be farther away than they would through a longer lens. You can exaggerate this perspective distortion by tilting the camera so that the film plane is no longer at right angles to the ground. Straight subjects, such as tree trunks, will then appear to converge toward the center of the picture, unless you use a special perspective-correcting wide-angle lens.

Most often I use my wide-angle lenses to relate plants to their particular habitat; indeed, I refer to them as my ecological lenses. If the lens is carefully focused and well stopped down, you can gain a sharp image extending from the foreground to infinity. Wide-angle lenses are rarely suitable for showing a single wild bird or mammal in its environment, simply because it is impossible to come close enough without frightening them. Static subjects of animal origin such as skulls or fossils are, however, ideal for foreground emphasis. Ultra-wide-angle (16mm or less) lenses are best suited for creative rather than representative images.

Setting the scene ▽
The clear water of this chalk stream showed the underwater vegetation patterns. Standing on a bridge, I used a Hasselblad Superwide camera (below) with a fixed 38mm lens, and added a polarizing filter to reduce the reflections.

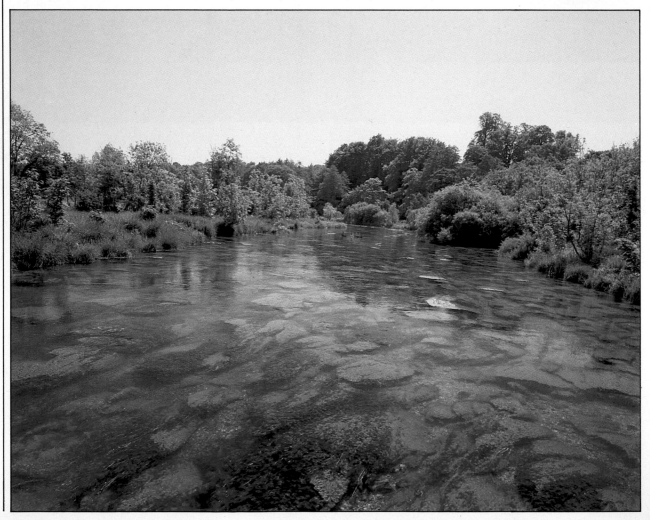

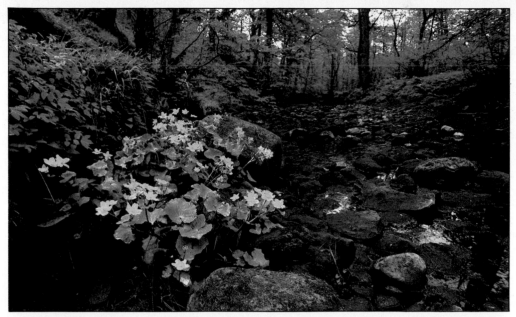

◁ Flowers in their habitat
The combination of a wide-angle lens (20mm on a Nikon) and a low viewpoint is one that I often use to illustrate a conspicuous clump of flowers in conjunction with its habitat. This picture of marsh marigolds (*Caltha palustris*) in a Yorkshire wood demonstrates my approach to field photography. The bright yellow flowers show up well against the somber moss-covered stones.

◁ Taking a wider view
I had been using a 400mm lens to take portraits of the game from the lodge of this East African game park when I decided to switch to a 35mm lens and try to capture the whole breathtaking scene, with the marabou storks in the foreground, the zebra drinking at the water hole, and the elephant lumbering between them across the savanna grassland. I did not choose an even wider-angled lens simply because this would have made the animals appear so small that they would have been completely overshadowed by the landscape.

Using long lenses

Because long lenses magnify distant objects on film, they are ideal when used for taking timid animals such as birds and mammals; for bringing closer inaccessible subjects such as alpine and aquatic plants, parts of trees, lichens on roofs, and glacial crevasses; and for tighter framing of landscapes. Wary insects, such as butterflies, are best taken with a medium long lens (135mm to 200mm) used in conjunction with extension tubes (see p. 158) because this combination provides a good working distance between the camera and the subject and also ensures a reasonable-sized image.

Long lenses give limited depth of field, which can be useful in isolating a subject from its background. However, this small depth of field does mean that you have to focus the lens precisely. Long lenses also foreshorten perspective so that distant objects appear much closer to the foreground.

Camera shake tends to be magnified when you use long lenses for hand-held shots. As a rough guide to minimizing camera shake, your slowest shutter speed should be approximately equal to the reciprocal of the focal length of the lens (for example, 1/250 sec for a 200mm lens) although, if you brace your body against a tree or the ground, you can safely use slower speeds. There is nothing comparable to a sturdy tripod for supporting a camera with a long lens, but this is practical only when taking static subjects. Then, once the picture is composed and the camera focused, camera shake can be reduced still further by locking up the mirror on an SLR camera and making the exposure with a cable release. For active subjects, you simply won't have time to erect a tripod, but you can solve the problem by having your camera already attached to a monopod, a pistol grip, a hand grip, or a shoulder pod.

Keeping a safe distance ▽
Early in the morning, while on a walking safari in Zambia, we came across a hippopotamus herd in an ox bow lake. A 300mm lens gave me a safe working distance for this head-on shot taken with the camera supported by a hand grip (shown below).

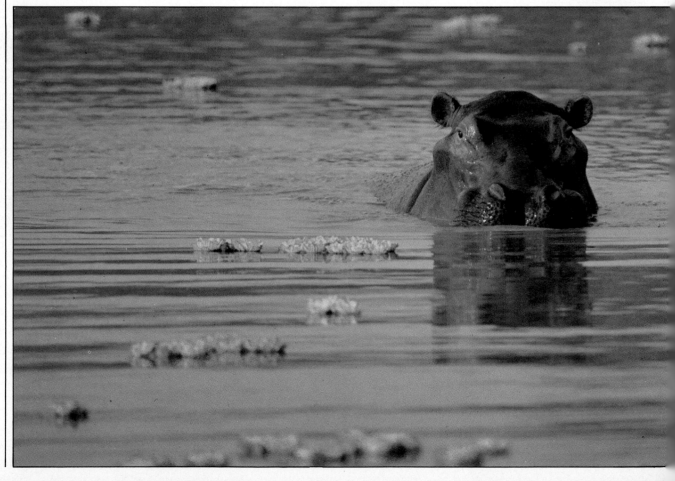

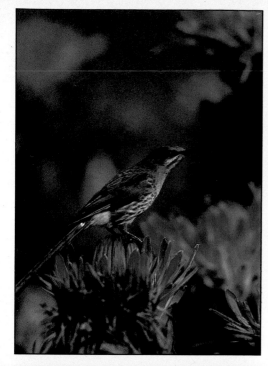

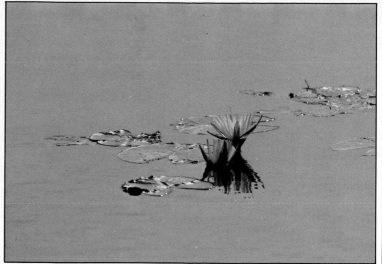

◁ A wary subject
Having had no success at stalking sugarbirds feeding on proteas in South Africa, I eventually took this picture by staying in one place with a 400mm lens attached to the camera on a tripod.

Reaching the inaccessible △
Because I was unable to wade out to photograph these two water lilies and their reflections in the silvery water of a Zambian lake, I used a 400mm lens to enlarge the image size.

Cropping in ▽
I have photographed beech leaves many times, but this backlit branch, curving around the shadow, proved irresistible. A 200mm lens provided a precise crop.

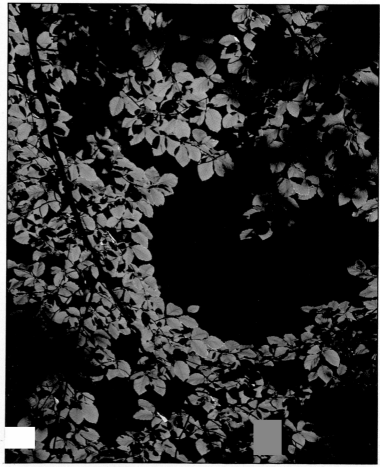

Capturing action

Mastering the technique of freezing action presents one of the greatest challenges to the wildlife photographer. When working in the field, you learn to capture action either by reacting quickly to the unexpected or by planning carefully and anticipating expected behavior patterns or responses. It is essential to be in the right place at the right time with your camera at the ready: time spent fumbling in a gadget bag for another lens can mean the loss of a valuable picture. To achieve one worthwhile frame, you have to be prepared to expose plenty of film and to discard those frames in which the combination of exposure, lighting, degree of movement, and composition fall short of perfection. With a motor drive, you will be able to take action sequences, and will also be more likely to get at least one acceptable action picture. If possible, use a camera that has an automatic exposure control for taking action pictures when the light levels are fluctuating and you do not have time to adjust the exposure manually. When the subject-to-camera distance is constant, for example, when you are photographing birds flying past a headland, or mammals migrating in a line, you can prefocus the camera and this will allow you to concentrate on framing the subject and composing the picture. Handling and using your camera should be quite instinctive.

When you are relying on available light, fast shutter speeds (1/1000 sec to 1/250 sec) are essential for freezing the most dynamic action, although you can use slower speeds (1/60 to 1/30) by releasing the shutter as you pan the camera following the direction of the moving subject. If you want to photograph birds in a dark location, as they enter or leave the nest, for example, remember that flashlight will produce better-quality images than will a high-speed film without flash.

Arresting movement in the studio should present fewer problems, because a captive subject will not disappear and you will be able to control the lighting carefully. You may, however, find it difficult and time-consuming persuading the subject to behave naturally.

Quick reflexes ▷
My main purpose for visiting this large frozen pond was to take icicles in close-up. As soon as I heard the powerful wing beat of a swan, I changed my 55mm micro-Nikkor for a 300mm lens, unscrewing the camera from the tripod just in time to pan it as the swan took off after momentarily alighting on the icy surface.

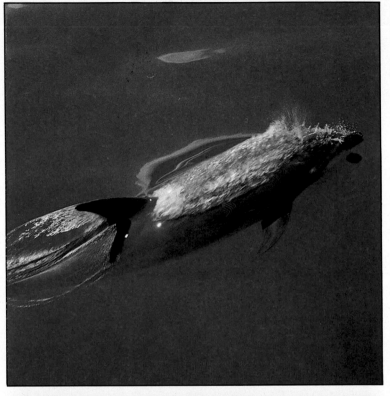

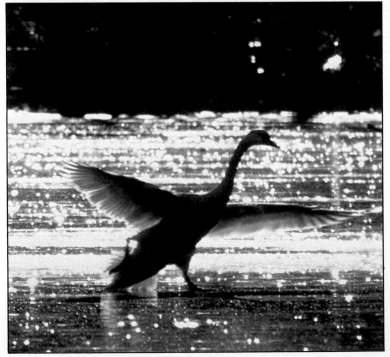

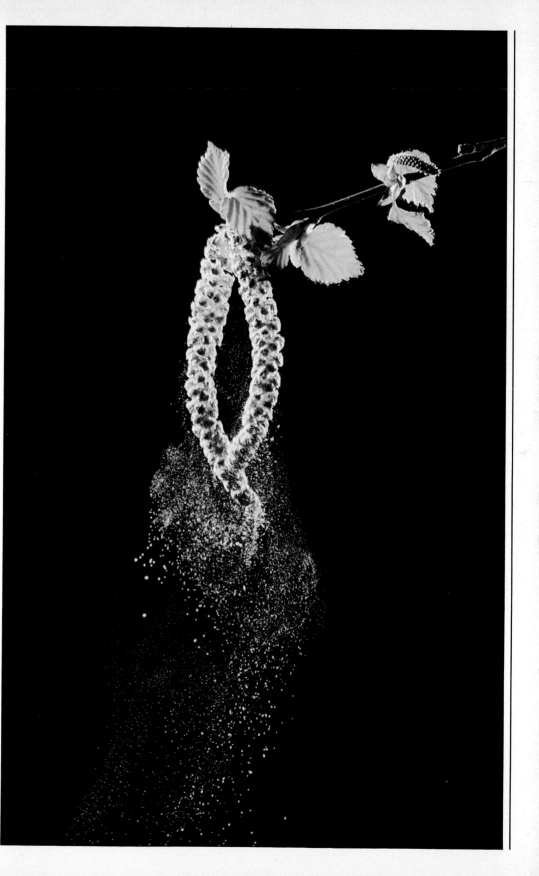

◁ **Prefocusing**
Throughout our journey around the Galapagos Islands, porpoises shadowed our small boat. In calm water, the distance between the deck and the sea was constant, allowing me to prefocus the camera and expose as the porpoise surfaced to breathe. The natural backlighting and the ripple-free deep blue sea both accentuated the upward spurt of water from the blow hole as well as the streamlined water flow over the porpoise's body.

A moment in time ▷
As wind blows ripe male catkins to and fro, it disperses the microscopic pollen grains so that some can pollinate the female catkins. Outdoors, the minute amounts of pollen that are being shed all the time are difficult to capture on film. I controlled the dispersal of the pollen grains by keeping the catkins indoors, free from drafts. I lit this picture with two small electronic flash units placed obliquely behind the catkins, and made the exposure as an assistant blew on them. The backlighting highlighted the microscopic pollen cloud.

Long exposures

Deliberate use of a slow shutter provides most scope for the landscape or the plant photographer wishing to take advantage of static subjects in poor lighting or for the photographer using slow fine-grain films in order to achieve good-quality color reproductions. In dull conditions without flash, such films dictate long exposures with slow shutter speeds which necessitate a robust tripod. Long exposures are also useful for crisp close-ups of flowers and fungi that are quite motionless, because they allow you to stop down the lens and bring the entire specimen into focus.

To anyone who specializes in crisp action pictures, slow shutter speeds are anathema; yet it is possible to convey action by using a slow shutter so as to blur movement. Provided that the main subject can be defined, blurring may give a better sense of motion than a single sharp image that captures motion that is faster than the eye can perceive. If you use a fast shutter to take water moving over rocks or down a waterfall, the movement appears unnaturally frozen, whereas the soft blurring that you can obtain with a slow shutter gives the impression of continuous flowing movement.

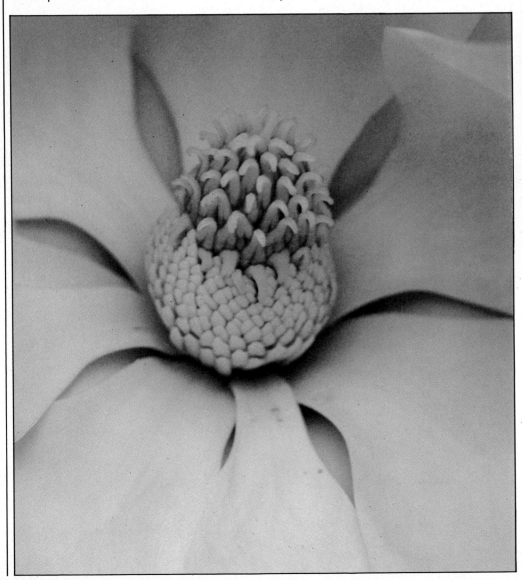

◁ **Depth in close-up**
Whenever I photograph white or pastel-colored flowers, I always try to light them by diffuse indirect rather than by direct light. On this occasion the sky was so overcast after a rain storm that I had to use a 1 sec exposure to make sure that all the internal parts of the flower appeared sharp.

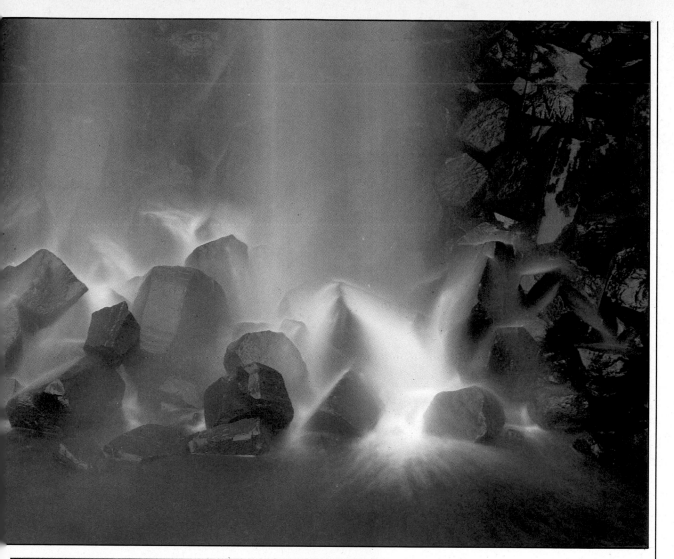

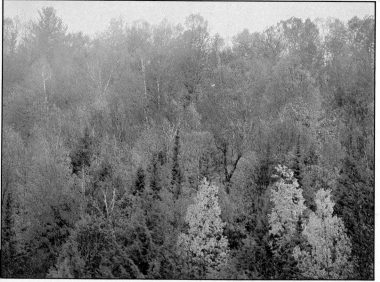

◁ **A dull day**
The fall in New England is renowned for its beautiful colors, with the changing hues of the deciduous trees contrasting well with the somber evergreen conifers. I was initially disappointed when I awoke to this misty day, but I soon appreciated that the soft lighting had transformed the previous day's harsh sunlit scene into a gentle, muted mosaic of color, resembling an Impressionist painting. The still conditions enabled me to use a slow shutter speed with a slow-speed film.

Creating an impression of movement △
After I had used a wide-angle lens to photograph the full drop of this Icelandic waterfall, I decided to crop in tightly on the base with a 200mm lens. The 1 sec exposure highlighted the way that the water radiated out on impact with the broken basalt columns.

Planning sequences

All nature is a progression of changes and movements—both long- and short-term. You can illustrate progression by making a photo-sequence, either by taking a series of several frames per second of still photographs using a motor drive, or by taking the same subject under identical conditions at an interval of minutes, days, months, or even years.

With the aid of a motor drive and fast reflexes, you will be able to take sequences showing how a bird takes off or alights, or how a mammal runs, for example, without much difficulty. When taking fast-action sequences with a motor drive, however, you will find that the repetition rate is limited by the speed at which the shutter can be fired or, if you are using electronic flash, by its recycling time. It may therefore be preferable to work with available light, especially when you are using a long lens, or to push the film to double the recommended speed, so that you can combine a fast shutter speed with a reasonably small aperture.

While you may achieve a fast-action sequence simply by chance, longer-term sequences require forethought and planning. Try to avoid extremes of lighting, such as long shadows cast by hills lit early or late in the day, which may obscure in one frame features of a landscape that are visible in another. Decide in advance how best to frame your picture so that, however the subject may change, you will still be able to include all of it in the frame. You may find it difficult to remember the exact viewpoint you used for the first picture, so, if you are taking a photo-sequence of, say, the dramatic seasonal color change of a deciduous woodland, refer back to previous photographs to check your precise viewpoint and framing. In places where the high-ranging spring tides occur early and late in the day, it is possible to take a pair of pictures, on the same day, of the intertidal zone when it is exposed to the air and when it is covered by the sea. After taking the first picture, make a rough sketch of any obvious landmarks, and note the focal length of the lens used. If you used a tripod, mark the leg positions on the ground, so that you will be able to repeat the viewpoint and framing for the rest of the sequence.

It is often more practical to take some time-lapse series, such as a flower bud opening (see p. 107), a sea anemone unfurling its tentacles, or a toad walking (see p. 135) in the studio, where you can control the lighting.

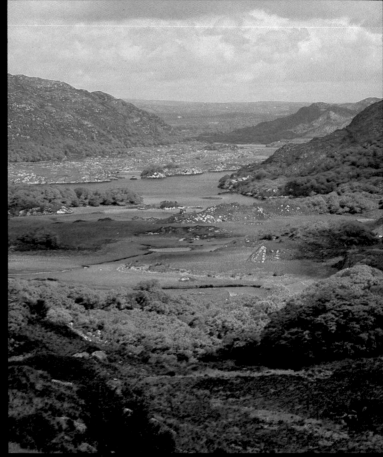

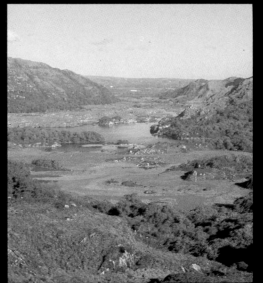

Seasonal variation
Two pictures of the Killarney Lakes in Ireland, taken from the same viewpoint, illustrate the dramatic color change that takes place from one season to another. I took the first picture (left) in early December, when the oak leaves were beginning to turn brown. The entire open grassy area had changed from green to brown and the winter water level was high. The second picture (above) was taken six months later, in June, using a polarizing filter to reduce the sky-highlights on the vegetation and enrich the green of the oak trees.

An opening sea anemone

Because the plumose sea anemone (*Metridium senile*) is found very low down on the shore and is accessible from land for only a short time during low water of spring tides, it was impossible to take a sequence showing its changing shape, as its tentacles opened, in an authentic setting. Instead, I searched for an anemone attached to a flat stone, so that I could transfer it, with the minimum disturbance, to a small sea-water aquarium for studio photography. The aquarium was two-thirds full of sea water, which I had first filtered through a fine mesh nylon plankton net, so that it was completely clear. I attached a Hasselblad camera to a copying stand to give me an overhead view of the anemone's mouth and tentacles. A pair of electronic flashes was angled in through opposite sides of the aquarium, to provide enough light for me to stop the lens well down. I kept the magnification constant for the first five frames of the photo-sequence, taken at approximately five-minute intervals, but the out-of-focus corners of the last frame show that I had to refocus the lens because the anemone had extended its column vertically upward and so reduced the camera-to-subject distance.

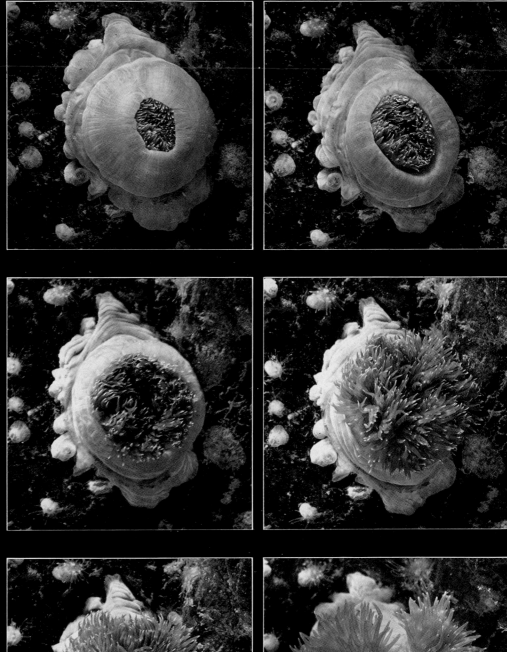

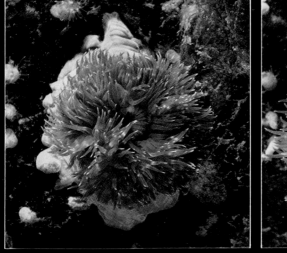

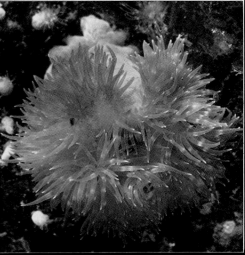

Using filters

To take authentic photographs of the natural world, you should use a filter only if it enhances the image. If you want to experiment with filters, those that are made of gelatin are the cheapest, but, because they are easily scratched or bent, they do not last as long as glass filters. A more expensive, and perhaps the most valuable, filter for nature photography is the polarizing filter. If you use it with an SLR camera, you can view the effect of rotating the polarizing screen directly through the camera. I use my filter for reducing skylight reflections on water or shiny fruit and leaves. It is particularly effective in increasing the color saturation of leaves and green trees in landscapes and, if the camera is aimed at right angles to the sun, the filter darkens a blue sky to give maximum contrast with clouds, snow-capped mountains, and autumnal leaves. When the filter is fully polarized, the loss of $1\frac{1}{2}$ stops exposure may create problems if you are taking a moving subject on a slow film.

The versatile skylight filter (1B) helps to warm up the cold tones produced by an overcast sky, and it can be kept on the lens for most pictures, or until you wish to use another filter.

The blue of some flowers is especially difficult to reproduce accurately on color film because it reflects some red and infra-red light, which renders it mauve on film. This color cast is most noticeable in sunlight and can be reduced by photographing in the shade. If this is not possible, a blue color-correction filter, such as a 20CC blue, will help to restore the blue of the flower but will also add a bluish cast to the rest of the picture.

Two other filters that can be useful to the nature photographer are a UV filter, for reducing haze by absorbing ultra-violet rays, and a graduated filter, for compensating for the high contrast between the sky and land in landscapes. Most other filters produce too much distortion for realistic nature photography.

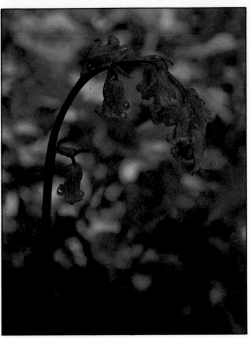

◁ **Restoring natural color**
Whenever I photographed bluebells on color film, they came out as pinkbells, until I experimented with a blue color-correcting filter. I took this picture with a 55mm micro-Nikkor lens, and a 20CC blue filter which counteracted the infra-red reflections, and reproduced the color quite accurately.

Darkening the sky ▷
I took this heathland scene on an overcast day, when the colorless sky would have appeared very over-exposed alongside the somber foreground had I not decided to use a gray graduated filter (right) to darken the sky.

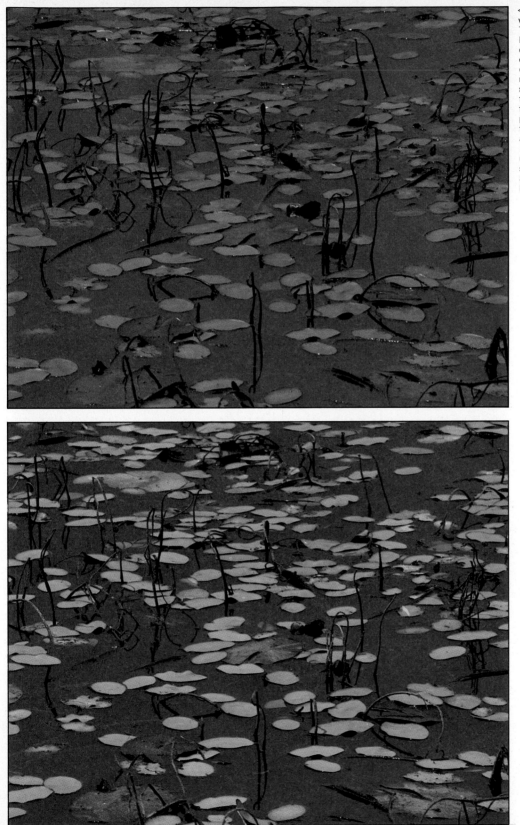

◁ **Removing reflections with a polarizing filter**
These two pictures of water lily leaves on a Zambian lake demonstrate vividly how effective a polarizing filter can be at removing skylight reflections on the water surface and on leaves. I first took the picture without a filter (left), and then used a polarizing filter to enhance the color of the green leaves and to darken the water (below left). Because I was unable to walk out over the soft muddy margins, I used a 200mm lens to gain a bigger image of the leaves.

Using filters

Some filters are invaluable for monochrome work. In particular, strongly colored contrast filters can be used to increase the contrast between two colors which would otherwise be reproduced as similar tones of gray in a black and white print.

When working in monochrome, remember that to lighten a particular color you have to use a filter of a similar color, and to darken it a filter of a complementary color. For example, a yellow filter will darken a blue sky, while a red filter will provide an even greater contrast between the sky and the clouds.

All filters reduce the amount of light reaching the film, but not all of them require an exposure increase. When an exposure reading is too high to allow you to take a picture with a fast black and white film, a neutral density filter, which reduces the overall light intensity, can make an exposure possible. With the majority of lenses you attach the filter to the front of the lens. However, the filter is attached to the rear of the lens on those fish eye and mirror lenses that do not have a built-in filter system.

Distinguishing tree types ▷
On monochrome prints of trees taken with panchromatic film it can be difficult to differentiate between tree types. Here I used Kodak High-Speed Infra-red film 2481 and a Wratten 89B filter, which made the deciduous birches appear white against the dark conifers.

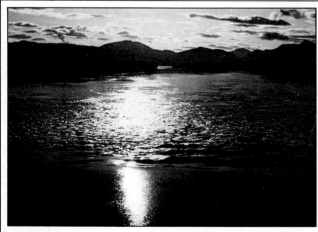 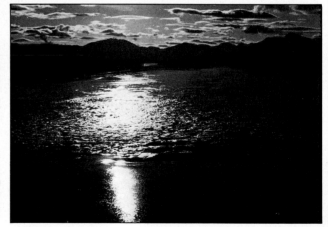

Enhancing the sky
I was driving over a bridge spanning the inlet of a Scottish sea-water loch when I saw the early-morning sun reflected in the rippled water of the incoming tide race. I photographed the scene first without a filter (above), then with a red Wratten 25 filter (above right) to darken the sky and the water and so produce a more dramatic image.

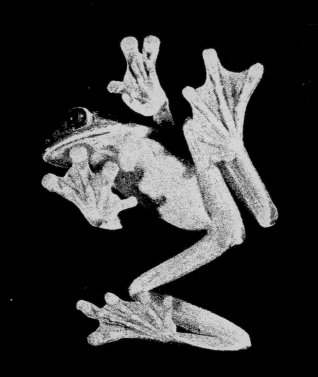

LIGHTING

Exploiting natural light

The ability first to assess, and then to utilize, the quality of natural light so that it strikingly enhances the image you are taking is fundamental to nature photography. The landscape photographer is completely dependent on natural lighting, and may use low-angled lighting early or late in the day, or when a combination of stormy clouds, wind, and sun produce very dramatic sky patterns. The nature photographer, on the other hand, is usually so preoccupied with finding a particular plant or animal that lighting is of secondary importance. Whatever the subject, you should consider carefully the type of lighting (direct or diffuse), and its direction (front, side, overhead, or back) before you expose a single frame.

Always try to estimate which kind of light will best emphasize an interesting feature or form. While it is impossible to move the position of the sun, you can usually modify the camera angle; if this is not practical, make a return visit at a different time of day. Above all, resist the temptation to work with stereotyped lighting. Experiment with light and shadow, by moving around the subject, or tying back overhead branches, or even diverting a sun beam with a mirror. Continuous cloud cover provides a soft, diffuse light, which is ideal for gentle pastel-colored scenes and subjects. Such conditions require long exposures with slow color films, and you will need to use a tripod. In complete contrast, direct, low-angled light, coupled with harsh, long shadows, can be used to spotlight the subject, to build bold patterns, or to rim-light solid forms. When sun shines through strongly colored translucent flowers or leaves, they appear to glow, and there is no better way of emphasizing spines or hairs.

Just as important as assessing and selecting natural light, is knowing how to expose correctly for extremes of light and shadow. Through-the-lens (TTL) metering may be a very quick way of obtaining a reflected light reading, but it is not always so accurate as an incident reading made with a separate light meter. When taking either leaves backlit by sun against a bright sky or a dark woodland scene, I use TTL metering to measure the light shining directly through the leaves by holding another branch in the same plane, so that the entire frame is temporarily filled with glowing leaves.

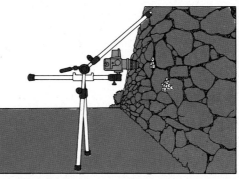

Study in soft lighting ▷
I first noticed these pennywort (*Umbilicus rupestris*) leaves growing out from the wall on a sunny day, when strong shadows from overhanging trees spoiled the simple image. Four days later, when the sun was blotted out by clouds, I was able to take my picture using the wall itself to support one leg of the Benbo tripod (shown above).

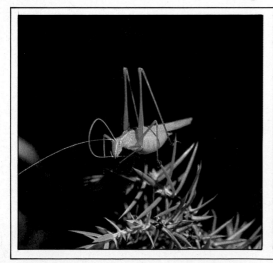

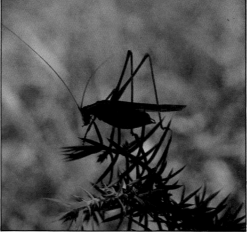

Using light and shadow
You can effectively isolate a flower or an insect from its background by manipulating light and shadow. I took this pair of pictures in France within minutes of each other. The insect as I first saw it (left) was completely in shadow, silhouetted against the background. As I bent a small nearby conifer to one side, the insect became lit directly by the sun (far left) and a shadow was cast on the background.

◁ **Transillumination**
Transillumination is most effective with strongly colored leaves or petals; and the dramatic backlighting shining through the translucent petals of this ginger flower caught my eye as I was walking through a garden in Hawaii. Using a macro lens, I took a TTL reading by moving two other flowers temporarily into the field of view.

Dapple lighting ▷
This fallow buck calling during the autumnal rut, is one of my favorite deer pictures. In contrast with the oak in deep shadow, the head and antlers are spotlit by low-angled sun. The dappled light-and-shadow pattern is repeated in the deer's own coat.

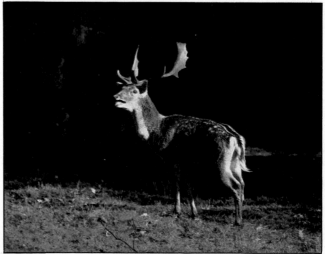

Exploiting natural light

Many nature photographers work exclusively in color, because it plays such a significant part in the natural world. However, there are occasions when black and white pictures can be more effective. For example, silhouettes work very well as monochrome prints, as do any pictures of trees taken with low-angled cross-lighting.

When working in monochrome, you should consider lighting even more carefully than when photographing in color. A successful black and white print needs to show good contrast between the subject and its background. Because black and white film reproduces the world of color in various tones of gray, you must ensure that the tones do not gradate into each other. Color itself can enhance the image, whereas a black and white print will appear flat and lifeless unless lighting is used to stress shape and form, making the subject stand out well from its background. Unless the subject is backlit, you will rarely produce a satisfactory monochromatic image by simply switching from color to black and white film and taking the photograph from the same viewpoint.

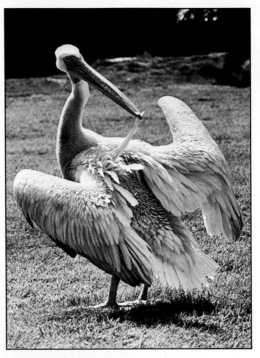

◁ **Modeling with cross-lighting**
Whenever I photograph animals, I try to find an unusual viewpoint or interesting behavior. It is an extra bonus when the combination of these two criteria is enhanced by ideal lighting as it is here. The late-afternoon sun shining across the pelican gave form and depth to the body and feathers. I used a 250mm lens on a Hasselblad to give a reasonably close crop on the original negative.

◁ **Lucky timing**
This picture was only made possible by my being in the right place at the right time. Rounding a bend, while driving through the spectacular Haast Pass in the South Island of New Zealand, I was confronted by these stark silver beeches isolated from the evergreen bush behind by the light pouring down over the hill.

Shapely silhouette ▷
After exploring Mount Egmont Forest in the North Island, New Zealand, I turned to walk back to the car and saw this northern rata (*Metrosideros robusta*) profiled against a clear sky. I decided to expose for the sky in order to obtain a bold silhouette of the tree, and the epiphytic perching lilies, but it took me several minutes to find the precise camera position for the natural starburst effect of the sunlight glinting through the branches.

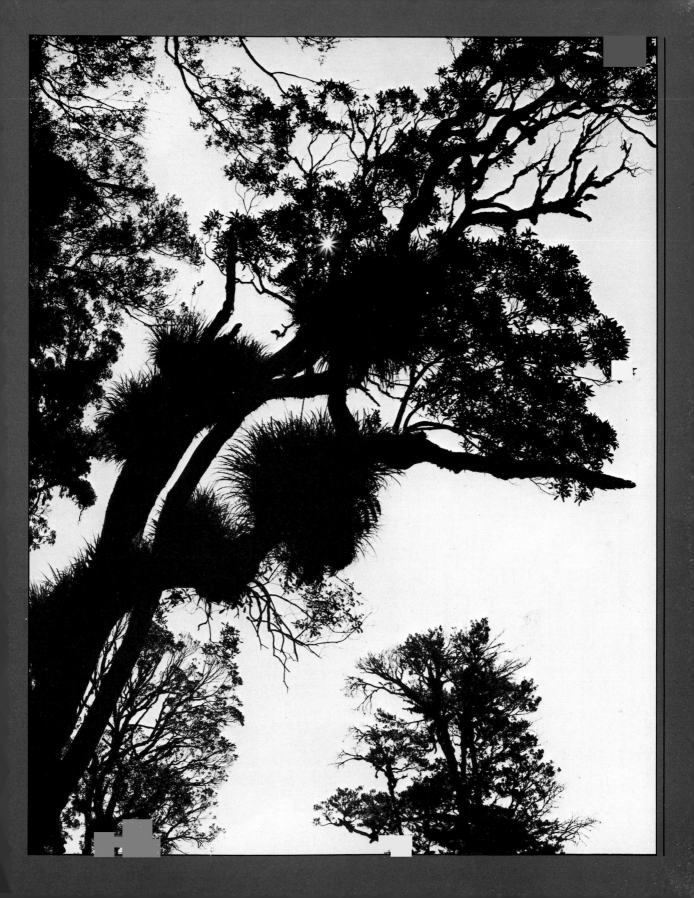

Time of day

Throughout a 24-hour period, the intensity and the quality of light are ever-changing. From dawn to dusk, the direction and strength of the light continually change, and so does its color temperature. When the sun rises, and when it sinks, its low-angled light passes through a thicker layer of atmosphere, which absorbs blue light. Sun that has had some of its blue light absorbed is said to have a lower color temperature. Because color film is balanced for mid-day light, which has a higher color temperature, landscape pictures taken early or late in the day have a reddish hue. In contrast, totally overcast skies tend to absorb red light, and consequently pictures taken in such conditions have a bluish cast, which is most obvious when there is a blanket of snow or ice. A couple of hours after sunrise and before sunset, low-angled sunlight models landscapes effectively without a strong color cast.

In temperate regions, the proportion of daylight to darkness changes markedly with the seasons, whereas in the tropics, the length of the day is much less variable throughout the year. In mid-summer at high latitudes — in Iceland and Alaska, for example — it is possible to photograph by available light throughout the 24 hours, but in winter, the sun may be above the horizon for less than an hour.

The quality of changing light has long been appreciated by all photographers working outdoors. But, for the nature photographer, the time of day is also important in relation to the activities of certain plants and animals. For example, if you do not want to waste time, it is essential to know, *before* you set out to photograph them, that crepuscular animals such as deer are most active at dawn and dusk. In a number of flowers, light, or sun, or even darkness, is the stimulus that triggers their opening. Many daisy-like flowers open their petals only when the sun is shining, whereas nocturnal flowers, such as the night-flowering cactus, open and produce their attractive scent only at night to attract moths; by the morning the flowers have withered.

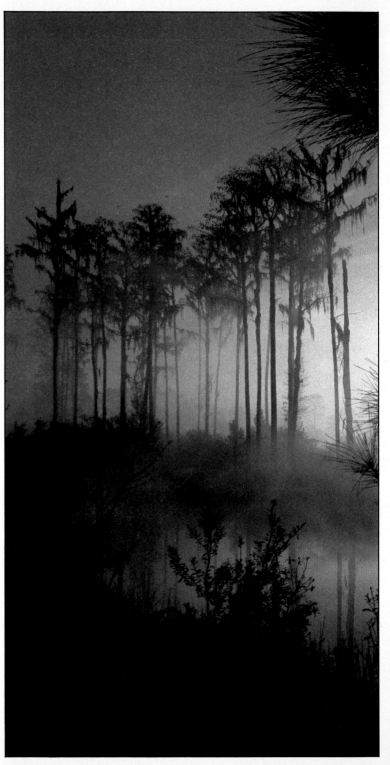

A misty dawn ▷
As I was driving in the Okefenokee Swamp in South Georgia on a cold April morning, the swamp cypresses loomed out at me from the mist. Somewhere there had to be a picture. By wading through a reed bed, I came in sight of this view. Instinctively, I put the 35mm lens on the camera and set up the tripod with its legs pushed down into the water. Only after the exposures were made, did I feel qualms about the resident snakes and alligators.

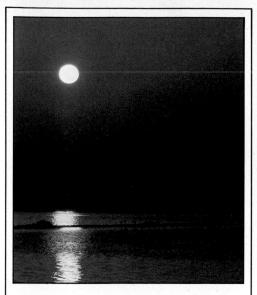

Rising sun
I was in position before sunrise for this picture of flamingos silhouetted at dawn in the Camargue area of France. With a 200mm lens, I was able to capture both the sun and its reflection in the water. A slight mist prevented lens flare.

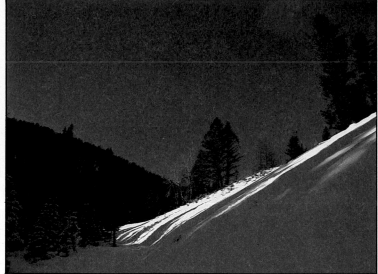

Afternoon shadows △
The sky color, strengthened with a polarizing filter, is repeated in the long late-afternoon shadows in Cache Valley, Wyoming. The white snow, lit by a shaft of sunlight, relieves and highlights this blue landscape.

Dusk ritual ▽
London's Trafalgar Square is an assembly point for starlings before they fly off to their night-time roost. As sunset approaches, the birds converge on the trees and buildings. The cue for photographing their mass lift-off comes when the birds cease chattering.

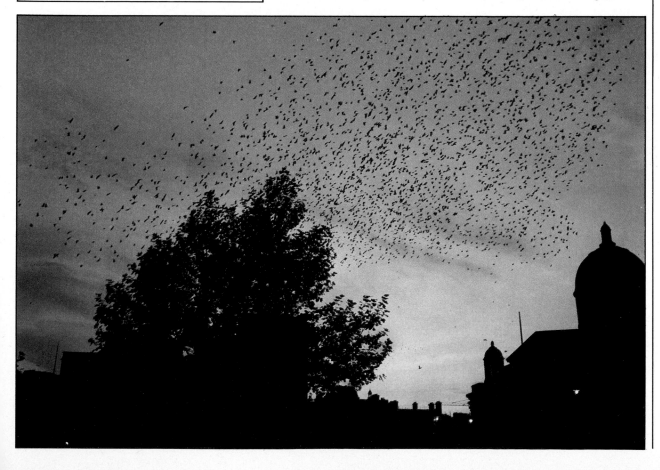

Night photography

Sitting out at night in the hope of photographing a nocturnal animal — often in cold weather — requires dedication, but the sense of achievement can be infinitely greater than when working by day. It is essential to know precisely when and where the subject will appear, for it is difficult to roam far afield without disturbing nocturnal birds and mammals, which have acute senses of hearing and vision.

Birds such as owls can be photographed from within a hide that you have set up by day (see p. 155) as they come and go from their nest sites. You do not need a hide for taking mammals such as badgers and foxes, but you must sit downwind of them. Flash is essential for night photography, except for taking luminescent animals, such as glow-worms, and animals that may gradually become accustomed to floodlights, such as raccoons. If you know the flash-to-subject distance, you will find an automatic flash easy to use at night. A tele-flash attachment (see p. 157) is useful for concentrating the flash beam over long distances. If the camera is mounted on a tripod and prefocused, it can be triggered by remote control or by the subject setting off a trip device (see p. 157). You will probably have to focus a hand-held camera by a red light, to which most nocturnal animals do not react.

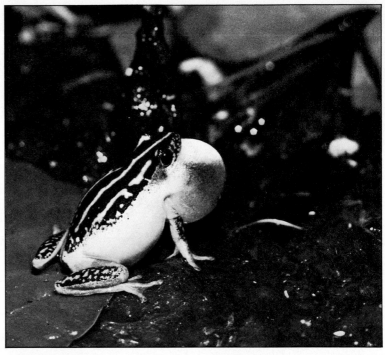

Behavior after dark △
I located this painted reed frog calling at night in a South African pond by panning a flashlight from side to side, and took the picture with an auto flash.

A nocturnal hunter ▷
I took flash pictures of the flightless New Zealand kiwi after I had baited a small area inside a large enclosure with earthworms.

A night walker ▷
On an island in New Zealand, my headlamp spotlit a tuatara roaming from its burrow. Using an electronic flash set on an auto mode (see above), I framed the picture with the reptile at the bottom, so that the nocturnal scene would be emphasized by the distant, unlit background.

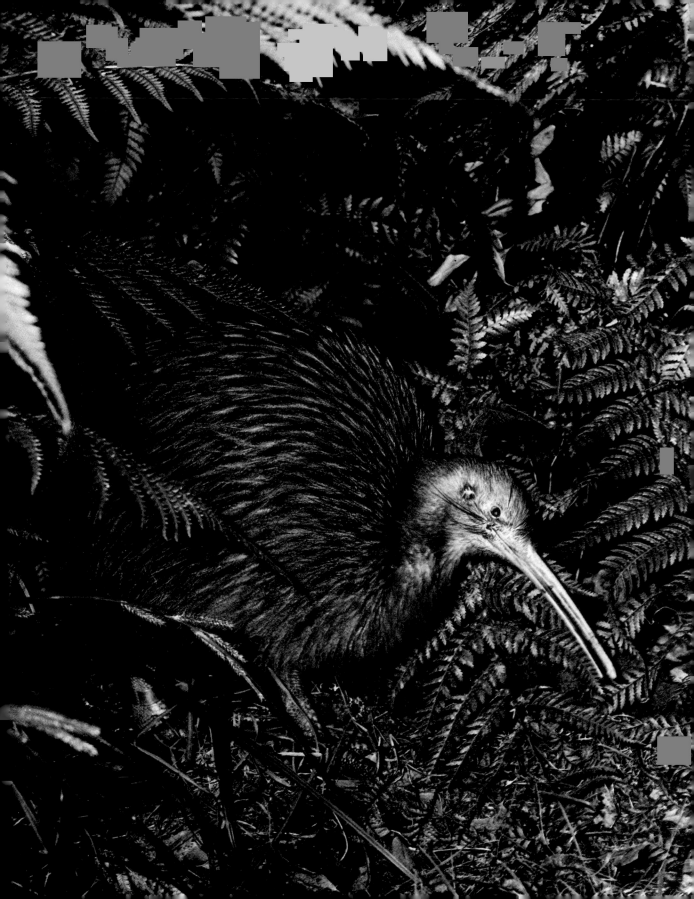

Using flash

Flash can be used not only to boost low light levels, but also to arrest movement, to gain extra depth of field, and to fill in shadows cast by sunlight. It is important, when using flash, to make sure that the full opening of the shutter synchronizes with it, so that the entire frame is illuminated by the flash. A camera with a between-the-lens shutter, such as a Hasselblad, synchronizes at any speed, whereas a camera with a focal-plane shutter synchronizes at 1/125 or 1/60 sec and at slower shutter speeds. If the camera design forces you to use a relatively slow speed, this can result in a ghostly image appearing when you use synchronized flash to take a moving subject by daylight; the flash freezes the subject, which continues moving during the remainder of the exposure, and the daylight allows this movement to be registered on the film. Used with care, automatic computerized flash guns should ensure a correct exposure. Flash is not always an easy solution to photographing in a dark forest or cave during the day or in any location by night. A single side flash can cause a harsh shadow to appear, and flash used for taking shiny fruits or subjects in front of a wet surface can create distracting highlights. When a flash is used to light a subject with a distant background, it results in the unlit background having a nocturnal appearance. This may, however, be a useful technique for effectively isolating a subject from its background.

To help fill in the shadows cast by a single flash, either use a second flash or try the open flash technique. This method, which involves keeping the shutter open while repeatedly moving the flash and firing it manually, will only work with static subjects and a slow-speed film. If you want a softer light, try bouncing the flash off a reflector, or you can diffuse the light by placing a sheet of muslin between the flash and the subject.

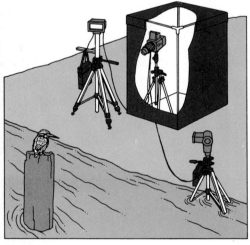

Boosting daylight with flash ▷
I had to use two flashes to bring out the brilliant color of the plumage of this kingfisher near its nest site on an English river. Only after I had positioned the hide did I decide to synchronize the flash exposure with the daylight. I found that the available light reading for the background trees, using an aperture of f11, was 1/15 sec, and I then calculated the distance of the two Vivitar 365 flashes for this aperture. In England it is necessary to secure special permission from the Nature Conservancy Council to photograph at or near the nests of these birds. Similar restrictions apply to the photography of other endangered species in Britain and elsewhere (see p. 147).

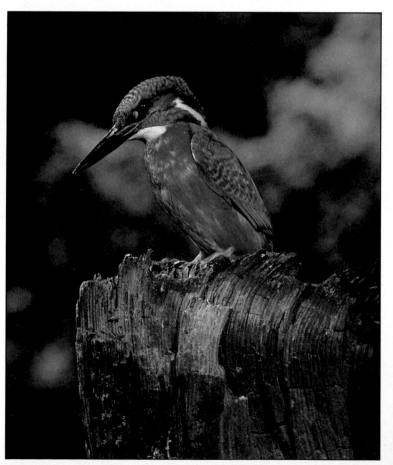

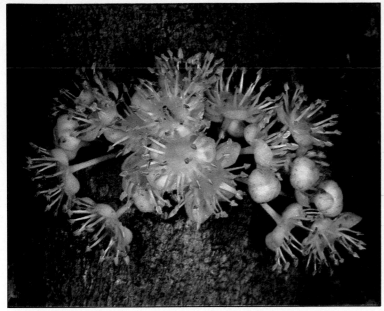

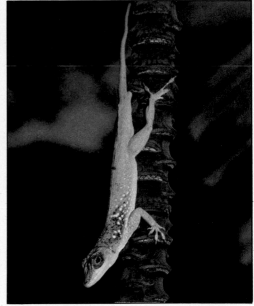

Lighting the shadow △
The Natal drypetes tree bears its flowers on the trunk, where they are shaded by the overhead branches. I therefore had to use a small flash for this close-up.

A flash in the dark ▽
I used a flashlight to check the focus on these nocturnal fairy prions before exposing with an electronic flash set on auto mode.

Freezing movement △
I used a single flash to gain maximum depth of field and to arrest the movement of this anole lizard as it ran down a banana flower stem in Barbados. The rapid fall-off of the flash produced this nocturnal effect.

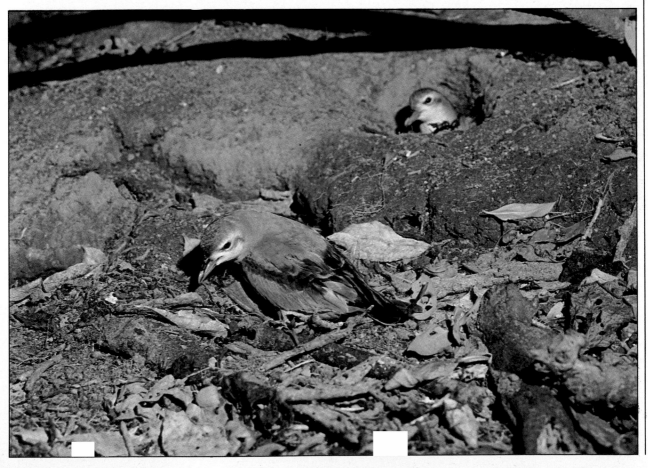

Using flash

One of the disadvantages of using flash in the field is that none of the small portable electronic flash guns has a built-in focusing lamp, so you cannot preview the precise effect of the light and shadow. With experience, however, you should be able to predict the final result. Small lightweight flash units are quite adequate for field photography of fungi, mosses, flowers, insects, amphibians, reptiles, and marine life, but they are not powerful enough for longer-range photography of birds or mammals. A useful accessory for night photography is a telephoto flash attachment (see p. 157).

Many SLR cameras now have a hot shoe attachment as the sole means of connecting a flash to the camera, yet a single flash-on-camera provides only frontal lighting and is ineffective for close-ups because it cannot illuminate the area close to the lens. A single flash will provide more imaginative lighting if it is attached to a flash extension cord and so can be moved off the camera. If your camera has only a hot shoe connection, you will have to use a hot shoe-to-cold shoe adaptor to link up with the extension.

As with natural lighting, you can use a flash to light the front, side, back, or top of a subject. If more imaginative lighting is required, you can position a flash behind the subject either on a tree clamp or simply on a wooden stick pushed into the ground and bearing a ball-and-socket head topped with a flash shoe.

Highlighting a web ▷
A spider's web is most conspicuous when wet, but at such times the spider is often absent, perhaps sheltering beneath a leaf. When the web dries out, the spider takes up its position in the center of the by-now almost invisible orb. To highlight the dry web in this picture, I used two flashes angled in at about 45° behind the web and a reflector sheet in front so that some detail was visible on the spider's body.

◁ **Dual-purpose flash**
Even when a hover fly has alighted on a flower to feed, it is still very active. The only certain way to freeze all movement is to use electronic flash, which also boosts the light level, allowing the lens to be well stopped down and so making sure that the entire insect appears sharply in focus. For this picture I used a single overhead flash (see the diagram above).

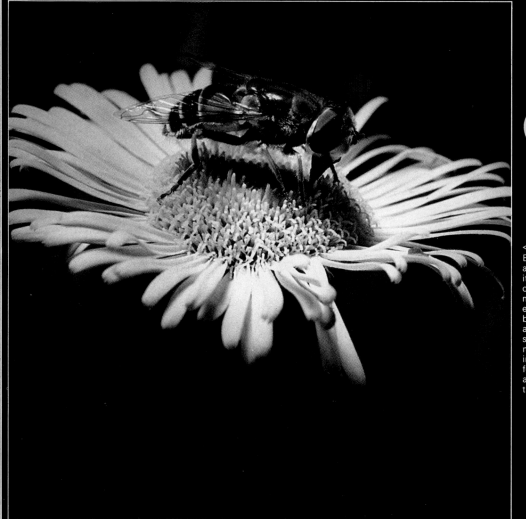

Working in a studio

Sometimes the best place to highlight plant structures or animal behavior is indoors. Nature photography outdoors can prove unsatisfactory at times; for example, you may lose the opportunity of a good shot because of poor lighting, bad weather conditions, or an animal moving unexpectedly. In the studio, on the other hand, you can choose the best camera angle, select your background, and contain an active subject. With complete control over these variables, you should be able to concentrate on producing the best possible image.

Working in a studio does not necessarily mean that you have to rely on flash to highlight your subjects. If you wish to photograph a large plant by diffuse lighting, try positioning it near a large window and taking the picture by daylight on a day with light cloud cover.

A continuous artificial light source, such as a photoflood, requires a special tungsten light film, but you can use a normal daylight color film in conjunction with a color-conversion filter (80A or 80B) to increase the color temperature. Such continuous artificial lighting, however, is generally not suitable for live subjects because it generates too much heat. Small spotlights are useful for lighting shells and fossils, while fiber optics are ideal for spotlighting static subjects precisely. They have the added advantage of producing a cold light. Electronic flashes are preferable for studio work because, as well as generating a negligible amount of heat, they have the same color balance as daylight, allowing you to use daylight color film in the studio. Most small flash guns do not possess built-in modeling lights for assessing the lighting and the shadows before the exposure is made. You can overcome this problem by either strapping a small light to each flash gun or temporarily substituting each flash with a spotlight, making sure that you return the flashes to their original positions.

Sunlight through the window ▷
I wanted to light this collection of marine shells as naturally as possible, so I placed them in a tray on a wide window sill in my sitting room. I used a large sheet of aluminum cooking foil placed around the three sides of the tray away from the window to boost the soft afternoon light. The camera was supported overhead on a copying stand.

A split-second study ▷
The chances of three live fishes
positioning themselves so perfectly in
an aquarium are slight. Although I took
many more frames after this shot, I
never managed to repeat this
composition. I lit the fishes with a pair of
electronic flashes, and masked out all
reflections, of the camera, lens, tripod,
and my hands, with a piece of matte black
cardboard, as is shown above.

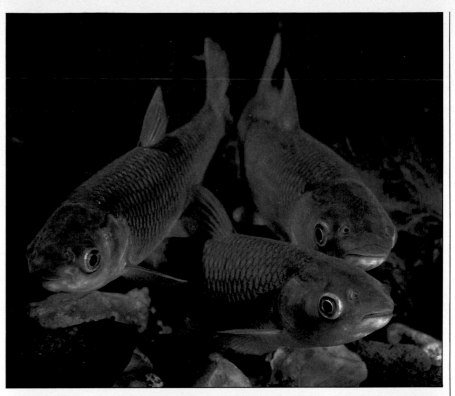

Painting with backlight ▷
Static subjects, such as this maidenhair
fern, offer plenty of opportunity for
experimenting with lighting. I arranged
the fern frond so that it hung down
naturally parallel with the camera. To
make the thin, translucent leaves glow
with color, I used dual-source oblique
lighting behind the fern, positioning
each flash at an angle of 45° outside
the field of view (see above).

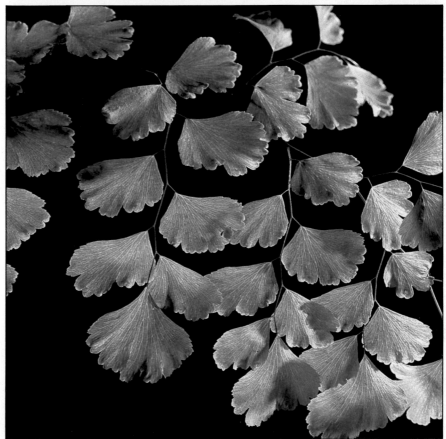

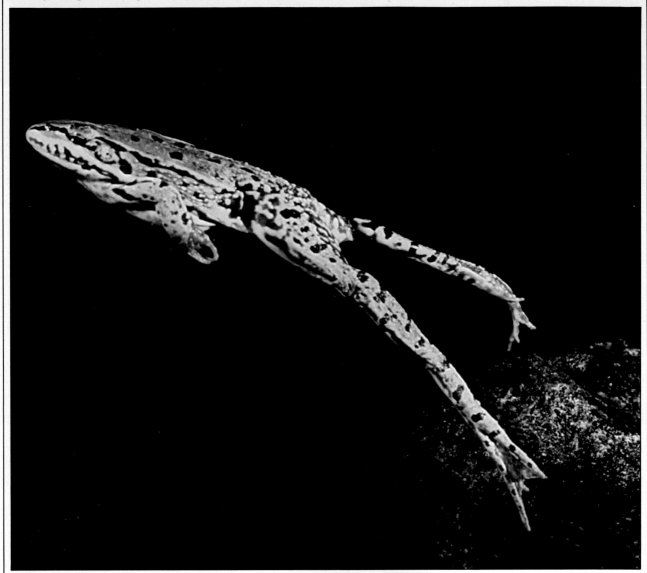

High-speed flash △

To photograph an edible frog leaping from a stone, I arranged the studio set-up shown on the right, so that everything was ready when the frog jumped. First, I set up a continuous light beam that shone on to the photo-detector. I then prefocused a motorized Hasselblad by holding my hand in the center of the light beam's path. I set two electronic flashes to 1/25,000 sec to freeze all movement, and positioned them on stands so that they would illuminate the area on which the camera was focused. After I had connected both flashes to the camera, I persuaded the frog to jump through the light beam. This gave the signal for the photo-detector to trigger the camera shutter and the flashes. The picture clearly shows the powerful thrust of the back legs and the front legs tucked against the moving body.

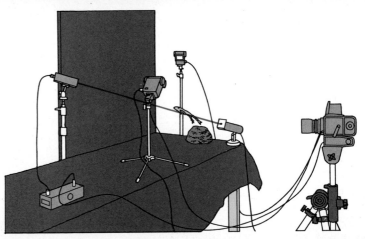

SEEING DETAIL

Close-up techniques

Taking close-ups introduces a completely new world. They can focus attention on the shape of a flower or the behavior of an insect, while, at high magnifications, they may reveal unexpected structures or textures. The art of taking good close-ups lies in the ability to decide how best to frame for the maximum effect; and this may not always mean moving in as close as possible. The simplest (and cheapest) way of filling your frame with a small subject is to attach a supplementary close-up lens to the front of the camera lens. The power of these lenses is quoted in diopters, a +2 diopter lens magnifying twice as much as a +1 diopter lens. This is the only way of taking close-ups with a fixed lens camera, and the amount of light reaching the film is not reduced. The single lens reflex (SLR) 35mm and $2\frac{1}{4}$ square cameras are most versatile and practical for close-up work: the image you see in the viewfinder is identical to the image recorded on the frame, and you can remove the lens and insert extension tubes or bellows to give magnifications on the film plane up to life size and beyond.

The ideal lens, however, for anyone who wishes to specialize in close-ups, is a macro lens, which has its own built-in extension, allowing a continuous focusing range from infinity to, usually, half life size. Macro lenses, which come in various focal lengths — 55mm, 105mm, and 200mm — can, of course, be used in conjunction with extension tubes or bellows, both of which move the lens farther away from the film plane and so reduce the amount of light reaching the film.

To achieve crisp close-ups with available light, a rigid tripod is essential, and a cable release is preferable for triggering the shutter. With magnifications larger than life size taken in the studio, the subject-to-lens distance is greatly reduced, which means that there are few possible positions between the camera and the subject for flash or spotlights. Indeed, it may be both easier and more effective to illuminate a translucent subject from behind. Careful appraisal of backgrounds is important for close-ups. Simple monotoned, out-of-focus backgrounds are most effective (see p. 74).

An eyeful ▷
I took this impact close-up of the eye of a tuatara (*Sphenodon punctatum*) by daylight on Stephen's Island in New Zealand. This nocturnal reptile normally emerges from its burrow for only brief periods during the day, but here a hand-held specimen had been removed from its burrow to be marked. By using a 55mm micro-Nikkor lens at full extension, I completely filled the frame with the eye.

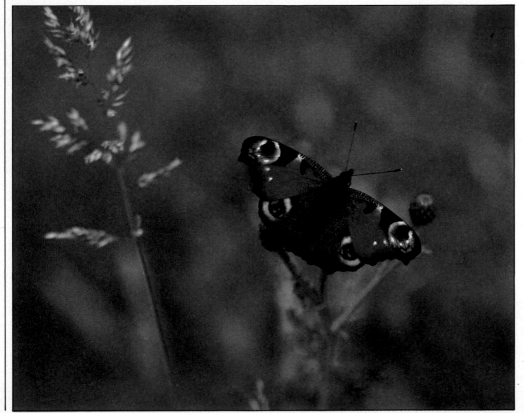

◁ **Stalking an active insect**
A butterfly feeding on flowers on a mid-summer's day rarely rests for any length of time on one flower, and so gives the photographer no time to set up a tripod. When I spotted some peacock butterflies flying around a patch of thistles, I put a 105mm micro-Nikkor lens on the camera, which I attached to a monopod (above). This gave me some support for a quick exposure of a sharply defined butterfly well separated by differential focus from its background.

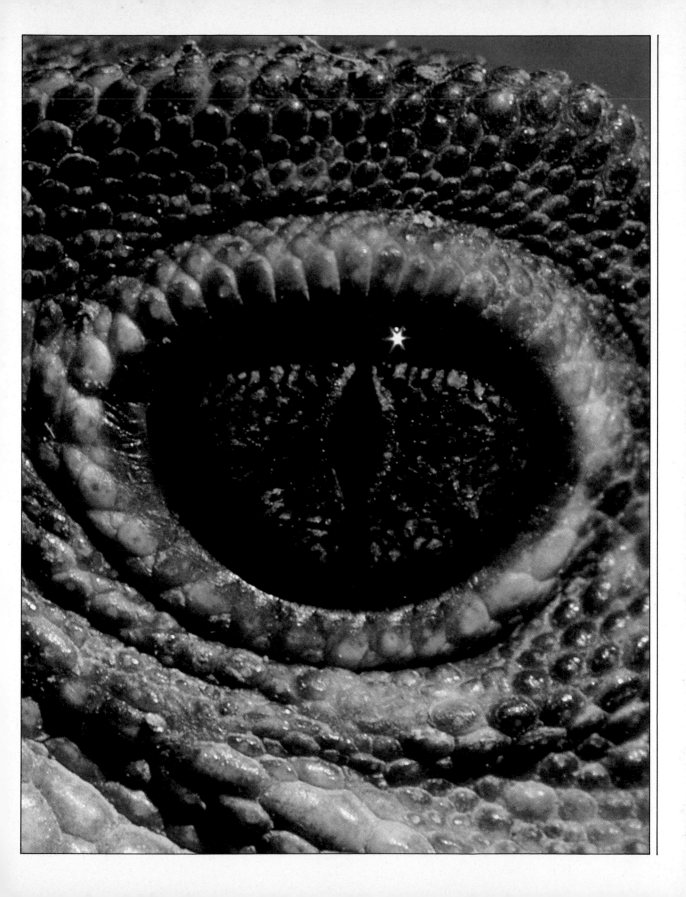

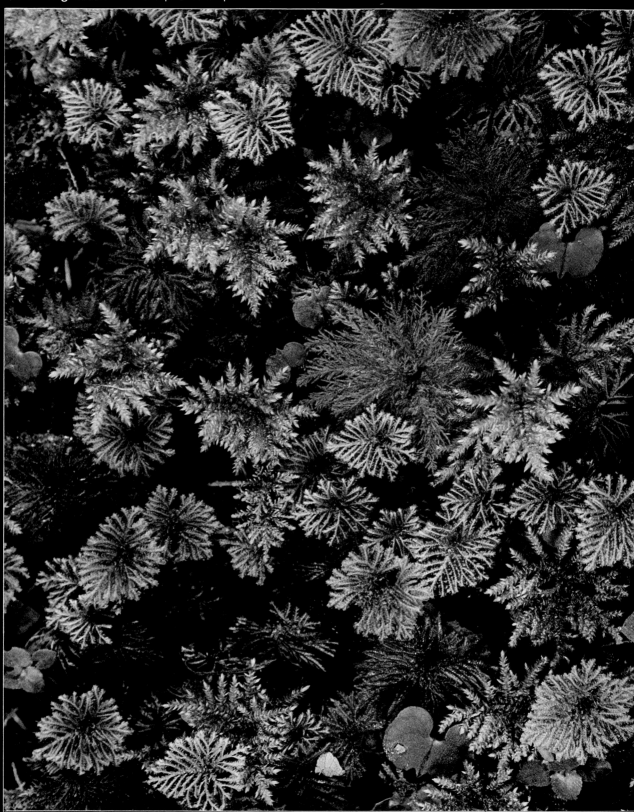

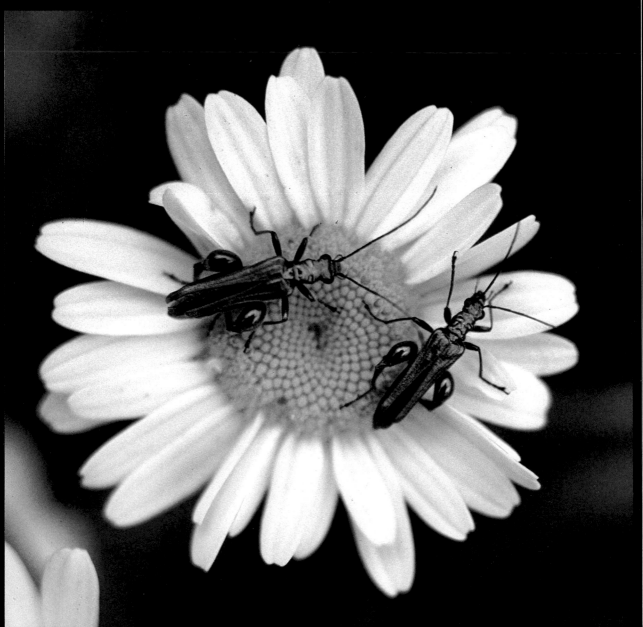

◁ **Mossy carpet**
The high rainfall in New Zealand's Westland, in the South Island, creates a lush evergreen forest where mosses and ferns abound. There I found that a mossy mosaic provided a perfect subject for an overhead close-up taken through a Hasselblad 80mm lens with a 55mm extension tube. The poor light inside the forest meant that I had to use a 1 sec exposure in order to give some depth to my picture. A sturdy tripod was essential to prevent camera shake and allow me to frame the composition precisely.

An overhead viewpoint △
A large flat flower head on top of a long stalk, such as an ox-eye daisy, makes a good, clear close-up photograph because it stands out so well from its background. I would not normally consider taking beetles at an exposure of 1 sec because of the risk of their moving, but this was an instance when I had no flash and so had to make do with the diffuse available light, which – for the white flower petals at least – was ideal. I took several frames, nearly all of which captured the beetles while they were feeding.

Depth of field

Depth of field is the extent to which the image appears sharply defined in a zone extending from in front of and behind the distance at which the lens is focused. Knowing how to use depth of field for maximum effect is crucial for successful close-up photography. First you must be able to focus your camera precisely, since sloppy focusing will be all too obvious in a close-up. The depth of field becomes greatly reduced as the image size is increased or as the lens aperture is opened up. Therefore, if you require the maximum depth of field possible for a close-up, you should stop down the lens to almost the smallest aperture for the best resolution. For this reason, macro lenses have a relatively large maximum aperture but a very small (f32 or less) minimum aperture. Remember, when you stop down, that the depth of field increases more beyond the plane of focus than in front. You can check the extent of the depth of field either by looking at the distance markers on the lens mount or by stopping down the preview button and viewing directly through the camera. Selective use of depth of field, so that the subject appears sharp against an out-of-focus background, is a very effective way of isolating the subject. Do not forget, however, that for creative nature photography the maximum depth of field is not always desirable.

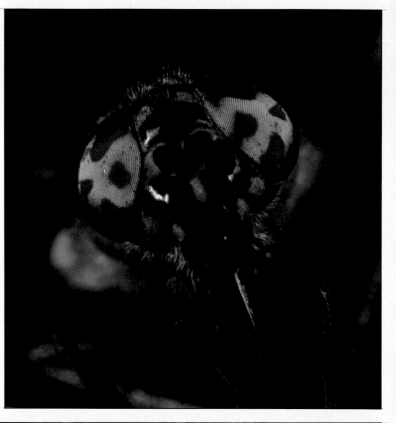

All in one plane ▷
Lichens, encrusting a flat rock at 13,500 feet up in the Himalayas, presented me with no depth of field problems once I had made absolutely sure that the film plane was parallel with the surface of the rock.

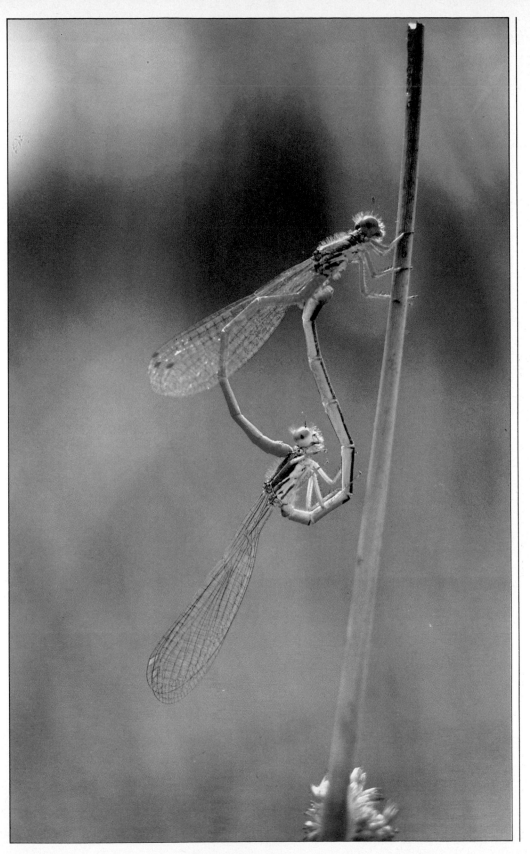

◁ Larger than life
I took this striking shot of a
horse fly's head in the studio
using a 55mm micro-Nikkor
lens and bellows extension.
The brightly colored eyes
were highlighted by two
small electronic flash heads
which I had attached to
flexi-arms angled in on each
side of the fly's head. At a
magnification of more than
three times life size on the
transparency, the faceted
structure of the compound
eyes is clearly visible. The
background blur, caused by
the very limited depth of
field at this magnification,
focuses attention on the
huge eyes.

Isolating the subject ▷
After these paired
damselflies (*Ceriagrion
tenellum*) alighted on a reed
stem, they remained there
for several minutes, giving
me enough time to assess
the best camera angle. Even
though the red bodies were
quite conspicuous, I used
my depth of field preview
button to check the whole
frame and then decided to
open up the lens by one
stop to make sure that the
damselflies were well
isolated from the brown
reeds behind.

Lighting for close-ups

Both the direction and the type of lighting are particularly important in close-up photography. For example, backlighting is ideal for spotlighting even the smallest hairs on plants, while sunlight diffused by clouds into a gentle soft tone is preferable for photographing white flowers. Because close-ups concentrate attention on detail, it is essential to record the subjects as sharply as possible. With a slow-speed, fine-grain film the image is crisp even when greatly enlarged. However, when using such a film in available light in the field, you will find that your depth of field is minimal unless you set the lens to a small aperture, which means that, for sufficient light to reach the film, you have to use a slow shutter speed. This in turn can lead to a blurred image, especially if you are taking a moving subject.

Flash is particularly useful for eliminating camera shake and so obtaining crisp images of subjects in close-up. The powerful light emitted over short distances allows you to stop down the lens in order to gain greater depth of field. Close-ups taken by a single direct flash, however, may look quite unnatural because, if the flash completely overrides the daylight, the distant background will appear black. You can eliminate this nocturnal effect by synchronizing the flash with sunlight (see p. 62).

You will find it much easier to photograph active subjects if you can approach them with the camera and flash supported together as a single unit on a flexible arm bracket. By working with a dual-bracket system, you can use one flash to fill in the shadows cast by the other. To illuminate deep-throated flowers at larger than life size, try using a ring flash mounted around the lens to provide frontal, shadowless lighting. In the studio, you can use flash for most subjects although small spotlights may be preferable for fossils and shells, which are not affected by the heat output.

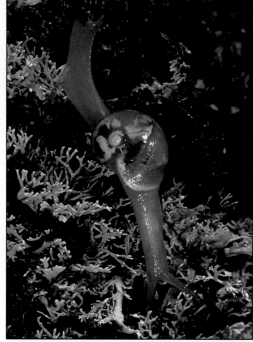

◁ **Twin flash in the field**
I found a shelled slug in an Australian forest of evergreen beeches. Watching it inch its way over the moss- and lichen-clad trunks, I realized that I would have to use flash to arrest all movement in the dark interior of the forest. The slug was lit by two small flash heads mounted on a boomerang-shaped support screwed on to the base of the camera (see the diagram on p.112).

Spotlights in the studio ▷
This fine specimen of a fossil fish (*Mene rhombus*) was one of several fossils that I took in the geological section of a museum. I used continuous lighting, which allowed me to view precisely the effect of light and shadow on the subjects. A pair of small tungsten halogen spotlights were ideal for lighting this fairly small fossil taken with a Hasselblad 80mm lens and a 55mm extension tube.

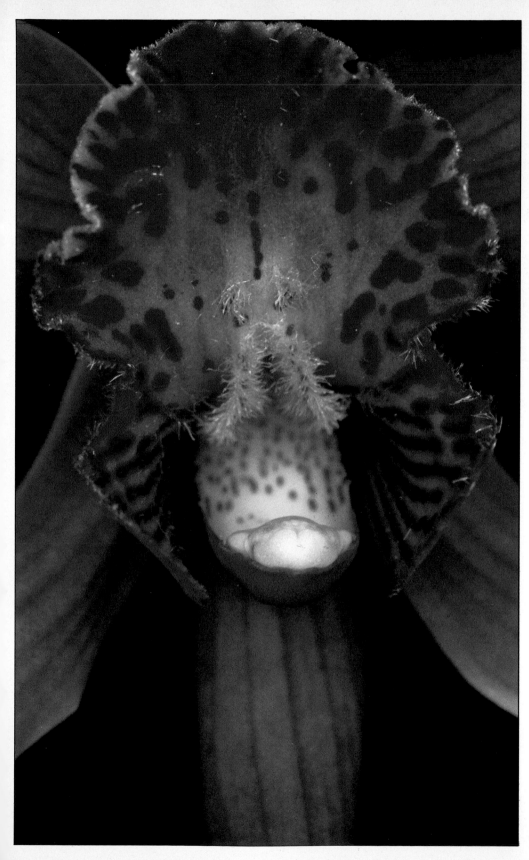

◁ **Using ring flash**
Because this exotic orchid had no natural foliage, I could photograph it only as a studio close-up. As I focused on the flower, using a 55mm micro-Nikkor lens on a bellows extension (see above), I decided to crop the outer petals and thereby fill the frame with the center of the flower. To illuminate the flower's deep throat I used a ring flash screwed onto the front of the lens.

Dark field illumination △
I collected a small spider crab from the rocky shore and
photographed it in my hotel bedroom, where I put together
the set-up shown on the right. I placed the crab in the sea
water in a shallow glass dish over a central hole in a small
table, which rested on a sheet of black paper. The two
small flashes angled up from below rim-lit the crab so that
it glowed against the black background. The artificial black
background and the dramatic lighting clearly illustrate the
shape of the body and legs which, in the crab's natural
habitat, are perfectly disguised by the attached seaweeds.

THE NATURAL
SCENE

Seasonal variations

At high latitudes, the seasonal succession from winter to spring, to summer, to fall, and back again to winter is a familiar and striking feature of the natural world. In the tropics, alternating wet and dry seasons are just as important in determining when plants flower, birds nest, and animals migrate. The seasons present the photographer not only with an ever-changing variety of subjects, as migrants come and go and animals and plants progress through their life cycles, but also with a dynamic pattern of mood in landscape and habitat.

Illustrating the seasonal changes within the habitat makes an excellent project for a photographic essay in deciduous woodlands, where the dramatic springtime flowering of the ground plants and leafing out of the trees is followed by the lushness of summer and the superb coloration of fall, leading into the bare starkness of winter. To make sure that you will be able to repeat the viewpoint and framing precisely, note carefully the focal length of the lens and any relative landmarks. It is also a good idea to bring one of the previous season's pictures with you, so that you can check all minor details. In temperate latitudes, there are few special problems associated with photography in spring, summer, and fall. In winter, however, a highly reflective blanket of snow can give a false high reading by direct metering with the camera, especially when the sun is shining, and so it is advisable to bracket snow scenes by opening up an extra half or one stop above the reading to produce a white rather than a gray snowscape. It is important to realize that in extreme cold batteries can give an inaccurate reading (see p. 98), and, when you hold your camera up to your eye, your breath will condense on the body where it may later freeze. To prevent ice penetrating the camera, cover its back with self-adhesive tape.

The major hazard associated with taking photographs during the tropical dry season is dust. As well as settling on the lens of your camera, it may find its way inside, where it can easily scratch the film. Therefore try to keep all equipment covered with a cloth when not in use.

The autumnal ritual ▽
To make sure of a shot of a red deer stag calling to his hinds during the autumnal rut, I had to rise before dawn. I was then on site, wearing a camouflage jacket, as the sun filtered through the mist. Rather than waste time setting up a tripod, I braced my body against a tree (see below) to help steady the 300mm lens.

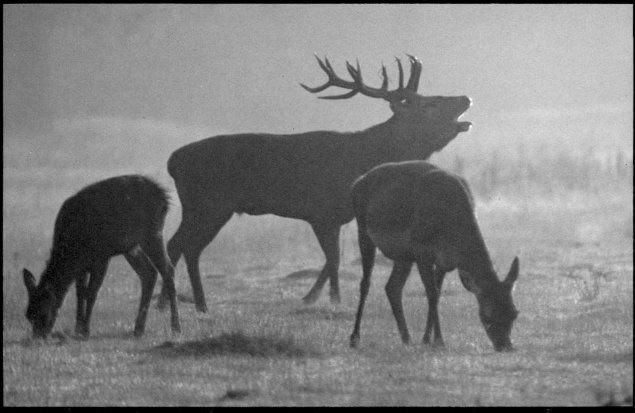

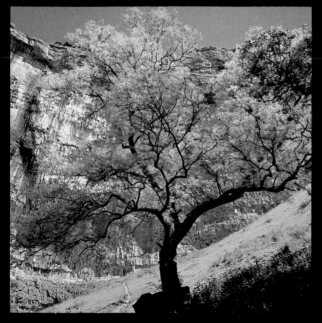

Spring leaves △

The fresh green young growth on the ash tree epitomizes the spring for me. I spotted this tree while walking on top of the distant limestone outcrop. As I approached the tree, I decided to use a wide-angle lens in order to fill the 6cm × 6cm frame completely with the vibrant green branches. This delicate color lasts for only a few days before the green darkens.

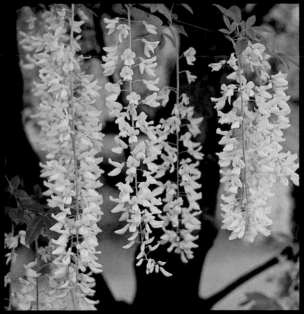

Summer blossom △

The brilliant-yellow pendulant flowering stems of the laburnum, attractive to insect pollinators, especially bees, are so conspicuous that they make the tree noticeable from a distance. I took this close-up on an overcast, windy day and so had to wait for a lull in the breeze before the flowers stopped blowing back and forth and I could safely use a slow shutter speed.

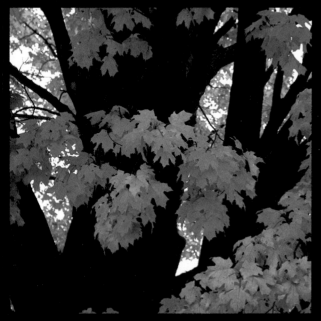

Autumn color △

The sugar maple is one of several trees that contribute to the glorious New England fall colors, the intensity of which is enhanced by cold frosty nights. I selected a viewpoint from which the orange leaves were enhanced by the somber trunks. The day after I took this picture, strong winds blew away most of the leaves, proving that precise timing is vital for autumnal scenes.

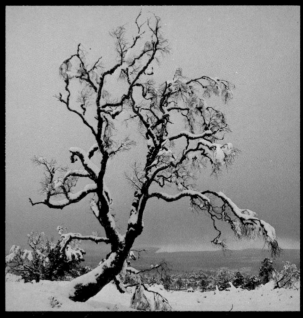

Winter skeleton △

Near the tree line in the Scottish Cairngorms, this birch tree loomed out from the dark, stormy sky. To reach it, I had to walk through snow several feet deep and, to prevent the tripod from falling over, I pushed the legs well down into the snow. Dull lighting is ideal for showing up the fine detail of branching twigs, which do not stand out against a bright sky.

Mountain and valley

Snow-capped peaks, steep-sided valleys and canyons, glaciers, waterfalls and ice lakes are some of the breathtaking views you can find when photographing in mountain areas. When planning any mountain trip, it is essential to know that weather conditions can change suddenly and dramatically. You should carry warm and waterproof clothing, wear climbing boots, snow shoes, or skis, and goggles to protect your eyes. Reduce your photographic equipment to the minimum, so that both hands are kept free for climbing. I have been out in sub-zero temperatures when my hands were so cold that I was unable to move my fingers to release the shutter. Very cold temperatures affect the camera and film as well as the photographer. Because a TTL meter may give a false reading in cold temperatures, a selenium meter such as a Weston Euro-Master, which operates without batteries, is preferable. At high altitudes, there is so much ultra-violet light that it is advisable to keep a UV filter permanently on your lens to eliminate an obvious blue cast. Even so, views taken into the light will still have a blue cast.

Much of my enjoyment of photographing alpine flowers stems from the initial thrill of finding rare species and then taking them with a wide-angle lens in their mountain setting. I often resort to using a pair of small binoculars to locate such plants on high ledges. Some mountain animals such as ptarmigan, stoat, and mountain hare, which develop a white winter coat, are so well camouflaged during winter that they present the photographer with problems in distinguishing them. You can make them stand out by choosing your lighting or backgrounds carefully (see p. 34).

Dawn at the Grand Canyon ▷
I photographed my first, breathtaking view of the Grand Canyon from the South Rim one February morning. I had set out while it was still dark to make sure that I had the camera ready on the tripod before the sun rose. The pink dawn enriched the colors of the rock strata.

High-altitude survivor ▽
This clump of *Aquilegia fragrans*, which I took at an altitude of 12,000 feet while on a pony trek in Kashmir, was one of the few that had not been eaten by nomadic sheep. By using a wide-angle lens and shooting from a low angle, I was able to include the blue glacier lake in the frame.

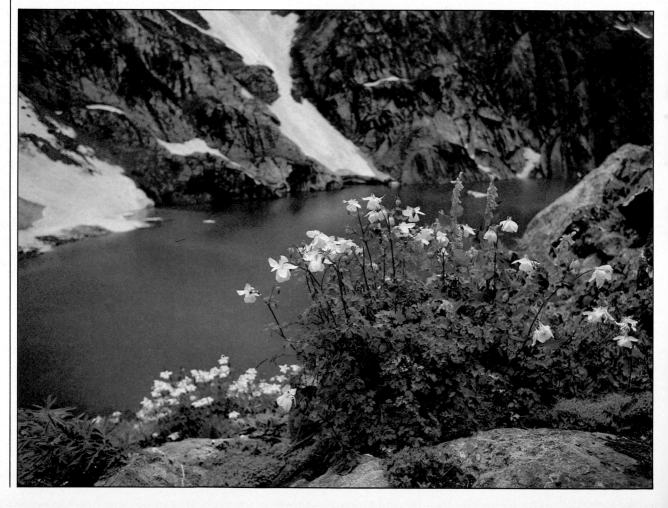

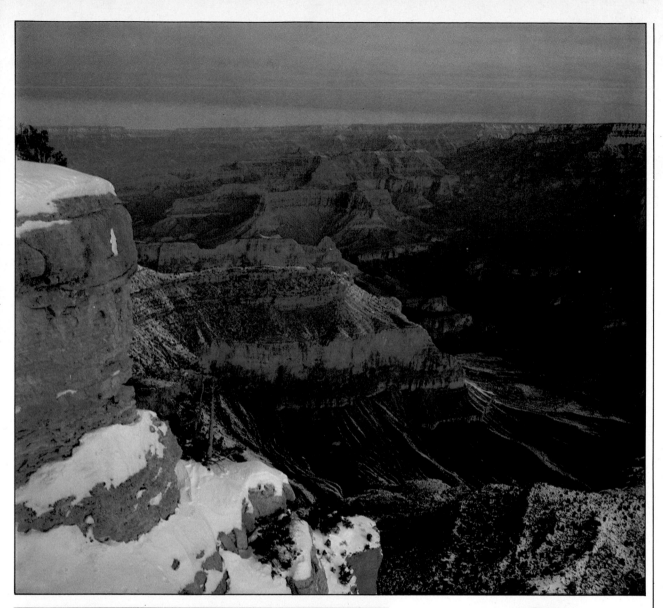

◁ **Winter refuge**
As winter advances, these wapiti move down from the
mountains in Wyoming to their winter refuge at 7,000 feet.
I took the picture using a 200mm lens supported by a
shoulder pod (shown above).

Forest and jungle

The interiors of evergreen forests, and of deciduous forests when the trees are in leaf, are either dark or appear as a mosaic of light and shadow. The problem of poor visibility is often made worse when photographing at ground level in the humid hothouse atmosphere of tropical forests where the undergrowth is lush. If it is impossible to move farther back from the subject, or to climb up above the undergrowth, you usually have no option but to tilt the camera skyward.

Unless there is a gap in the forest, created by a fallen tree or by the course of a river, you will find that a wide-angle lens is essential for forest interiors. The perspective-correcting lenses (see p. 40), used primarily for architectural photography, are especially useful for taking trees. If a higher viewpoint is necessary, try climbing a natural incline such as a termite mound, a man-made high-level platform, or a rope ladder. Opportunities for photographing forest mammals are limited, because they are highly adept at moving quickly. Paddling a canoe

down a forest stream may be the easiest way of getting close enough to wary animals.

General views of forest interiors are often best taken on overcast days using a long exposure with the camera on a tripod. Flash is a reasonable alternative only for close-ups. Color films are sometimes unsatisfactory for forest work because they do not have the latitude to reproduce both the dark shadows and the bright sunspots created by shafts of sunlight penetrating the overhead canopy.

The high humidity of tropical rain forests can cause equipment to corrode and fungal growths to appear on film and on lenses. Therefore, both before and after use, be sure to keep everything sealed in plastic bags containing silica gel. Exposed film should be kept cool and processed as soon as possible.

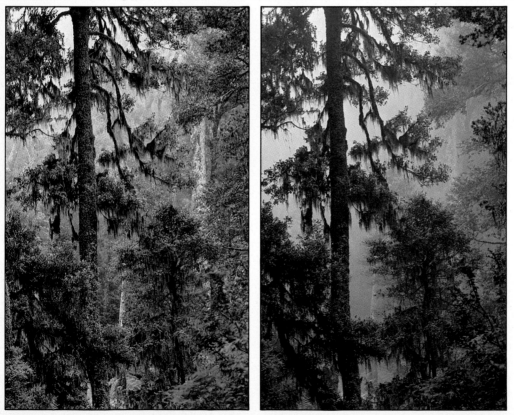

A changing mood
I took these two pictures within a few minutes of each other inside a temperate rain-forest area in New South Wales, where the very humid conditions encourage copious growth of the epiphytic mosses that hang down from the branches of the *Nothofagus* beeches. A winding, foresters' track made a gap in the trees, which allowed me to stand far enough away to use a 105mm lens without tilting the camera on the tripod. As the low cloud lifted, the rest of the forest beyond the foreground tree became visible, and the fixed position made it easy for me to take more than one picture from the same viewpoint and thereby illustrate the changing mood of the forest interior.

◁ **In the heart of the jungle**
Madagascar is the home of
many different kinds of
lemur, whose numbers are
fast dwindling as their forest
habitat is slashed and
burned. Photographing any
arboreal mammals from
ground level is not easy,
because they can so easily
escape upward or sideways
out of view of the lens. I
used a 200mm lens to take
this brown lemur as it
momentarily paused on an
overhead branch, pondering
on the intruder below. In
such grab shots there simply
is not time to appraise
background shapes and
shadows in order to select
the best viewpoint. The first
consideration is to make
sure that the subject is
sharply in focus.

Field and meadow

Taking scenic views of flowering fields and meadows from ground level offers a real test of compositional skill because of the uniform continuity of the entire vista. Close-ups of the flowers can also present problems because the background vegetation often appears as an irritating out-of-focus pattern of criss-crossing stems and leaves. Even flowers that are well behind the subject can appear as unsightly blobs of color.

You may be able to resolve some of these problems by changing your viewpoint. For instance, a low viewpoint can be useful for isolating flowers and grasses against the sky, while a high viewpoint can be ideal for a panoramic view down onto a flowering meadow. By changing the focal length of the lens and exploiting a different perspective, you may be able to achieve a more atmospheric picture. Occasionally, by using a long lens, I find I can lift a tiny segment of a landscape out of its broader context and isolate its particular properties and balance of color to create an image that excites me. When taking such distant shots, I prefer to use a slow shutter speed so that the depth of field extends from the front to the back of the picture. In open countryside, however, the air is rarely perfectly still, which means that, if the shutter speed is too slow, any movement will be sufficient to rob the picture of that critical crispness which is so often the aim of the nature photographer.

Poppies in the landscape ▽
The use of selective weed-killers has made extensive areas of colorful weeds a rare sight in cultivated fields. Rather than take a close-up of a few poppy flowers, I decided to take this dramatic band of color — which resembles a Monet painting — in an otherwise monotoned field, using a polarizing filter to bring out the clouds more clearly.

Alpine meadow ▷
I took this luxurious flowering meadow, dominated by the tall spikes of the foxglove *Digitalis lanata*, at an altitude of 7,000 feet in Kashmir. The other red, yellow, and white flowers stood out well from the green leaves, and the dark conifers in the background provided a contrast with the flowers to give the picture a balanced composition.

◁ **Close to the ground**
A snail survives extended periods of drought by climbing up a plant stem and secreting a mucus layer across its shell opening to prevent its tissues from drying out. It then ceases feeding and undergoes a summer hibernation known as estivation. I used the simple low-level support shown above to take this pair of heath snails estivating on a chalk grassland site. The camera was attached to a robust ball-and-socket head screwed onto a square wooden block which had four nails projecting from the base. This support, which can be pushed into any soft ground in grassland and woodland habitats, allows the use of a long exposure coupled with a small aperture to give the maximum depth of field.

Lake and river

The action of water on the landscape presents endless opportunities for exciting photographs in all seasons. Where there is a large expanse of calm water, watch out for concentric patterns of ripples caused by fishes rising to the surface for food. Such patterns add interest to an otherwise flat surface, as do fringing reeds, emergent rocks, or reflections of overhanging trees. The mood of a river can change quite dramatically from one season to another. Even within a single season, different weather conditions can alter liquid landscapes substantially, and a gentle, clear stream can be transformed into a raging muddy torrent overnight. Caught at the right moment, the sparkle of sunshine on moving

water can give life to an otherwise bland picture. Try experimenting with slow and fast shutter speeds coupled with small and large apertures to view the changing effect of the play of light on water. A river bridge provides a good viewpoint for taking photographs along the length of a river but it is best to look for close-ups of water plants from the bank or from a boat. Use a polarizing filter to enhance the contrast between floating leaves and the water surface as well as to reveal any hidden patterns of underwater plants.

Framing the Falls ▷
Finding a new camera-angle for such a well-known and much photographed location as Victoria Falls is not easy. I took this picture from one of the many viewpoints on the Zimbabwe side of the Zambesi river, and had carefully selected the lens so that the view was framed by the verdant vegetation. I had to drape a cloth over the camera to prevent its being drenched by the persistent spray from the waterfall.

A floating mosaic ▷
I took an intriguing natural mosaic of floating leaves on Kashmir's Dal Lake by leaning over the edge of a flat-bottomed shikar. Each kind of leaf is itself an interesting shape, and the random natural mix of them all makes a striking design.

◁ **Dramatizing a pool**
During a chance visit to a new location, I quickly assessed how best to frame the scene and I deliberately exposed for the water to achieve this mid-afternoon silhouette study. In any photograph of a lake or a river, the inclusion of foreground vegetation helps both to frame the picture and to create a three-dimensional image. Here the powerful outlines of the banks and the reeds belie the starkness of this recently man-made pool.

Coast and seashore

The coastal environment offers plenty of opportunities for taking dramatic seascapes, portraits and behavioral studies of seabirds on the cliffs, and colorful close-ups of marine life and seaweed patterns between the tides. Waves on a flat beach are greatly enhanced by low-angled lighting behind the crests of the waves. When taking dramatic pictures of powerful waves crashing against cliffs, make sure that you protect all equipment from the highly corrosive sea water. Use a plastic bag to cover all of the camera, apart from the lens, which should be protected by a haze filter, unless you are photographing rock pools, when you will find a polarizing filter useful for eliminating skylight reflections. Sea water also corrodes metallic tripod legs that do not have a protective anodized coating. A temporary,

cheap method of safeguarding your tripod legs is to place each leg inside a tough plastic bag. A large plastic sack makes a perfect lightweight groundsheet. If sea water does come into contact with any equipment, be sure to wipe it off immediately. Keep the metal contacts of flash leads dry and clean, otherwise they will not function properly. Sand can also create problems, for a single grain inside the camera can so easily ruin irreplaceable pictures.

An alert predator ▷
By cutting the outboard motor of our boat and drifting silently in the Galapagos offshore waters, I was able to come close enough to a great blue heron to photograph it with a 250mm lens on the Hasselblad. The simple, early-morning scene was enhanced by the low-angled, misty light.

Sand, sea, and sky ▽
As the waves break on the south coast of Madagascar, they are highlighted by the low-angled sun. I first saw this scene early in the day, but I waited until the foreground tree was in silhouette and the sky had darkened before I exposed any film.

A rock-pool kaleidoscope ▷
The variety of animals and their range of colors in a South African rock pool made it a beautiful natural aquarium. When taking this picture, with a 55mm micro-Nikkor lens, I used a tripod (as shown above), which allowed me to assess the optimum camera angle for the polarizing filter that I was using to eliminate surface reflections.

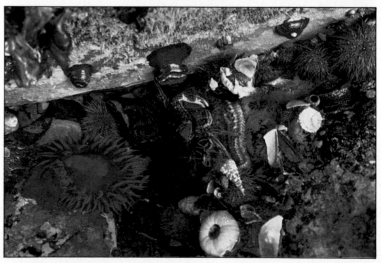

Urban wildlife

Man's vast and growing conurbations might seem irrelevant to the nature photographer; in evolutionary terms, these sprawling areas of concrete jungle, polluted by smoke, automobile exhausts, and industrial discharges, are very young habitats for life on Earth. Consequently only a few of the tougher plants and animals have quickly adapted to be able to survive in urban areas.

On city walls, buildings, and even on tombstones, you can find an endless selection of urban plants. In areas of neglect or dereliction, the nature photographer can take mosses growing on damp walls, weeds sprouting from cracks in the paving, and fungi flourishing on wet or damp timber.

Cities also offer some advantages for animals: city dwellers often throw out large quantities of food and, during the winter, cities are several degrees warmer than country areas. The most numerous animals found naturally in the cities are pests, ranging from rats living in sewers to flour beetles and cockroaches living in food. Pictures of such animals evoke in many people feelings of revulsion, which unfortunately can blind them to their potential as valid subjects for nature photography.

You can attract urban wildlife by baiting. Squirrels living in the trees of gardens or parks will raid bird tables, and foxes have learned to raid dustbins. The camera can be remotely triggered by a trip device (see p. 157) set up at a baited area. Birds can also be attracted by bait or by appropriate nesting sites. Many of the birds that now breed in our towns and cities were originally cliff-nesters. As their populations have exploded, they have sought out alternative nest sites, notably high-rise buildings. Pigeons are now almost ubiquitous in cities throughout the world, and gulls are beginning to invade cities adjacent to the coast. Generally, city wildlife has learned to tolerate man's presence and so is far more approachable than wildlife in rural areas.

Night raider ▷
To photograph a raccoon raiding a bird table at night in Florida, I had first to set everything up during the day. I prefocused the camera on a tripod inside the house, with the lens hood of the 135mm lens pressed against the window. After darkness fell, I used a red light to observe the raccoon without startling it, and took the picture using a single electronic flash held beside the camera and set on auto mode.

Birds and industry ▽
I came across this picture quite by chance after seeing from afar one of a pair of swans landing on a lagoon. Once I had tracked down the swans, I decided to photograph them with a standard lens, so that I could include the power station behind.

Mossy invaders △
In towns where the air is pollution-free, old, weathered walls provide valuable sites for colonizing mosses and lichens. As I walked out of my local car park, I was stopped in my tracks by the sight of the attractive green mosses growing on the red brickwork. I chose an overcast day for this picture, which I took looking along the wall.

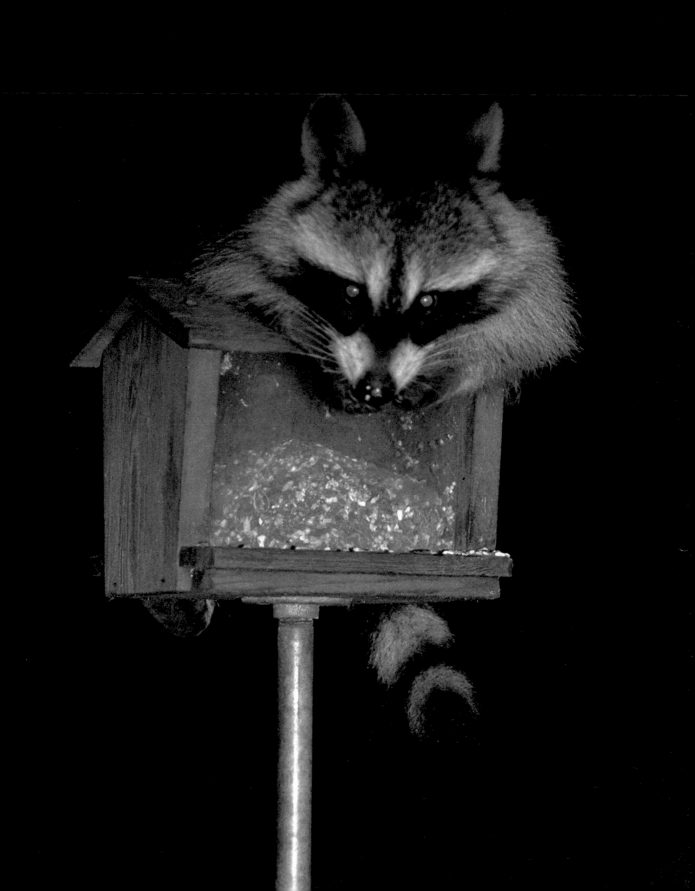

Sky

The interpretation of the sky can so often make or mar a landscape photograph. A colorless, overcast sky may reduce a view to a mere record, whereas the same view can be given atmosphere by a colorful sunrise or sunset, by dramatic lighting and stormy clouds, or by sunlight filtering through a misty backcloth. Remember also that uniform blue skies are not nearly so interesting pictorially as skies with intermittent cloud cover, which you can enhance on both color and monochrome film by using a polarizing filter and photographing at right angles to the sun. With black and white films, you can also use a deep-yellow filter to darken the sky and thereby increase the contrast with white clouds.

The position of the horizon — the demarcation between the sky and the land — is crucial in the composition of any landscape photograph. Where emphasis is placed on the sky, the horizon will inevitably be positioned low in the frame, or it may be omitted altogether. Even a narrow band of trees, however, will help to give scale to sky photographs. The sky provides a natural backcloth for isolated trees or mammals standing on a horizon, especially at sunrise or sunset, as well as for birds in flight at any time of day.

You can use a wide range of lenses for photographing the sky, from 20mm to 400mm. The circular framing of a true fish eye lens can produce exciting images, provided that you make sure that direct rays from the sun are masked by clouds. Some of the most dramatic skyscapes exist for only a fleeting moment, so it is essential to have your camera always at the ready. Taking time to find the best viewpoint for photographing a sunrise or a sunset will pay dividends; for example, the inclusion of a striking foreground silhouette can only enhance a rising or a setting sun.

Very effective pictures can also be taken of the night sky. For example, an hour-long exposure of a clear sky at night will record the stars as bright streaks across a dark backcloth.

Polarizing for contrast ▷
This skyscape came into view as I drove across a windswept moorland in south-west England. I used a polarizing filter to darken the sky and so emphasize the high-level, wispy cirrus clouds. The clump of trees gives the picture a natural scale and also shows the direction of the prevailing wind.

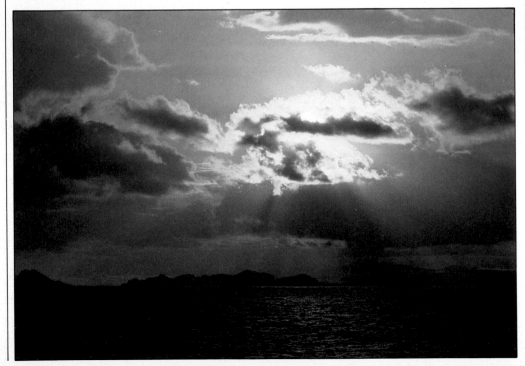

◁ **Dramatic sunrise**
As I sailed into a drowned river valley, or ria, on the north-west coast of Spain, the sun rose behind rain-clouds. I metered directly through the camera, so that the islands were silhouetted on the horizon, and the waves were highlighted by reflected sunlight.

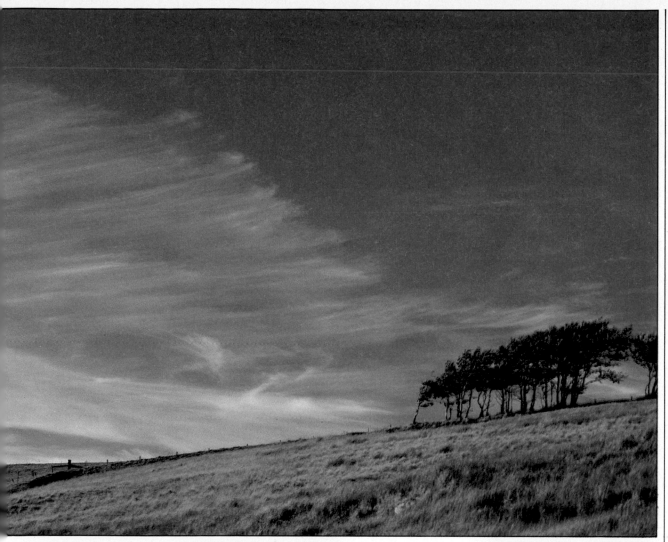

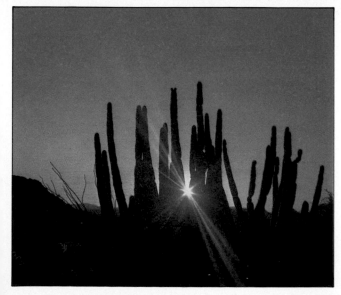

◁ **Sunburst**
I had originally intended to photograph the setting sun so that it was on one side of the organ pipe cacti. However, because of the clear sky, the sun shone directly into my wide-angle lens, so I used the silhouetted cacti to mask the sun partly and create a starburst effect.

Fireball ▷
During the dry season in Africa, the dusty air causes the blue rays of the sinking sun to be scattered, making the sun resemble an orange ball of fire just before it reaches the horizon. I used a 400mm lens for framing this simple image.

Rain and water

At the first sign of rain, the instinctive reaction is to pack away all equipment and take shelter, yet some of my best pictures have been taken on rainy days, with the help of umbrellas, plastic bags, and a great deal of patience. But photography in the rain is not easy; there is always the risk of rain seeping into the camera, the light is usually poor, and falling raindrops constantly vibrate stems and leaves. On the other hand, there are times when misty rain blots out an unsightly background and so helps to enhance a picture.

Watch out for a rainbow if rain falls when the sun is low in the sky, because each raindrop acts like a prism to bend and split the light into different-colored wave-lengths. Raindrops add a new dimension to close-ups. Sunlight, or flash, makes water droplets on flowers or spiders'

webs glisten with a jewel-like sparkle. A water droplet in close-up appears as a tiny picture within a picture, because each acts as a minute lens and focuses on a distant scene. Wet rock or leaf surfaces, however, can give undesirable and distracting reflections, especially if you shine a flash onto them directly.

When working in the rain, I hold an umbrella over the camera and I also drape a towel over it to absorb any rain that blows in beneath the umbrella. If moisture seeps inside the camera, wipe it off at once and leave the camera open overnight on a layer of silica gel crystals in an airtight container. Permanent hides overlooking lakes or marshes provide good viewpoints for taking pictures of raindrops falling on water. Photographed with a long exposure, the rain-drops appear as a series of long streaks.

Raindrop pattern ▽
I was paddling my way in an open shikar through Kashmir's beautiful Dal Lake when it began to rain, so I hastily pushed my cameras under cover. After the rain had stopped, I noticed a pattern of raindrops on the large lotus lily leaves and, once the shikar was stationary, was able to take a hand-held shot.

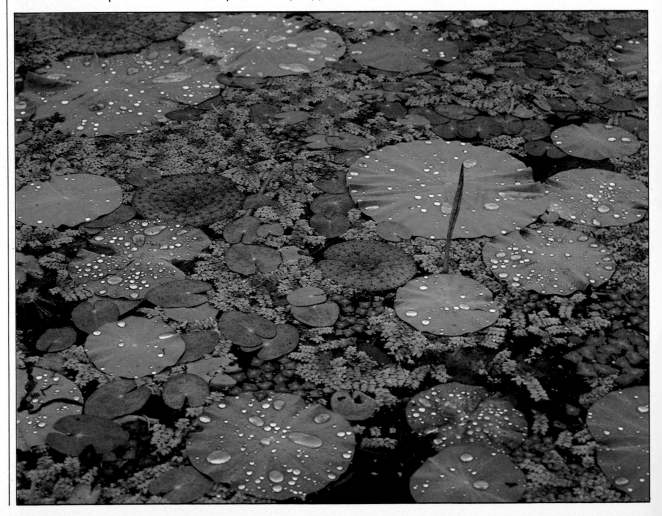

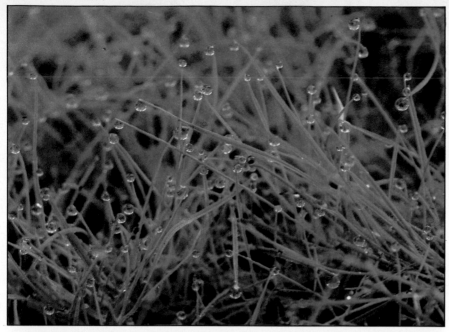

◁ **Water droplets in close-up**
Early one autumn morning I found a
clump of grass highlighted by water
droplets. Resembling dew, such
droplets are excreted by the leaf tips
during warm humid nights — a process
known as guttation. With the camera
supported on a table-top tripod
(shown above), I lay on my raincoat to
gain a low viewpoint.

◁ **Working in the rain**
It took me almost a whole day to find
and photograph this insectivorous
plant, the greater butterwort
(*Pinguicula grandiflora*), in an Irish
bog. Once I had found a perfect
specimen, I had to wait until its stems
stopped moving in the rain. After
prefocusing the camera on a tripod, I
covered it with a thick plastic bag until
the worst of the rain had abated. I
removed the bag to make the 1 sec
exposure, and held an umbrella over the
camera to protect it from the few
raindrops still falling.

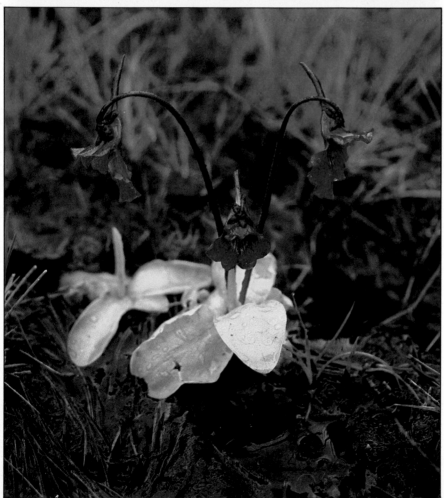

Snow, ice, and frost

In temperate parts of the world, photography of snow, ice, and frost has to be telescoped into a relatively short cold winter spell. In high latitudes, however, and at high altitudes, opportunities exist all the year round although, because the number of daylight hours is much reduced during high-latitude winters, prime moments may be rare.

A landscape blanketed by a heavy snowfall can appear rather monotonous, especially when lit by diffuse light on an overcast day. Modeling with light and shadows is therefore essential for extensive ice- and snowscapes. Because snow acts like a huge reflector, direct light readings are high and there is a tendency for shadow detail to be lost (see p. 80). Shadows also tend to take on a bluish cast, particularly at altitudes, which you can correct by using a skylight filter, or preferably an ultra-violet filter, on the lens. Each type of color film will give a different rendering, so it is worthwhile experimenting with different films.

If sub-zero temperatures are unlikely to persist throughout the day, it is essential to rise early before the sun begins to sculpt the ice or frost with the warmth of its rays. Try using a single flash to add sparkle to frosty close-ups, such as field grasses and spiders' webs, either by grazing the flash over the subject or by using it to backlight the subject.

When subjected to low temperatures, film becomes brittle and so is much more likely to be damaged as it is advanced through the camera. Condensation can also be a problem. If you are returning to a warm car or building after working outside in the cold, condensation will develop on the lens. A wise precaution is to seal the camera in a plastic bag containing some silica gel, which will absorb the moisture, before you leave the cold surroundings. In deep snow, it is sensible to wear skis or snowshoes or to ride on a snow-mobile.

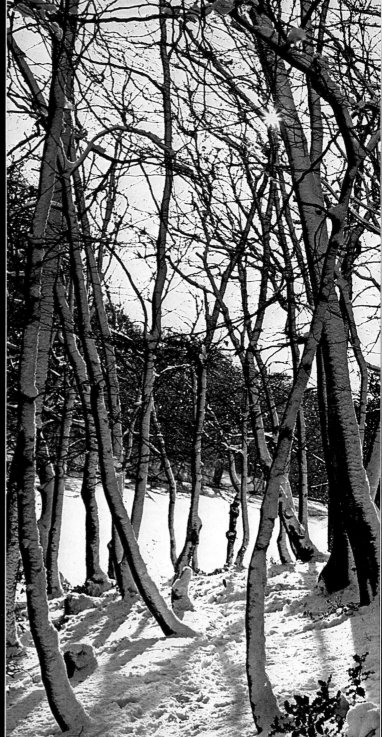

Winter woodland ▷
When falling snow is blown by the wind, it etches the entire length of tree trunks or posts in its path. This woodland scene was enhanced by the sun backlighting the young tree trunks. I positioned the camera so that the sun's rays were restricted by the trunks to give a natural starburst effect.

◁ A frosty detail

Having heard that a sharp frost was forecast, I rose at first light, so that I would have plenty of time for taking photographs before the frost melted. The simple shapes of the ivy leaves, highlighted against the fence post by their frosty edges, immediately caught my eye. I took this close-up on a still, overcast morning using a shutter speed of 1/2 sec and a 21mm extension tube for precise framing with an 80mm lens.

◁ Frost pattern on glass

Now that many houses are centrally heated, frost patterns on windows are a rare sight. I spotted this feather-like pattern of frost crystals on the glass of a cold frame in our garden. No special technique was used to take this close-up picture before the sun rose, but I did make sure that the film plane was parallel to the glass.

A heavy frost ▷

The weight of an extensive hoar frost or rime can completely flatten grasses and other plants with delicate stems. I was intrigued by this almost abstract design of frosty reed stems and leaves criss-crossing each other. Such a subject reproduces well as a monochrome print and, indeed, I much prefer this to the color transparency that I took at the same time.

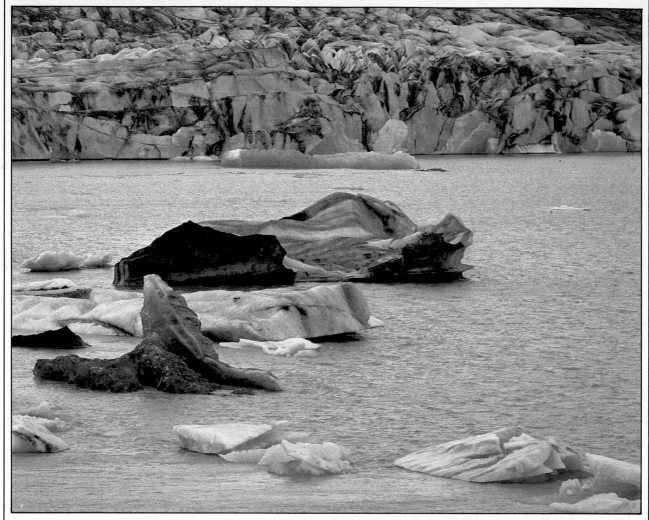

A northern scene △

At the point where the edge of a glacier — the snout — enters a glacial lake, the slowly moving ice breaks up to form icebergs of varying shapes and sizes. I took this picture, showing the snout of the glacier behind the icebergs, in mid-summer in Iceland. The blackened parts arise from the morainic material plucked off the mountain by the moving ice. Although the picture lacks a range of colors, I especially like the subtle bluish shades in the elongated ice floe which has just broken free from the glacier. Such a scene would have presented exposure problems if the sun had been shining.

Crucial timing ▷

I first spotted these icicles hanging down from an alder bough as I drove past in my automobile. I had a race against time to take this transient scene before the sun disappeared behind a cloud or the icicles melted away. I used a 105mm lens on a Nikon to capture the natural spotlighting of the icicles against the somber, blue-frozen lake. The irregular shape of the icicles at their tip shows that they have been created by alternating periods of freezing and thawing over a period of several days.

THE WORLD OF PLANTS

Selecting the subject

Within the plant world there is an infinite variety of size, shape, form, and color, which provides opportunities for every kind of nature photography, from trees in the landscape to plant portraits and very detailed anatomical close-ups. No matter what the subject, the first priority is to select the best-possible specimen for photography, since it is a waste of time and film to take poor specimens. A tiny blemish can become a great distraction when it is enlarged on a print or projected onto a screen.

There are two main approaches to photographing plants. First, you can go in search of a specific plant; for example, many people like to concentrate on one group of flowers, such as wild orchids, which combine attractiveness with rarity. It is then essential to find out when they flower and precisely where they are to be found. If a rare flower is growing on private land, you must seek permission for access and make sure to disturb the habitat as little as possible. Far too many photographers allow their driving ambition to achieve a picture at all costs to blind them to the damage they may be causing to fragile environments. When I am working abroad, I resort to the second approach, which is to take whatever happens to be flowering at the time. The element of chance is reduced if you enquire from local naturalists or museums which localities are likely to be most rewarding.

Without care and thought, plant photographs can appear very stereotyped, unless you consciously vary the lighting, the viewpoint, or the magnification. When I walk in the countryside, I am constantly on the look-out for new and exciting subjects, or even familiar subjects in more photogenic surroundings. In a forest, which is a more three-dimensional habitat than a flat meadow, I scan the ground cover, then the herb layer, looking up at the canopy and back down again. It may be the way in which a plant is lit by the sun that first catches my eye; or a colorful bloom or fruit may make me look twice. Sometimes I find a subject where the background competes for attention. I then spend time looking for a different viewpoint, which may involve my lying on the ground or climbing a tree. Occasionally, it may be necessary to "garden" away distracting bleached twigs or grass stems from the field of view. Always do this with great care, so that a delicate subject, such as fungus, is not damaged in the process and the background looks completely natural in the photograph.

1 This swirling pattern of seaweeds was exposed on a wave-cut platform on the south coast of Britain.

2 When the rain stopped, I was able to photograph some flowering spikes of *Ludwigia* in a Galapagos pool.

3 An old, weathered skeleton of a Monterey cypress tree was taken at Point Lobos on the Californian coast.

4 The translucent leaves of the maidenhair fern show up well when photographed on top of a light box.

5 The large pale brackets of this fungus stand out very clearly against the bole of an oak tree.

6 Venus' necklace is an inter-tidal seaweed that flourishes in shallow pools on wave-cut platforms in New Zealand.

7 Seeds of the Andean *Puya raimandi*, which I lit from below, grow into the world's tallest flowering spikes.

8 The flattened daisy head illustrates well the arrangement of outer ray petals and inner disc florets.

9 Walking beside a river bank in Scotland, I found a rare alpine (*Alchemilla conjuncta*) cascading over the rocks.

10 I emphasized the striking design of a cow parsley umbel by isolating it against a black background in the studio.

11 To illustrate the texture of the flaking bark of Sitka spruce (*Picea sitchensis*) I used a long-focus lens.

12 By leaning over some rocks I was able to take this bladder wrack seaweed buoyed up by the rising tide.

1

5

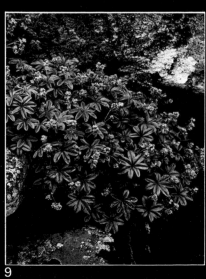
9

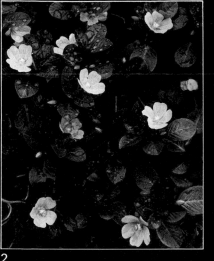

2

3

4

6

7

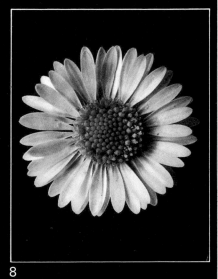

8

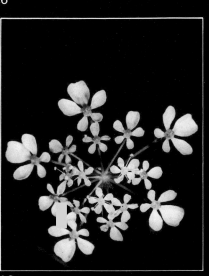

10

11

12

Flowers

The striking shapes and colors of flowers, as well as their inability to move out of camera range, make them appear deceptively simple subjects for photography. If you have spent time searching for a particular specimen, it is well worth taking a little longer to check that you have found a perfect bloom and also to look beyond the flower to make sure that there are no nearby brightly colored flowers, which, even when out of focus, will draw the eye away from the subject. If you have a depth of field button on the camera, use it to appraise the background critically.

Close-ups of flowers are most successful if you can isolate the subject from its background. If the petals contrast with the surrounding vegetation, the flower will simply isolate itself; otherwise you will have to use one of a variety of techniques. You can make a flower stand out from its background by using differential focus; by creating a background shadow; by using sky (with a low viewpoint) or water (with a high viewpoint) as a natural background; or by placing a piece of cardboard behind the flower.

You can show large plants, or clumps of flowers in their habitat, by using a wide-angle lens. This technique works well for mountain, woodland, and seashore flowers. You can restrict the movement of tall-stemmed flowers by using either a plant-clamp or a clear plexiglass windshield curved behind the plant. Vary your approach to flower photography by using different magnifications and also by experimenting with lighting — both natural and artificial. Flash can be used as the main light source or to fill in shadows cast by the sun. White cardboard, aluminum foil, or a small hand mirror are very useful aids when you want to boost the natural light.

A hint of color ▷
I had the idea for this picture before the poppies came into flower, but it took me some time to find an isolated bud with a uniform green background. I used the plant clamp shown on the right to steady the tall stem in a gentle breeze.

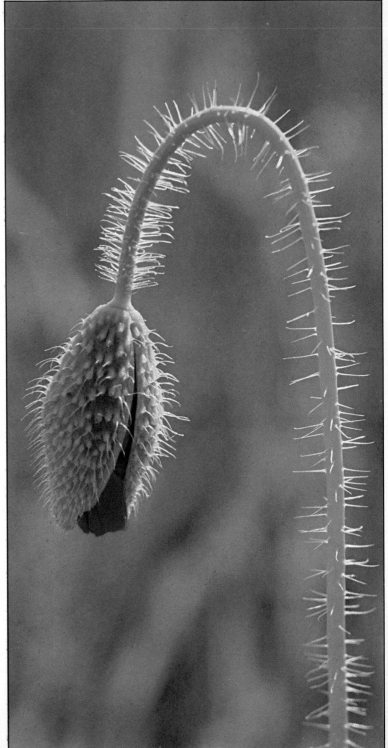

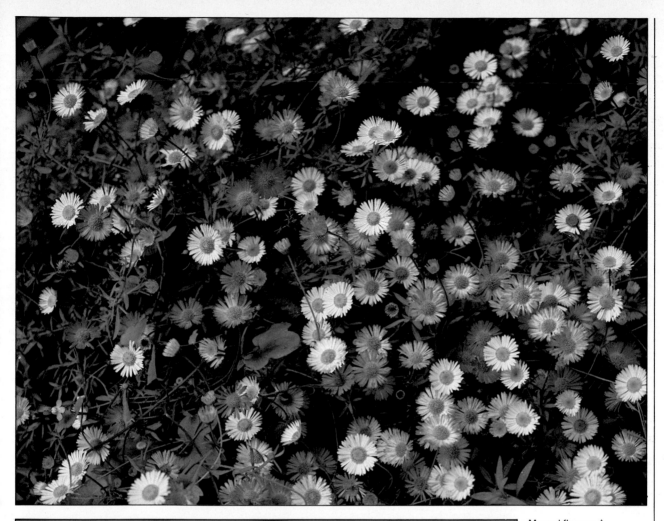

Massed flowers △
Once established, Mexican
wall daisies flourish on
sunny walls. The variation in
color and stem height of the
different-aged flowers
helped to add interest to this
mosaic of circular images.
When such a mass of
flowers completely fills the
frame, there is no
background problem.

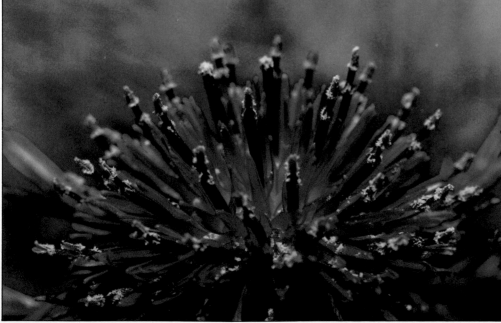

◁ **Floral anatomy**
I deliberately cropped the
outer florets of a greater
knapweed flower
(*Centaurea scabiosa*) before
taking a larger-than-life
close-up, giving a bee's eye
view of the stamens laden
with yellow pollen grains. I
used two flash heads to
freeze all movement.

Flowers

Although many wild-flower enthusiasts argue that the only place to photograph flowers is in their natural surroundings, and it is now illegal in some countries to pick rare wild flowers (see p. 147), studio photography can be invaluable for illustrating the structure of cultivated blooms or common wild flowers without the drawbacks that are often found in the field. In the studio, there is no wind to move the subject, and you can select the background and light that best define the flower's shape.

Techniques that are especially suitable for indoor photography include backlighting to highlight petal patterns, ring flash for lighting the cavities of deep-throated flowers such as orchids, time-lapse sequences, and photography by ultra-violet light.

Photofloods are impractical for indoor plant photography, especially for delicate blooms, which soon wither from the heat generated. Electronic flash is most suitable for taking flower portraits, and you can experiment with the lighting positions of the three flash heads of the versatile Macro Flash (see p. 162). Light from a ring flash falls on the subject from the direction of the camera lens and so produces uniform, shadowless lighting without modeling the subject. If you cover portions of the ring flash with black masking tape, you will not alter the direction of the light source but will create a series of small lights instead of one circle.

To photograph a pastel-colored flower, such as a water lily, floating on water, avoid a harsh, direct light source. Instead, diffuse the light by using either a sheet of muslin or a light tent. Special photographic light tents, in the shape of cylinders or cones with each end open, are now available made from white plexiglass (see p. 162), but you can improvise by making a cone from tracing paper. Place the bloom inside the tent and focus the camera down through the open upper end. Shine one or two lights from outside through the wall of the tent to obtain a soft, shadowless light.

You should select your backgrounds just as carefully as you choose your light source for indoor work. Black velvet makes the best black background for both color and black and white pictures. White or gray boards can also be used for monochrome work, while naturalistic colors such as greens, blues, or browns are more suitable for color film. Try to avoid harsh, unnatural-colored backgrounds such as orange, red, or pink.

A technique that is of particular interest to the naturalist is ultra-violet photography. It is now known that many apparently monotoned flowers exhibit ultra-violet light patterns and obvious honey guides for insects, which are visible to the human eye only in photographs taken in ultra-violet light with a special black filter on the camera lens.

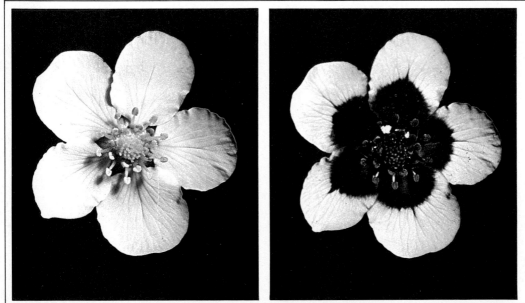

Ultra-violet pattern
I took a silverweed (*Potentilla anserina*) flower first in visible light (far left) and then in ultra-violet light (left). For the picture on the left, I lit the flower with a mercury vapor lamp, and placed a Wood's glass (OX1) filter over the camera lens to exclude the visible wave-lengths. This filter, which appears black, requires an exposure increase of 12 stops. By visible light, the flower appears as a monotone, but in ultra-violet light, a pattern is revealed, with the center absorbing the short ultra-violet wave-lengths and appearing dark in contrast to the pale outer parts of the petals, which reflect the ultra-violet light.

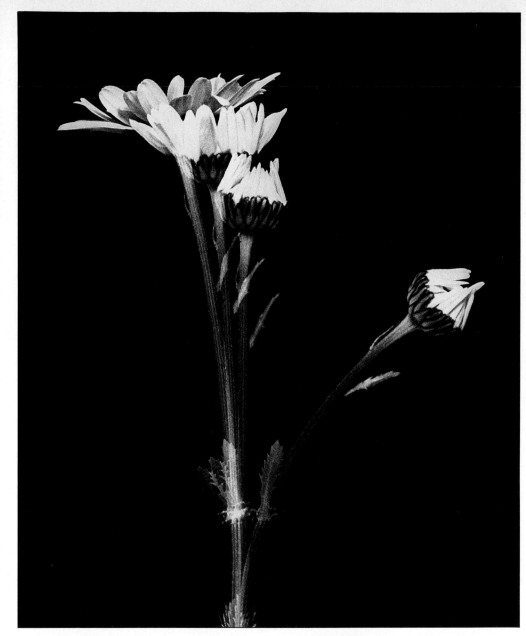

◁ **Multiple time-lapse**
I recorded four stages in the opening of an ox-eye daisy (*Leucanthemum vulgare*) on a single frame, using a Hasselblad mounted on a tripod. To obtain the multiple images, I carefully removed the film back after exposure, so that the shutter could be recocked without advancing the film. The four exposures were made at six-hourly intervals by the light of a single photoflood. I marked the position of the flower bud, at each stage of the time-lapse, in grease pencil on top of the ground glass screen of the camera viewfinder (as shown above) so that I could visualize the pattern of the increasingly composite images formed as the petals opened and the stem straightened and elongated.

◁ **Time-lapse series**
I used a fluorescent striplight covered with a diffuser to provide constant, even lighting for a series of studio close-ups of a single iris against a white board. The series took two days to complete, with an interval of 24 hours between each exposure. When framing the iris bud in the viewfinder, I allowed plenty of space around it, so that I could use the same magnification for the open flower.

Trees

It is perhaps surprising that trees are not among the most popular subjects for nature photographers, since they are infinitely variable in shape, form, and color. Fine specimens of open-grown trees with spreading branches can be found both in the countryside and in landscaped parklands, while collections of trees occur in woodlands and in arboreta.

Photographing such large and static subjects might seem easy and straightforward, but there are pitfalls. As always, select your viewpoint and your lens carefully. You can use a lens of any focal length for taking trees, but I find the 135mm the most useful. I use this for taking whole trees as well as parts of trees, such as a trunk or a flowering or a fruiting branch. Check that there are no unsightly buildings, telegraph wires, or vapor trails in the background. Does the lighting do justice to the tree? If not, it may be worth paying a return visit. Side-lighting provides better modeling than front light. Backlighting is very effective for enriching autumnal colors, particularly if the distant background is in shadow. The branching pattern of leafless deciduous trees and of conifers with spreading branches can be emphasized in silhouette. A snowy background helps to enhance tree silhouettes, particularly those of conifers in mountainous areas. White-barked trees, such as birches or aspens, look very striking when spotlit by the sun against the deep shadow of other trees or against a blue sky darkened by a polarizing filter. For many months of the year, trees may appear not to change, but they do have photogenic stages which persist for a few brief days. The delicate green of the young spring leaves of temperate trees, and the attractive coppery hues of tropical trees leafing out, quickly turn into harsher greens, and the lovely autumnal leaves are blown away all too soon.

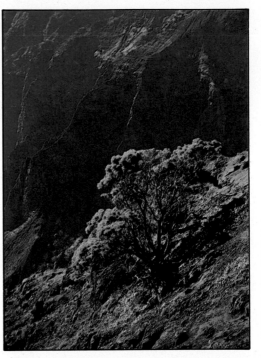

◁ **Using a long lens**
I used a 200mm lens to take this lone koa tree (*Acacia koa*) growing near the upper rim of Waimea Canyon in the Hawaiian islands. The tree was spotlit by the early-morning light, which picked it out from the shadows of the precipitous cliffs behind.

Taking a silhouette ▷
I had to wear snowshoes when crossing deep snow to reach the viewpoint from which I took a Jeffrey pine, growing 6,400 feet up in the Sequoia National Park in California. The backlighting from the golden setting sun emphasized the shape of the tree in silhouette and provided strong color.

Color contrast ▷
The strong color of the sugar maple (*Acer saccharum*) leaves during the fall in New England makes the trees stand out clearly from their neighbors. I used a 150mm lens on a Hasselblad to photograph them on a day when the air was still and the sky overcast, so it was the tree itself, rather than the available lighting, which provided the color for the picture.

Trees

A worthwhile long-term project, which involves using a range of lenses and techniques, is to photograph all stages of one kind of tree throughout the seasons. These pages show just a few of the hundreds of frames I have taken of the beech (*Fagus sylvatica*), which is my favorite tree. It does not matter in what season you begin your project, or in what location you are working. Even now, I am continually adding to my collection of both black and white negatives and color transparencies illustrating the beech tree. I am particularly fascinated by the distorted shapes of beech trees that have been repeatedly pollarded by man to provide a source of fuel or of food for deer.

Perhaps the most obvious way to start is by photographing a few examples of the entire tree in different seasons, in the open and in woodlands. The mood of a deciduous tree, such as beech, changes dramatically from one season to the next. The form of a tree also changes as it grows from a small sapling to a mature tree and then begins to die back as fungi attack and rot its trunk and branches.

After taking portraits of the entire tree, try moving in to focus attention on the trunk, bark, roots, buds, leaves, flowers, and fruits. If you are also interested in photographing insects, birds, and mammals, you could extend your scope to include those animals that use the tree for shelter or as nest sites or a source of food.

◁ **An old pollard**
Still standing in England's New Forest is a fine example of a beech tree pollarded over 250 years ago. I used a wide-angle (50mm) lens on a Hasselblad to take this spring picture.

A natural arch ▷
The natural backlighting from the low-angled autumnal sun emphasized the solid trunk and curving bough of an old beech and also highlighted the leaves.

Roots ▽
The roots of a beech tree growing on a roadside bank have become exposed as the high-level bank continually erodes away. I had no option but to use a low viewpoint from the road.

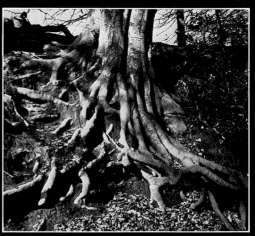

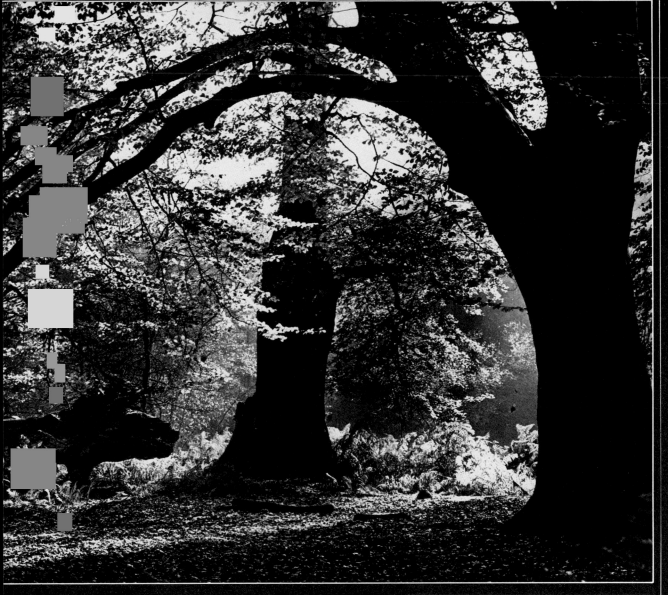

◁ Summertime
This fruiting branch was taken in a studio, using flash, because the heat generated by a large photoflood light would soon have shriveled the leaves.

Leafing out ▷
I used the bright natural light behind the branch to mark the contrast between the delicate young spring leaves and the old fruits shown in silhouette.

Seeds and fruits

After flowers have bloomed and withered, their seeds and fruits still make attractive subjects for photography. You can photograph large and colorful fruits either while they are still attached to the plant or when they have fallen to the ground, whereas tiny seeds are more suitable for macrophotography in the studio. I find a medium-long-focus lens, such as a 135mm or a 200mm, ideal for isolating a small portion of a fruiting branch from the rest of the tree, or I look upward from a low viewpoint to isolate a fruiting branch against the sky. If this is not possible, a backcloth of out-of-focus leaves can be effective. A useful technique for isolating fruits or flowers from a cluttered background of a similar color or tone is to ask your companion to stand where his or her shadow is cast behind a sunlit plant.

When photographing smooth shiny fruits by direct sunlight or flash, watch out for bright highlights appearing on them. These may not be too distracting on large fruits, but they can be very noticeable on a cluster of small shiny fruits. You can remove such highlights in one of three ways: by placing a muslin diffuser screen between the light source and the subject, by bouncing a flash off a white umbrella, or by using a polarizing filter attached to the camera lens.

Spiky fruits and hairy seeds are excellent subjects for backlighting. Even the tiniest hairs are revealed if they are brightly lit against a dark background. Look late in the day for seeding thistles against a background in shadow. When fieldwork is impossible, collect dry fruits and seeds for indoor photography and experiment with varying degrees of backlighting with small spotlights, making sure not to shine the lights directly onto the lens. Restrict the angle of the beam by wrapping a tube of matte black paper around the edge of the light.

A more exciting aspect of seed photography is the possibility of recording the actual dispersal of seeds from the parent plant. You will be able to capture dandelion or thistle parachutes as they lift off only by using either a fast film and a fast shutter speed or flash.

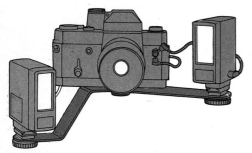

Twin flash for a studio portrait ▷
To illustrate the detailed structure of the miniature parachutes of a dandelion seedhead, which are so perfectly adapted for wind dispersal, I used a pair of small electronic flashes mounted on a boomerang-shaped bracket as shown above. These allowed me to stop down the 55mm micro-Nikkor lens to an aperture of f16 for a completely sharp image of the center of the head. Although unnatural, the black background was selected to provide impact. Because any spherical subject creates a problem with a rectangular 35mm format, I decided to crop tightly on one side of the head for additional interest.

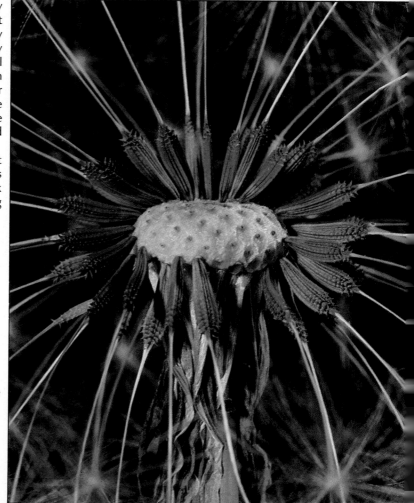

◁ Fallen fruits

The large fruits of the horse chestnut tree are difficult to photograph in close-up when they are contained inside their husks high up on the tree. Once they have fallen to the ground, however, they make ideal still-life subjects. I found it easy to take an overhead view of a group of horse chestnuts lying on a carpet of fallen leaves on the lawn in my garden.

Enhancing the subject ▽

The natural backlighting shining through the green leaves of akee (*Blighia sapida*) greatly enhances these colorful tropical fruits. I used a 200mm lens to enlarge the image size of the fruits and to throw the background out of focus.

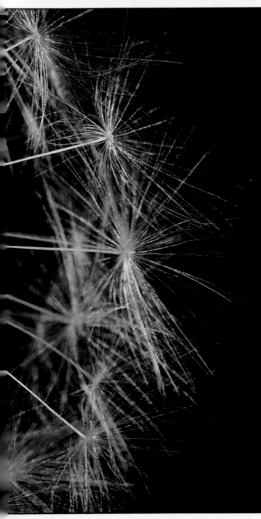

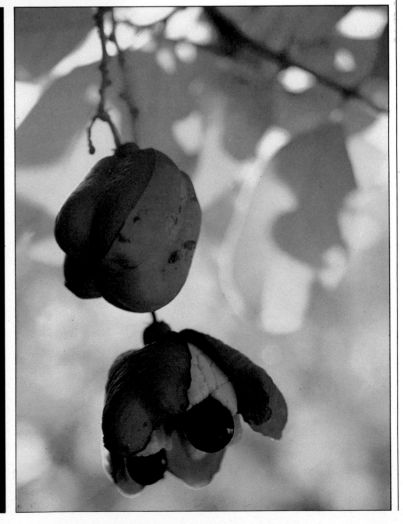

Fungi, lichens, ferns, and mosses

Flowerless plants — fungi, lichens, liverworts, mosses, and ferns — are much neglected by nature photographers, yet they offer exciting subjects, ranging from macrophotographs of lichens to landscapes of tree ferns. Most mushrooms and toadstools are ephemeral, and so you have to photograph perfect specimens as soon as you find them. If you postpone taking them by even a day, they may either be shrivelled, eaten by slugs, or reduced to an unrecognizable heap by hungry maggots. In temperate regions, the majority of fungi appear in the autumn, especially if rain coincides with a warm spell. Rain also triggers fungal growth in the tropics.

You will find a good variety of fungi in forests, expecially on rotting wood and on the ground. Because available light is much reduced inside a forest, use long exposures and try using a reflector to boost the available light rather than a harsh direct flash. If you must use flash, try bouncing it off a reflector or even a piece of white cardboard. Watch out for a false color cast on pale fungi caused by sun filtering down through a green or brown leaf canopy.

Moss and fern plants can be found throughout the year. They flourish in forests with a high rainfall or a persistent cloud cover, where they often grow on the trees as epiphytes. In deciduous forests in winter, more light reaches the floor after leaf fall, making photography by available light easier. Lichens often seek more open sites and, as encrusting lichens do not move, they are ideal subjects for windy winter days. Old weathered tombstones can be rich sites for lichens, while a persistently leaky gutter can create an ideal mini-habitat for mosses.

Flash for impact ▷
Distracting branches behind a gelatinous fungus, *Auricularia auricula*, made me decide to create a background shadow by using a flash behind the fungus as the main light source (see the diagram on the right). I also held another flash in front of the fungus to fill in the shadow.

A long exposure ▷
I found a white fork moss
(*Leucobryum glaucum*)
growing in the cracks of an
oak trunk lying on a dark
forest floor. By maneuvering
the versatile Benbo tripod, I
was able to use a 1 sec
exposure so that the whole
frame appeared in focus.

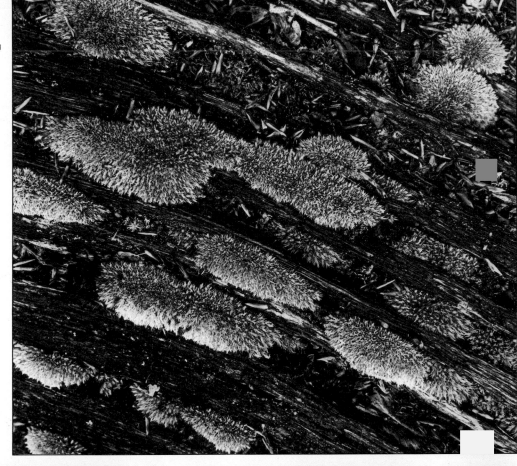

Boosting natural light ▽
Inside the dense New
Zealand "bush", where the
rainfall and humidity are
high, mosses and lichens
abound. To increase the
amount of available light on
a leafy lichen growing on a
tree trunk, I used a silver-
coated survival blanket as a
reflector sheet.

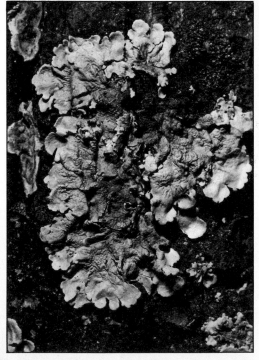

A radiating silhouette △
Looking up toward the sky inside the New Zealand "bush",
I took a striking silhouette of the fronds of a tree fern
surrounded by its neighboring trees. I metered through the
camera and used the straight reading in order to produce
a solid silhouette.

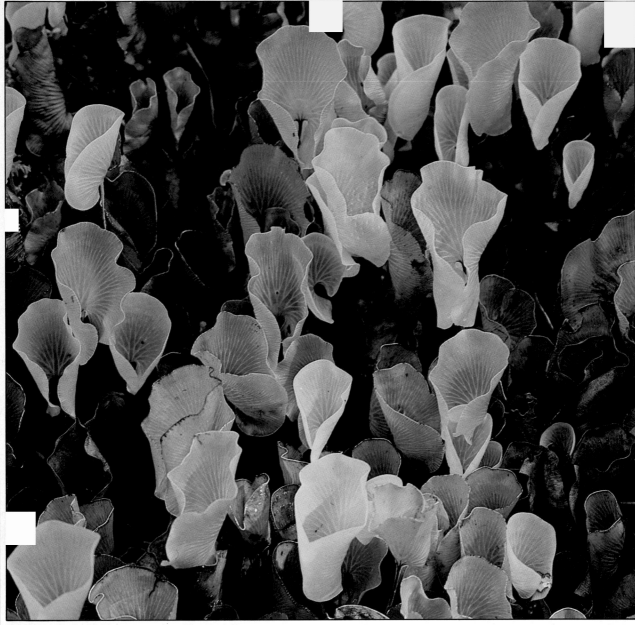

Maximizing depth of field △
The quintessence of this picture of delicate kidney fern
fronds (*Trichomanes reniforme*) in New Zealand is the
repetitive pattern sharply focused over the entire frame. The
soft diffuse lighting from the overcast sky created few
harsh highlights and shadows, but meant that I had to use a
very long exposure to gain the minimum aperture possible.
For such pictures I find a rigid tripod essential. Even so,
triggering the shutter directly by hand causes enough
vibration to rob the picture of its precision sharpness, and
so a cable release, or a delayed-action mechanism, is vital.
When making long exposures on the Hasselblad, I always
pre-lock the mirror to eliminate camera vibration. Windless
conditions are, of course, necessary for success.

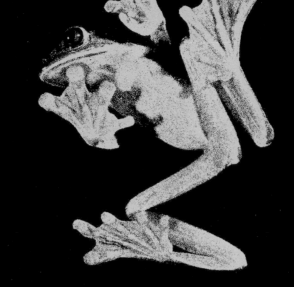

THE WORLD OF
ANIMALS

Observing the subject

The major difference between animal and plant photography is that animals, unlike plants, are generally free to move around and will probably move off as you advance toward them. There is nothing to compare with photographing a subject successfully after having stalked it in its own territory. Like a hunter, you have to use all your skill and cunning to avoid detection by a wary mammal or bird that is constantly on the alert for the approach of danger. The more hours that you spend observing in the field, the better wildlife photographer you will be, for, by becoming more familiar with animals' behavior, your will be able to anticipate their movements. Practice inching forward gradually with a slow, continuous, rather than a staccato stop-start, movement. An alternative approach to photographing wildlife in the field is to wait inside a hide that you have set up at a place to which birds or mammals return naturally to drink, feed, or nest or to which they can be attracted by baiting.

Luck usually plays an even greater part in animal photography than it does in plant photography, but you can improve your chances by researching carefully the behavior of your chosen subject. Indeed some wildlife pictures are achieved only by careful planning. However there is always an element of chance involved when you are taking unexpected and exciting scoop action pictures. In such cases, you are more likely to succeed if you have the correct lens on your camera, which is already loaded, prefocused, and set for an average light reading. Then you need only frame the picture and make whatever small adjustments to the exposure and focus that may be essential.

The twelve images on this spread cover a wide range of subjects taken both outdoors and in the studio. The relatively small reproduction necessitated the selection of simple images, well defined in their backgrounds. However, a glance at these pictures will show that in every case the camera viewpoint was selected carefully either to help isolate the subject or to bring the subject sharply into focus. Simple though they may appear, none of these pictures happened entirely by chance; each involved careful framing, precise focusing, and accurate exposure. As you gain experience, you will find that only by learning to handle your camera with instinctive ease will you ensure a consistently high level of success in your animal pictures.

1 Before spawning, the female Surinam toad develops a pad on her back, to which the eggs adhere.

2 Silhouetted against the sky, four frigate birds glide around, waiting to rob other birds of their food.

3 This studio portrait of a dormouse was taken in a naturalistic setting within a large glass-sided vivarium.

4 A graveyard of cockle shells on the banks of an estuary in Wales is proof of oyster-catchers at work.

5 In perfect unison, two tuxedo angelfish swim in a small aquarium in front of the lens.

6 This head-on picture of a Galapagos giant tortoise feeding was taken on the floor of an old volcano.

7 A low viewpoint can be very effective for isolating a butterfly feeding on a tall flower against the sky.

8 To take this picture of a grass carp, I prefocused the camera and released the shutter just as the mouth came into focus.

9 A red deer stag, resting by day inside a deer park, was clearly defined against a shadowy background.

10 As I was driving along, the simple silhouette of a duck pausing on an icy pond caught my eye.

11 On exposed lava on a Galapagos shore, a pair of Sally Lightfoot crabs meet eye to eye.

12 When a caterpillar feeds, it grips the leaf with its legs, as this picture of an Assam silkmoth caterpillar shows.

1

5

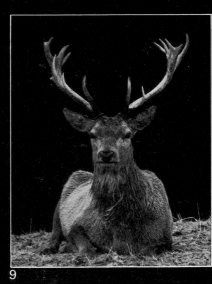

9

2

3

4

6

7

8

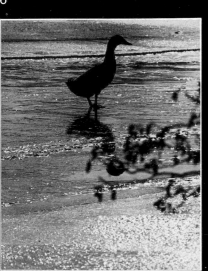

10

11

12

Insects

Insects make up the most numerous group of animals living today. They can be found at all times of year in every habitat, but in temperate regions the greatest variety occurs in spring and summer. A flowering hedgerow, woodland trail, or meadow are always rewarding when you are looking for insects. Once found, still or slowly moving insects can be photographed by available light, perhaps boosted by a reflector, and with the camera held steady on a monopod (p. 70). The only sure way of freezing a fast-moving insect, however, is by prefocusing the camera and using electronic flash. You can use a single flash head, twin flashes mounted on a double flash bracket or a boomerang-shaped bracket, or three flashes (see p. 162). When three flashes are synchronized, you can use one to illuminate the background, so that the insect does not appear to be in black unlit surroundings. A ring flash can be a very convenient way of lighting small subjects but is unsuitable for taking shiny-backed beetles or ants, because it produces a circular reflection on the subject, which, on the photograph, appears to be a ring-like body pattern.

The bright coloration of many butterflies, moths, and dragonflies makes them ideal subjects for color photography, but those that fly by day are usually too active to be photographed easily. You will find it less exhausting if you wait for the insect to come to a flower on which you have focused the camera, and which you know the insect is likely to frequent. As always with close-ups, look beyond the subject at the background. Try varying the magnification and the camera viewpoint. A head-on picture of a feeding butterfly always has impact. Macro lenses with a focal length of 105mm or 200mm are ideal for photographing insects in the field.

Anticipating the picture ▽
I took this picture in late fall, long after the attractive wild flowers had withered. I knew, however, that the ivy flowers, which I spotted early one morning, would attract the last few butterflies of the year. I therefore returned at noon, when the sun was warmer, and found two small tortoiseshells (*Aglais urticae*) feeding on the nectar. I used a 105mm macro lens to take this picture by available light.

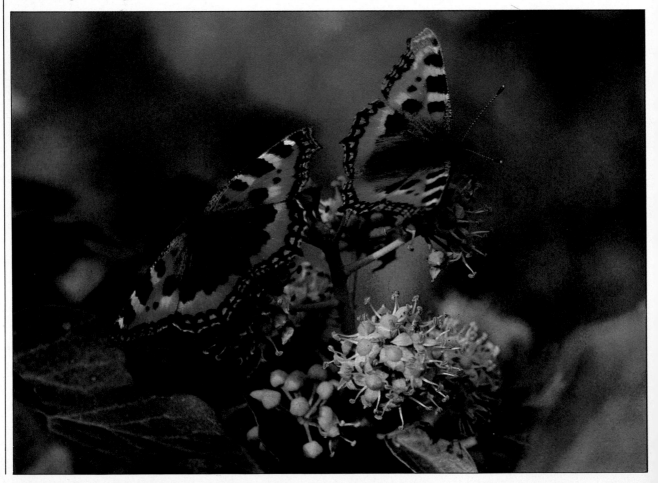

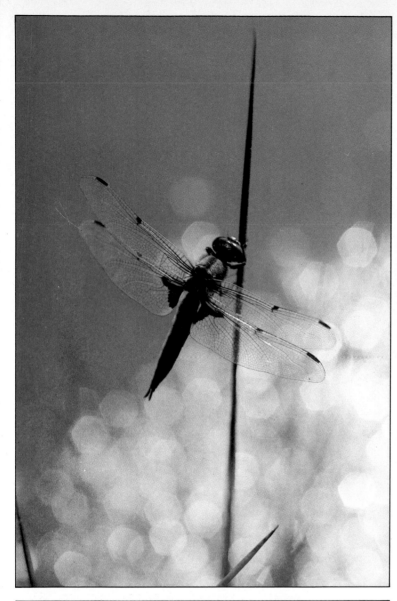

◁ **A long lens for a wary subject**
Large dragonflies fly so quickly that it is impossible to keep up with them. By panning the camera (see p. 126), you can photograph males in mid-flight as they go back and forth defending their territory. It is easier, however, to photograph a dragonfly when it alights on its favorite perch — usually a reed beside water. If you prefocus the camera, you will not disturb the dragonfly by sudden movements. I used a 200mm lens and, because of the persistent breeze, a shutter speed of 1/250 sec. Out-of-focus highlights on the water have been recorded as white hexagons, which is the shape of the lens diaphragm.

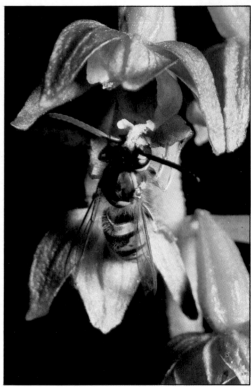

Using flash to record behavior △
I had visited a wood to photograph wild orchids, and I then spent several hours observing two wasps foraging on the flowers. On the head of this wasp can be seen a pair of yellow pollinia or pollen sacs from the flower. It was impossible to photograph the wasps by available light inside the dark wood and, as I had only a single flash with me, I had no option but to use it adjacent to the camera.

◁ **A static subject**
When caterpillars are at rest, it is quite easy to photograph them by available light. I found this scarce swallowtail caterpillar in France late one summer among the vegetation beside a field. It took me very little time to set up the tripod and attach a 55mm micro-Nikkor lens to the camera. The bold patterning of the handsome caterpillar makes it stand out clearly from the uniform, out-of-focus background.

Insects

The small size of insects, and the ease with which they can be bred in captivity, makes them suitable subjects for indoor animal photography. They also require less elaborate sets than do mammals. For example, you can take a straightforward portrait of a caterpillar feeding or a butterfly at rest on a small table, having placed the subject on a piece of plant, which can be supported in either wet sand or a florist's spiky base submerged in a jar of water. If the insect shows a tendency to fly away from the set toward a window, confine it temporarily inside a loose box until it settles. A loose box consists of an eight-inch-square wire, cube-shaped framework covered on five sides with transparent acetate. Cover the plant and the insect with the box, and focus the camera on the insect. If the insect settles on the inside of the box, instead of on the plant, flick it off from the outside. Sooner or later, it will land on the plant, whereupon you can gently remove the box before taking the picture.

Captive insects provide much better opportunities for taking extreme close-ups of anatomical details than do free insects. Indoors, you can control the lighting and carefully select the magnification. You may have to use a bellows extension to achieve images larger than life size on the emulsion.

Crawling insects can be photographed from below as they move over glass, or from above as they walk over a plain sheet of cardboard. If you prefer more naturalistic backgrounds, cover a tray with a layer of soil, leaves, or moss and photograph the insect from above.

Insects kept inside a spacious glass-fronted vivarium, with plenty of food, are much more likely to behave normally. For instance, grasshoppers and crickets will sing if their vivarium is on a sunny window sill, but they will remain inactive and silent if they are banished to a cool, dark corner of the room.

As a worthwhile project, try illustrating the entire life history of a butterfly or moth from egg, through caterpillar and pupa, to adult. Or you could take portraits of closely related species such as the beautiful hawkmoths, or attempt to show the variation in the shape of wing scales. A more ambitious project would be to take a series of pictures of flying insects, which would require an elaborate set-up including a light-trip beam and fast flash.

Walking on glass ▷
To illustrate the way in which an insect can walk up a window pane, I put a ladybug into a small, covered glass tank, having first placed a piece of white cardboard inside the tank at the back. I used two small flash guns, one on either side of the camera, angled in at about 45° to the front glass to light the underside of the ladybug. I attached a matte black mask to the front of the lens to eliminate all reflections of the camera in the front glass.

Breeding for perfection ▷
One way of obtaining
perfect butterflies and
moths for studio
photography is to breed
them. This white letter
hairstreak (*Strymonidia
W-album*) was bred by a
friend who brought it
round to my studio
before the butterfly was
ready to fly. Rather than
use flash, I decided to
photograph it by sunlight
streaming in through
the window.

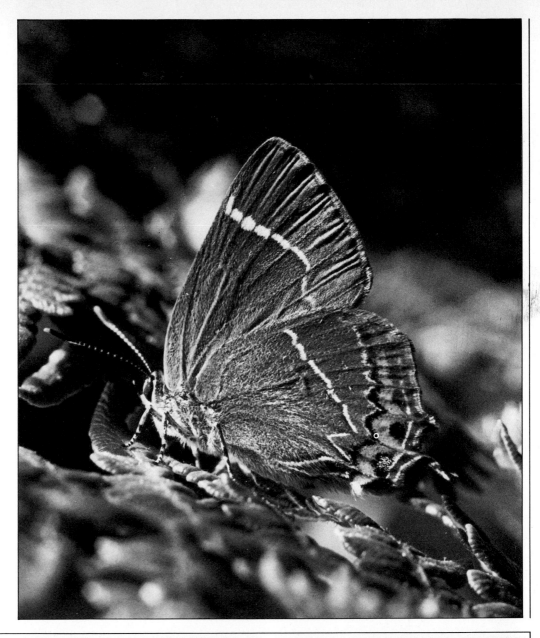

Butterflies in flight
These two pictures show a
green-veined white butterfly
(*Pieris napi*), which
triggered the camera and a
pair of high-speed flashes
by breaking a light beam. I
used the same set-up for
this as I did for the leaping
frog (p. 68), except that the
butterfly triggered the beam
as it flew head-on toward
the camera. I had no way of
knowing what would be the
precise wing positions until
after I had developed the
negatives, several of which I
had to discard because the
image was not sharp or the
wings were cropped.

Birds

With a combination of patience and knowledge of their habits, you will be able to take many worthwhile photographs of birds in the field without a hide, simply by stalking them or by reacting quickly to their behavior. All four of the photographs shown here were unplanned shots. Notice how I deliberately did not fill the frame with the birds, so that I was able to convey an impression of the habitat.

Because birds have excellent vision, I always look out for a rock or a shrub to use as natural cover when stalking a wary bird. Where there is no such cover, you will have to resort to alternately inching forward and "freezing". There is no ideal single lens for stalking birds, but usually a 300mm or 400mm lens is necessary for taking small individual birds, whereas shorter lenses, such as a 200mm, are adequate for taking colonies of sea birds or flocks of feeding waders. The advantage of lightweight mirror lenses with focal lengths of 500mm or more, is often counteracted by their fixed aperture, which can mean that you have to use a slow shutter speed in dull light conditions. Conversely, in good light and with static subjects, the lens cannot be stopped down to increase the depth of field. A motor drive will enable you to take sequences, showing a bird taking off or alighting.

A vehicle can often be used as a mobile hide, especially where a track runs close to fresh-water or the shore. You can lure birds close to the vehicle by baiting with food (p. 156) or by providing water during a drought.

Nesting seabirds ▽
Seabirds that nest out in the open will often tolerate a close approach, allowing the photographer to dispense with a hide. After making a very slow and careful approach, I took this pair of swallowtailed gulls in the Galapagos with a 150mm lens on the Hasselblad.

A lucky bonus △
I had just taken a few frames of an eel swimming over a rocky platform in New Zealand when this pied shag came down and grabbed the eel!

Stalking in the field ▽
I stalked my way slowly toward these carmine bee-eaters, which were nesting in a sandy riverside bank in Zambia, until I achieved this framing using a 400mm lens.

Using a vehicle as a hide △
As I was driving past a stream in Florida, I saw a Louisiana heron (*Hydranassa tricolor*) standing in the shallows. I stopped my automobile as quietly as possible, so that I could use it as a hide and photograph from the driver's open window. Before taking any pictures with a 300mm lens, I placed a bean bag on the bottom of the window frame (see the illustration above) as a broad-based support for the camera.

Birds

When birds are nesting, there is a fixed point to which they repeatedly return. This means that you can achieve sharp pictures once you have found a nest where, without drawing attention to it, you can erect a hide (see p. 154). You can then use a light-trip (see p. 156) set up across the flight path to photograph the adult birds as they come and go from the nest.

Most pictures of flying birds, however, are taken away from the nest. You will find no shortage of subjects if you begin flight photography from the cliffs above a breeding sea-bird colony. Mount the camera on a shoulder pod (see p. 83) and brace it against your body. Prefocus the camera, and pan it around, keeping the bird in the viewfinder. It is essential to use a camera with a pentaprism, otherwise the image in the viewfinder will move confusingly in the direction opposite to the subject; even with this method, only a few frames will be in focus.

◁ **Using a pylon hide**
I took this kestrel, peering out from its nest hole in a dead elm tree, from within a pylon hide. I was in the hide soon after first light and did not have long to wait before an adult returned with food for the chicks. Only after they had been fed did I release the shutter, which fired a pair of electronic flashes attached to the outside of the hide.

◁ **Panning for flight**
While I was sitting on a cliff top in the Galapagos, I noticed how the endemic swallowtailed gulls (*Larus furcatus*) repeatedly followed the same glide path. Having prefocused the camera, I was able to follow the gull's path by panning the camera in the same direction as the moving bird (see the illustration above).

A chance in a lifetime ▷
I doubt if I shall ever be able to repeat this perfectly symmetrical picture of a hawk hovering overhead taken with a standard 80mm lens on the Hasselblad! I was photographing some plants with this lens when the Galapagos hawk (*Buteo galapagoensis*) came right down to investigate me.

Mammals

You can photograph wild mammals either by stalking them or by baiting them into a chosen area in which you have set up a hide and perhaps a trip device (see p. 156). When stalking mammals, you will need a long lens and a shoulder pod and, if your camera does not have a matte black finish, it is sensible to mask any shiny reflective parts with black tape so that they do not warn a wary animal of your approach. If possible, wear camouflage clothing; otherwise, wear muted green or brown clothing, which blends in with the natural surroundings. Above all, avoid wearing or carrying anything that creates a noise as you move. Pale hands and face ruin the effectiveness of camouflage clothing, so it is a good idea to wear gloves and a balaclava, or darken them with burnt cork. Another solution, if it does not make you feel claustrophobic, is to crawl forward beneath a camouflage net, which will provide a perfect disguise.

There is no general guide as to how close you can come to mammals before alarming them. You will find that even individuals of the same species vary widely in their tolerance. It is a wise precaution to start photographing before the mammal shows any reaction to your presence, because it will probably sense your presence suddenly and flee. Many mammals have a well-developed sense of smell and so, before starting to stalk, check which way the wind is blowing, by raising a wet finger or by kicking dusty ground, and then stalk your quarry by approaching from downwind of it.

Many mammals are active at dawn and dusk when the available light is poor. If it is impractical to use flash, often the only way of achieving color pictures early and late in the day is by double rating the recommended speed of color film. Thus a 200ASA film is rated at 400ASA *throughout the entire film*. Make sure to check beforehand that the film can be "pushed", to mark the film accordingly, and to instruct the color-processing laboratory.

Photographing captive mammals in the studio does not provide even a fraction of the satisfaction gained from stalking a wild and free mammal. Moreover, it is by no means a quick and easy way of obtaining a picture. Creating an authentic set may take a whole day, and it may be several more days before a subject settles down in the set and behaves naturally.

Safety in a mobile hide ▷
While we were driving around Nairobi National Park in East Africa, I noticed that several vehicles had converged on one area. Looking through my binoculars, I saw that a pride of lions at a kill was the attraction, and so we also moved in for a closer look. The picture of a pair of lionesses lit by the late evening sun was one of the last of a series that I took, using a 200mm lens, from the safety of our vehicle. The color of the predators blends in perfectly with the dry grasses.

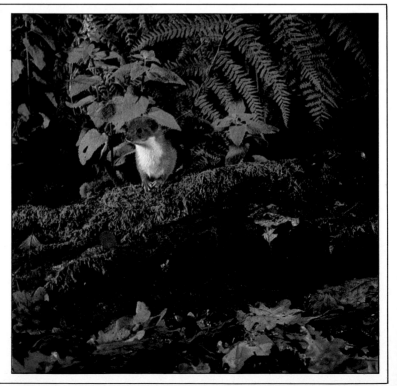

Arranging a studio set
To photograph a young weasel in a naturalistic setting in the studio, I made an enclosure (shown above) by first slotting a wooden rear wall and two side walls made of plate glass into wooden corner supports. Then I scattered some fallen leaves inside the enclosure before placing the mossy log in position and arranging the plants and ferns behind it. When the set was ready, I slotted in the front glass wall, making sure that it was spotlessly clean. I then introduced the weasel to the set and left him to explore his new surroundings. When he had settled down, I took several photographs by directing a pair of electronic flashes in through each side of the enclosure. As illustrated on p. 67, I attached a matte black mask to the front of the lens to eliminate reflections in the front glass.

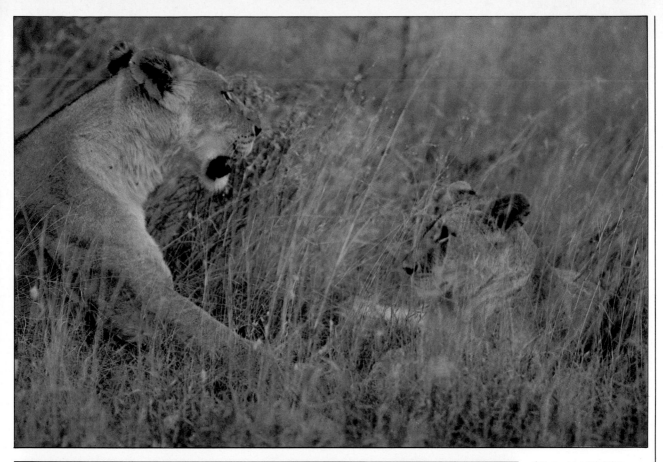

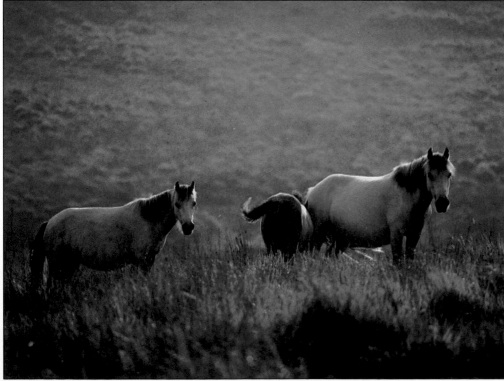

◁ **Natural backlighting**
I was driving through Brecon Beacons National Park in Wales late in the day when I spotted some ponies rim-lit by the low-angled sun. I quickly alighted from my automobile, attached a 200mm lens to the camera, metered the sunlight reflected off the vegetation by standing with my back toward the ponies, turned around, and then walked slowly up to them before taking the picture.

Mammals

Mammal photography that illustrates a facet of behavior is always more interesting than straight portraits, and some of the most appealing pictures of mammals are of mothers with their young. To achieve such pictures, knowledge about the mammal's life style, as well as fast reflexes, is essential.

When taking pictures of fast-moving mammals under changing light conditions, you will find that a shutter-priority single lens reflex camera, coupled with a motor drive, is invaluable: once you have set the required shutter speed of, say, 1/250 sec, the camera automatically selects the correct aperture for the right exposure.

Before attempting any night photography of mammals, it is worth first exploring the area by day for signs of activity such as an underground lair, frayed saplings, or paths that are used regularly. These are places to which mammals return repeatedly; therefore you can confidently prefocus the camera and arrange the flashes before darkness falls. The shutter can be released either manually, while you observe the mammal by a red light, or by a mechanical or infra-red trip, which the mammal itself triggers (see p. 156). Once the flash has been discharged, the animal will almost certainly be alarmed, and so it is unlikely that a second opportunity will occur on the same night.

Performing pets ▽
I transferred our pet gerbils from their plastic home to a plate-glass enclosure which had a single rock in the center. When one gerbil climbed on top of the rock, the others soon followed suit. I persuaded them to stand up on their hind legs by clicking my fingers above the top of the enclosure. I then took the picture, using a pair of electronic flashes, each positioned so that it shone directly in through either side of the enclosure.

◁ **A high vantage point**
I climbed part of the way up to a high seat in a tree (shown above) to photograph a chacma baboon foraging on a fallen fruit in a Zambian game park late one afternoon. The high vantage point not only gave me a different perspective on the baboons, but also kept my scent above sensitive mammalian noses. The backlighting helped to outline the baboon against its background.

Simplifying the background ▷
Having spotted a group of Coke's hartebeeste (*Alcelaphus buselaphus cokei*) on a mound in an East African game park, I drove the safari bus to a lower position, from where the hartebeeste appeared clearly defined against the sky. I hand held my Hasselblad, with a 250mm lens attached, to take the hartebeeste gazing quizzically down at me.

Amphibians and reptiles

Frogs, toads, lizards, and non-poisonous snakes might appear to be easier subjects for photography than insects because, being larger, they do not present the same depth of field problems. If you wish to take amphibians and reptiles in the field, however, you must first track them down. This is by no means easy, because many are cryptically colored (see p. 34) and blend in perfectly with their surroundings, and others are nocturnal and emerge only at night. One of the easiest ways of finding a frog or a toad is by homing in on their calls during the breeding season, although many nocturnal species will stop calling as soon as you shine a bright light at them. In the tropics, I have found it particularly rewarding to go out at night after the rains have begun to fall, when the night resonates with the croaking of frogs and toads. In temperate latitudes, it is temperature, rather than rain, that triggers spawning. If you visit a well-known breeding site at the right time of year, you will be sure to find frogs, toads, and newts, which return to the pond where they themselves were spawned. Amphibians do not always spawn in conventional ponds; some tropical tree frogs use the water trapped in leaf bases, whereas others carry their developing embryos around with them. Photographs of the complete life history of a frog or a toad can provide an interesting photo-sequence.

Reptiles, like amphibians, are cold-blooded animals which are unable to regulate their internal body temperature. Snakes and lizards are therefore most easily stalked as they bask early in the day before their cool bodies have had a chance to warm up and they become more active. Long-focus lenses are useful for photographing larger lizards, tortoises, and snakes; while a 105mm or 200mm macro lens is ideal for taking small frogs.

Background blur ▷
I spotted a chameleon walking across a brown dirt road in Madagascar, where its green body was no longer camouflaged. Making an emergency stop in my automobile, I gathered the chameleon up before it disappeared onto the green verge, and persuaded it to crawl up this plant. The weight of the chameleon's body bowed the stem toward the ground. I used a 135mm lens to give limited depth of field and so blur the background.

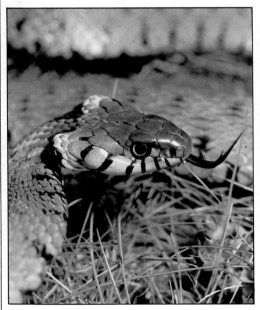

Freezing action △
This harmless grass snake (*Natrix natrix*) was photographed unconfined in the open. I used a single electronic flash to arrest the movement of the flicking tongue, "tasting" its surroundings, and to increase the depth of field. Such an action picture has more impact than does a shot of a coiled, motionless snake.

Studio portrait ▷
I took this head-on view of a Costa Rican flying frog (*Agalychnis spurrelli*), emphasizing its large eyes and broad mouth, in a studio using two electronic flash heads. The frog was kept moist in a covered, high-walled glass tank. An underside view of the same frog appears on the title page of each new section of this book.

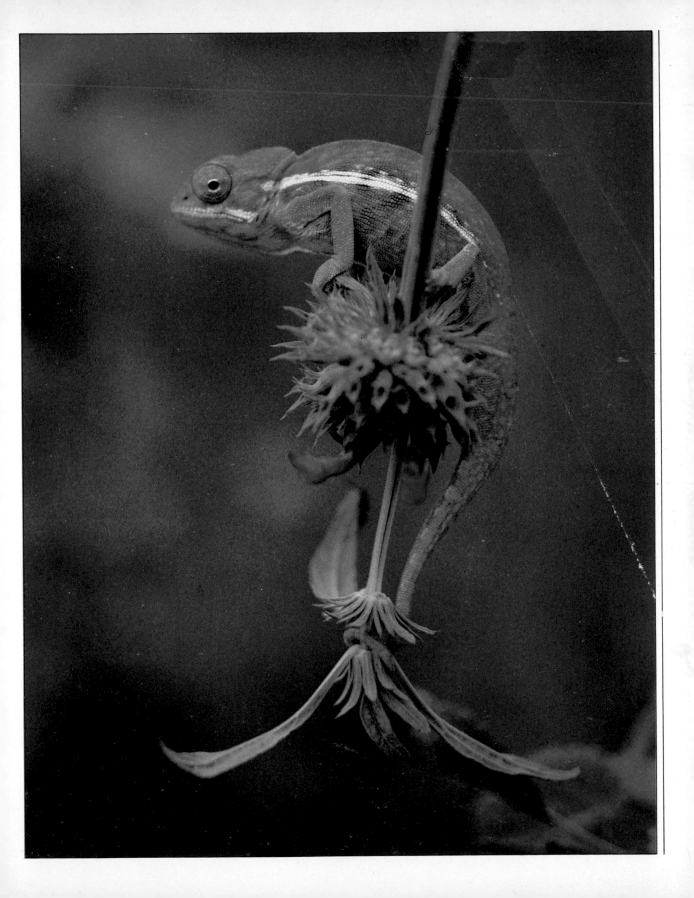

Amphibians and reptiles

Reptiles are not generally gregarious animals, and so opportunities for photographing large numbers of them together are rare. Exceptions include the Galapagos marine iguanas and giant tortoises, alligators in North American swamps, and young turtles scampering down the beach from their nest sites to the sea. Photography of these massed animals in their natural surroundings is possible using a standard or, on some occasions a wide-angle, lens. When using a short-focal-length lens, it is especially important to find a viewpoint from where any unsightly feature in the background does not appear distractingly in focus.

You can keep many types of amphibian and reptile quite easily in captivity, where you will be able to study them at leisure and learn to anticipate their behavior so that you will be able to take dramatic action pictures. Amphibians that breed in water or that spend most of their life underwater can be photographed in aquaria in which you have arranged stones and weeds beforehand. If you introduce a pair of newts to the aquarium during their breeding season, you may be lucky enough to get a sequence of pictures illustrating their courtship behavior. For reptiles and non-breeding amphibians, select a soil layer and natural props that look reasonably authentic; for example, a sandy floor for a desert snake, or a branch for a chameleon. Studio pictures are in no way substitutes for field pictures, but they can often complement them. Captive amphibians and reptiles also allow the photographer more time to select the desired magnification and the optimum lighting. You will find that, for amphibians in particular, flash is preferable to photoflood lighting, which generates too much heat. It may also be worth approaching a zoo for permission to photograph exotic species.

Tortoises in the landscape ▽
After spending a night camping in Alcedo Crater in the Galapagos, I set off to explore the floor of the caldera. Not far from my tent, I found these giant tortoises wallowing in temporary rainwater pools. Because the pools last for only a few weeks, timing is crucial for making sure of this unique setting. I took the picture with a wide-angle lens, so that I could include part of the floor and the distant rim of the crater as well as some of the vegetation. The backlit domed shells of the giant tortoises can be seen in the far distance.

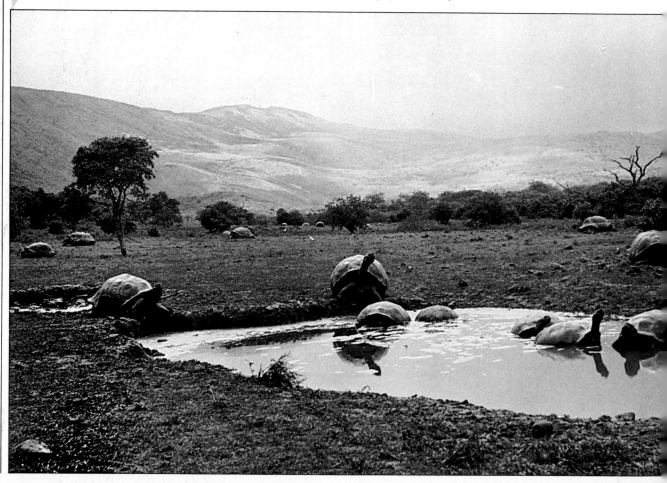

Analyzing movement

I took this sequence of a walking toad (*Bufo bufo*) in the studio as a series of separate frames. Before making any exposures, I watched the toad walking over the floor, to assess its speed. I then mounted the camera on a tripod, and prefocused it on a piece of wood the same thickness as the toad. I covered the floor with a large sheet of white background paper and released the toad on the paper. To eliminate any conspicuous shadow from the toad's body, I used overhead lighting from fluorescent strip-lights mounted on the ceiling. I used a shutter speed of 1/250 sec for taking a series of frames, from which I selected these three.

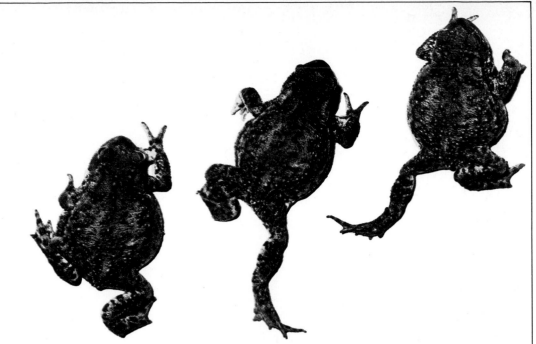

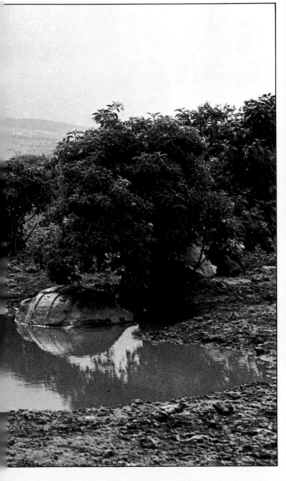

Using an aquarium to record breeding aquatic toads △
Because Surinam toads (*Pipa pipa*) live in tropical waters, I had to keep this pair in a heated aquarium. After several months they paired and began to spawn. The eggs laid by the female were fertilized by the male before they rolled toward the female's head, adhering to the spongy pad on her back. I used two electronic flashes to take this picture showing some eggs in position and the curious posture of the male clinging to the female from above.

Shooting into water

The most obvious way of photographing marine and freshwater life in its natural habitat is by submerging with a camera. However, this technique is not practical in shallow rock pools or in turbid muddy rivers, nor is it desirable for anyone who is not a skin-diving enthusiast. An alternative method, which can open up a new dimension in the photography of aquatic life, is to keep the camera out of the water and photograph down through the surface.

The water must be clear and its surface free from floating debris. You can use a small sieve to skim off unwanted seaweed fragments, but there is little you can do about any iridescent patterns caused by oil films on the surface. Surface ripples distort a subject below the surface (see pp. 28—9), so calm days without wind are ideal for rock-pool photography. On windy days you can avoid the problem of ripples by floating the camera inside a wooden or plastic frame floating on the surface. Or you can photograph through a glass-bottomed box, making sure that no air bubbles are trapped on the underside of the glass.

You will find it much more difficult to bring everything into focus in deep pools filled with many types of seaweed than in shallow pools that have a limited range of seaweeds and marine life. If you use a single lens reflex camera with a preview button, you will be able to see whether the sky is reflected in the pool surface when you stop down the lens. Eliminate any reflection either by holding a piece of black cardboard or a black umbrella above the pool, or by using a polarizing filter (see p. 91).

You can apply similar techniques to photographing into shallow sea water, ponds, streams, and rivers. In still freshwaters, you will find a polarizing filter invaluable for revealing submerged vegetation patterns. If the available light is low, or if you are taking a moving subject, use flash to boost the light level and also to arrest movement, making sure that the flash is held to one side of the camera so that it is not reflected in the water's surface

Playful behavior ▷
I spent some time watching a number of Galapagos fur seals playing in a grotto before I took pictures recording their antics. I used no filter, because the deep-blue sea water contrasted so well with the partially submerged brown bodies.

Taking close-ups through water
When photographing an Australian jellyfish at close quarters in shallow water, I used an electronic flash to freeze the movement of its bell. I held the flash to one side so that its reflection was outside the field of view. I used a different technique when taking a close-up of this shore fish, known as a blenny, lying well-camouflaged in a rock pool. A polarizing filter eliminated the gray surface and thereby clarified the view through the water.

Working underwater

The only way to appreciate the interactions of underwater life is to dive beneath the surface for brief periods with a snorkel, or for longer periods with scuba gear. You then enter a different world, a silent world of moving shapes and colors. To take underwater photographs, you will have to either enclose your camera in a watertight housing or use an amphibious camera such as the lightweight Nikonos. The latter is not a reflex camera, but you can interchange lenses or add close-up lenses, and can use it safely to a depth of 200 feet.

A specially designed soft, plastic bag with a circular glass window or porthole is available to provide adequate protection for any 35mm camera down to a depth of 30 feet. You operate the camera controls by inserting a hand into an internal glove. When diving to greater depths, you will have to use a more robust camera housing made from either rigid plastic or aluminum with the basic camera controls, such as shutter release and film advance, being operated by remote control. These more sophisticated housings allow you to focus the lens and make other adjustments underwater.

Even with an underwater camera you will not be able to achieve good photographs unless you are also able to determine the correct exposure. You will find it very difficult to view underwater the exposure reading of a camera with TTL metering; a separate light meter in its own housing is much easier to read. Before

making a dive, decide what film and lens you require because, once you have submerged, you will not be able to change either without resurfacing. Because light is refracted as it enters the water, the underwater photographic image appears about a third as large as it would if taken out of water, and so a wide-angle lens is often necessary.

Water currents can make it difficult for you to hold your body, and consequently the camera, steady enough to avoid a blurred image unless you use a fast shutter speed for pictures taken by available light. It will help to steady the camera if you can keep your body still by holding onto a rock.

Silhouettes for contrast ▷
When photographing a coral reef in black and white, you will find that colored animals are indistinguishable from the background reef unless you choose a viewpoint from where they are isolated against the sea water. To photograph the damsel fish, I used a Nikon camera contained in a watertight plastic bag specially designed for underwater photography (see below).

A contrasting sea bed ▷
Sedentary marine animals, such as this sea cucumber, which spend their life on the sea bed can only be photographed from a higher viewpoint, which gives no choice of background. Fortunately the dark sea cucumber contrasted well with the pale, sandy sea bed, as did the sea urchin behind it. I swam down very slowly, so that I would not stir up a cloud of sand.

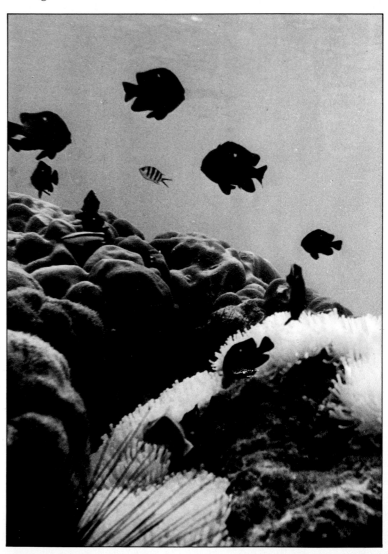

Coral close-ups

These two pictures
illustrate the graphic
images that can be
found in detailed close-
ups of corals. Coral with
its polyps partially
extended (right)
provides a very different
image than coral with its
polyps completely
drawn in and its surface
pattern revealed, as can
be seen on the brain
coral (far right). I took
both photographs in the
Indian Ocean using a
Nikonos with a close-up
lens and a Weston light
meter in a separate
underwater housing.

Working underwater

In clear waters, when the surface is calm and the sun is overhead, you should be able to take general underwater pictures satisfactorily using available light. However, you will find underwater photography impossible in turbid waters, whatever light you use.

Water acts like a blue filter and rapidly absorbs red light. Even at a depth of 10 feet, the red wave-lengths are reduced, and color photographs taken at greater depths have a bluish cast and lose contrast. You can counteract this problem in one of three ways: by photographing in very shallow water; by using a red color-correcting filter (20CC red to 50CC red, depending on depth); or by using flash. You can improve the color balance of underwater transparencies that have a bluish cast by copying them using a red color-correcting filter. When flash is used underwater, it reveals the true colors of aquatic life. Nowadays, electronic flash is used underwater in preference to flash bulbs, which have to be replaced after each

exposure. Underwater housings are available for conventional electronic flash guns, and there is now an automatic electronic flash with a remote sensor for the Nikonos camera. Flash that is triggered close to the camera will illuminate any particles suspended in the water to produce a snow-storm effect, which you can lessen by moving the flash away from the camera. For close-ups, however, when the lens-to-subject distance is much reduced, you can mount the flash on the camera — preferably on a flexible arm bracket. The close-up lenses attached to the front of the Nikonos lens enable you to change quickly from a distant to a close-up scene without surfacing, although you still have to use a field frame (see below right) for close-ups. You will find a single lens reflex camera with a motor drive and a macro lens useful for taking several underwater action pictures quickly. After emerging from a dive in the sea, be sure to wash your equipment in freshwater to remove the salt.

Submerging toward the reef ▽
I photographed fishes swimming among stag's horn coral while I was snorkeling in the warm tropical waters around the Seychelles in the Indian Ocean, where, even at the comparatively shallow depth of 20 feet, most of the red wave-lengths had been absorbed. Using a Nikonos camera, I metered the sunlight filtering down through the surface with a Weston light meter contained in its own watertight housing.

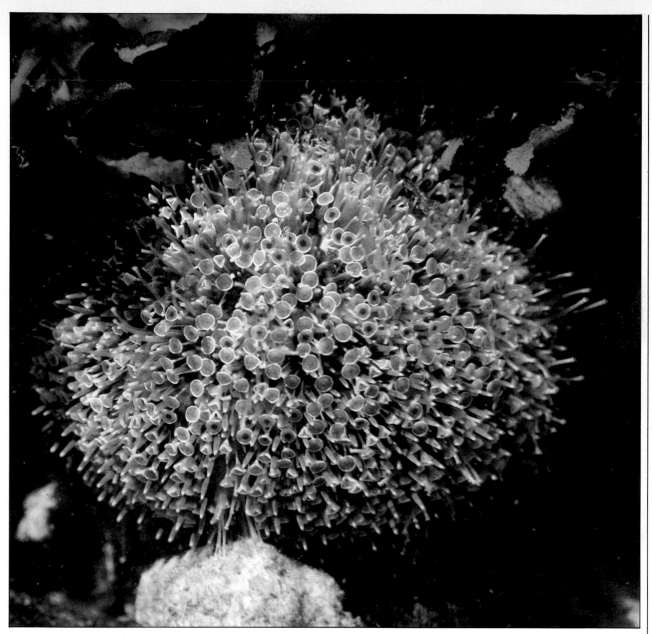

Using a close-up attachment △
In the shallow water inside the reef surrounding the
Seychelles, I photographed a poisonous sea urchin
(*Toxopneustes pileolus*) by attaching the large close-up
lens to the front of my Nikonos camera. As shown in the
diagram on the right, I measured the precise subject-to-
lens distance by placing the wire-frame viewfinder in the
same plane as the subject. The frame is ideal for taking a
relatively static subject such as this sea urchin, which was
attached to rocks only some 10 feet below the surface and
so could be lit entirely by available light. The stalked
structures with cup-like ends contain poison glands, which
can cause intense pain if they touch bare skin.

Public aquaria and wildlife parks

Although pictures of captive animals are rarely as satisfying as those taken by stalking in the wild, a photographic session in a zoo can be useful for trying out a new lens, and you may have more opportunities of achieving some good portraits using a medium long — 135mm or 200mm — lens. There are, however, many pitfalls involved in taking good zoo pictures. With the exception of walk-through aviaries with authentic plants, the animals' surroundings often appear unnatural. Although bars and wire mesh are now tending to be replaced by wet or dry moats, or glass walls, you must still look critically at backgrounds. Try to avoid including out-of-focus walls or buildings by looking down into an enclosure from a higher viewpoint, or by crouching to view tall animals such as giraffes from a low viewpoint.

Some zoos have glass observation windows through which you can photograph seals, turtles, and even sharks, swimming underwater. Eliminate reflections by holding the lens against the glass, or by attaching a matte black mask to the front of the camera.

Only by visiting a zoo several times will you discover when certain animals are most responsive or when an enclosure is best lit by available light. Take heed of all warning notices and always be sure to ask permission before using flash in aquaria.

A naturalistic background ▽
Because bears are often housed in pits at zoos, the photographer is usually restricted to a high viewpoint, looking down at the subject, with the bottom of the pit as the background. When a polar bear sat on a rock above a pool in Regent's Park Zoo, London, I was able to photograph it against the dark water. The dull lighting was more effective than sunshine in highlighting the texture of the bear's fur.

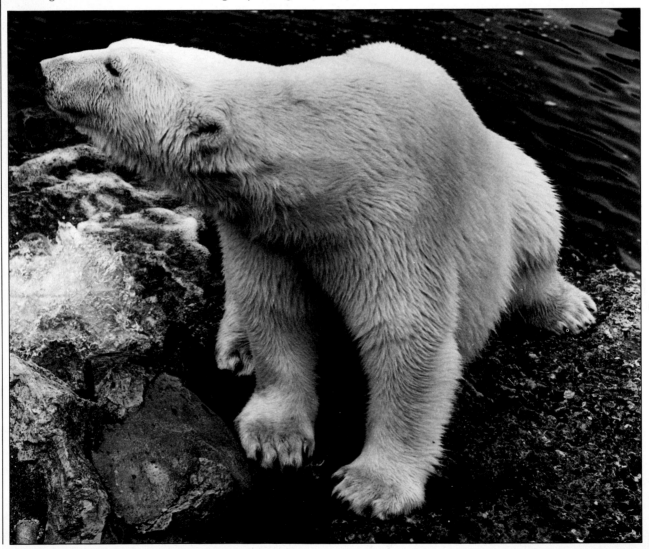

Working with wires
I used no special technique to photograph a sarus crane inside a wired enclosure at a wildlife park (top). I then moved closer and pressed the long lens of my camera against the wire mesh. The crane had moved away from the fence, and so I used a wide aperture to throw the mesh out of focus (above).

◁ **Shooting through glass**
A pair of young orang-utans cavorting in a zoo caught my eye. Because of poor light, I had to load the camera with Tri-X, which allowed me to use a shutter speed of 1/250 sec and to stop the camera down, so that both animals were sharply defined. To eliminate any distracting reflections, I pressed the camera against the front glass of the enclosure. The weathered concrete floor provided an ideal background for a monochrome reproduction of the dark-haired mammals.

Lighting a marine aquarium △
I particularly wanted to show the head shape of the bizarre-looking sea horse, with its elongated, trumpet-like mouth and the disruptive radiating lines surrounding its eye. I used an electronic flash both to boost the lighting and to freeze any movement. The proprietor of the aquarium kindly allowed me to remove the top cover of the sea horse's large tank, so that I could direct the flash down through the water to separate the sea horse from the distant unlit background.

Dandy display △
The magnificent courtship display of a blue peacock must
be one of the most colorful and best known of any bird.
Each feather in the train ends in a bright eye spot, and
some of the feathers are as much as six feet in length. I
took the picture in a wildlife park, using a 135mm lens to
make a deliberately tight crop for added impact to the
starburst effect of the radiating eye spots.

APPENDIX

Working in the garden

Never spurn your own garden as a location for taking nature photographs. Recording the wildlife there season by season can make a very worthwhile project, and the garden will provide you with an inexhaustible supply of both plant life and animal residents particularly suitable for close-up work. Among the visitors to your garden you may find bees, butterflies, amphibians, reptiles, birds, and mammals, which move in to feed or perhaps even to breed. The size of your garden, as well as its range of micro-habitats, will determine the variety of animal species that live in or visit it.

As well as providing food for birds in winter, you can encourage birds to nest in the garden by putting up nest boxes. Time and effort spent attracting birds to the garden, however, will be fruitless if you use insecticides, which will kill their food supply, or if there is a resident cat, which will scare them off.

Before you position a bird bath or bird table as a focal point for photography, find a suitable place in which to conceal yourself because, except in the depths of winter, wild birds will not tolerate a close approach in the open. If you do not have a hide, use a tool shed, a garage, a car, or even the house, as a ready-made hide. Glass must be clean if you intend to photograph through it, and you will have to mask out reflections in the glass (see p. 67). Camouflage yourself and your camera by pulling curtains across the window and poking the lens through the center slit. Once you have selected a position, look critically at the background, because a house, even when out of focus, can ruin a nature picture.

If you prefer to photograph birds against a more naturalistic background, erect a perch on which they can alight as they come and go from the bird table. If you are really dedicated, you could also plant berried shrubs in strategic positions. Ivy berries provide food for birds in summer, while the flowers provide nectar for wasps and butterflies (see p. 120) in fall. Night-flying moths are attracted by strongly scented flowers, such as *Nicotiana* and honeysuckle, while a saucer of milk set out regularly will entice small animals.

◁ Attracting butterflies
Butterflies can be attracted into the garden by food plants grown for them or their caterpillars. If you are prepared to leave a clump of stinging nettles in a corner of the garden, you will be providing food for peacock, small tortoiseshell, and red admiral caterpillars. Butterflies themselves are attracted to highly scented flowers rich in nectar. Among the flowers that are most attractive to butterflies are michaelmas daisies, lavender, and — best of all — buddleia, or the butterfly bush.

◁ Attracting birds
You can attract birds to even the smallest of gardens by providing a bird bath and a daily ration of food in winter. Instead of throwing food scraps onto a patio or a path, make them into a pudding mixture with lard, nuts, and seeds and pack it into an empty coconut shell. You can also hang up a string of peanuts or pack shelled nuts into holes in a log. If you hang these feeders on a branch just outside a window, you will be able to photograph foraging birds through the open window. The upturned lid of a garbage can provides a ready-made bird bath, although you will have to either sink it into the ground or prop it up with bricks. In cold weather, keep the bath ice free.

◁ Attracting wildlife
If you site a pond away from the house, it will attract shy birds and perhaps other animals to drink. Position a rock in the pool for small birds to use as an island when drinking. If there are fishes, or breeding amphibians, in the pond, you may have to cover it with wire netting to protect them from predators. Dragonflies and other winged insects that develop in water may deposit their eggs in the pond. A wall nearby will provide a screen for photography and a home for snails, woodlice, spiders, and beetles, which will serve as a food supply for birds and amphibians.

Planning a field trip

Whether you are contemplating a half-day's stroll in a local nature reserve, or a three-day trek along a mountain trail, it is sensible to plan a field trip in advance.

Researching the site
If you are setting out to photograph a particular plant or animal, you will have to discover the precise location as well as the best time of year for photographing it. While you may be able to glean some of this information from books, especially field guides, you will also do well to make contact with a regional natural history or conservation society. They will be able to put you in touch with somebody local, perhaps a ranger or a warden, who will then be able to tell you whether you require a permit to visit a reserve and also whether the season is early or late — information that can affect the timing of your trip. When I am working to a tight schedule, I cannot afford to spend time traveling to a location, only to find that I am too early or too late, or that the weather is impossible for photography. I owe an enormous debt to wardens and rangers, who can give me accurate on-the-spot information over the telephone. When I have no local contacts, I have to rely on the meteorological office.

I have been keeping records, over a period of 10 years, of my first annual sighting of a plant in flower or an insect on the wing, and it is surprising how the calendar varies for my own region of Britain alone. Do not forget that, if a plant has finished flowering in one locality, you can sometimes find it by driving farther north in the northern hemisphere or farther south in the southern hemisphere. If alpine plants are past their best, you may find them in flower at a higher altitude, where spring comes later.

Using maps
Once I have decided on the location, I buy as detailed a map as possible. Whenever I can, I try to use large-scale maps when I am driving, which show the roads, forests, waterways and areas of open water, cliffs, dunes, high- and low-water marks, and national parks as well as the elevation in 50 foot contours. If I want to photograph a flat area, I scan the map for any nearby high ground that will provide me with a higher viewpoint. When I am walking, I prefer to use even more detailed maps, on which coniferous and deciduous forests are differentiated and streams are marked. Intelligent map-reading can tell you a great deal about an area before you even set foot in it.

Making a check list
Once you have decided where to go, make a check list of the photographic and other equipment that you will need. I have a basic list (see p. 151), to which I am able to add if I am using the car or a field station as a base. If I am making an overnight trek, I prune down the basic list so that I have room for camping gear, food, and water. When making any trip to the mountains, I always carry a compass and emergency rations, because mountain weather can be so unpredictable. I also make sure to inform someone of my route and estimated time of arrival.

You will find a small tape-measure useful in the field for taking measurements of plant specimens, which you can record either in a field notebook or on a pocket tape-recorder. Take a hand-lens with you too, for examining anatomical details of plants, and a whistle, to be used only if you lose contact with a companion.

The nature photographer and the law
Ignorance is no defence. You should always be aware of the laws of the country in which you are taking nature photographs. For example, in Britain, any person who wishes to photograph at or near the nest of a rare breeding bird on the Schedule 1 List must first gain approval from the Nature Conservancy Council. For some of the rarest species, approval will not be given. Similarly in Iceland, photography of certain birds at their nests is prohibited without a permit from the Ministry of Education on the basis of a recommendation by the Bird Protection Committee. In many countries, it is now illegal to collect certain rare wild plants and animals. There are also legal restrictions on the exportation and importation of rare species.

Accessories for fieldwork

When I am working in the field, it is often a small accessory that helps me to achieve the desired picture. As well as checking my cameras and lenses, I therefore make quite sure that such accessories are also in my backpack. Indeed, when I am packing for an overseas trip, I leave nothing to chance and now always methodically work my way through a check list. The items illustrated below are those that I have found most useful. I keep most of these items permanently in my backpack. I also carry a field notebook, plastic bags, an aluminum reflector, a muslin diffuser, a tripod, and bush adaptors for converting the 3/8 inch continental socket to the standard 1/4 inch size. I sometimes include a compass, a pair of clippers, a light to help me focus the camera in dark locations, a white flash umbrella, and wire or string for tying back foreground branches.

Other equipment I carry only when I plan a particular type of photography in a certain location. For plant photography, I may use a plant clamp (see p. 104) ; a clear plexiglass windshield ; or a rope ladder for a high viewpoint. A large sheet of plastic is useful when you want to take a photograph while kneeling on wet sand in winter ; alternatively, individual knee pads, usually sold as gardening equipment, will protect knees on rough, rocky terrain. Remember to carry a towel to dry corrosive sea water off wet hands or equipment.

When I photograph active insects in the field, or any small animals moving in a dark forest, I use the boomerang-shaped bracket with the twin flashes illustrated on p. 112. When taking landscape pictures, you will find a spirit level essential for making sure of straight horizons. Many heavy-duty tripods have a built-in spirit level, as

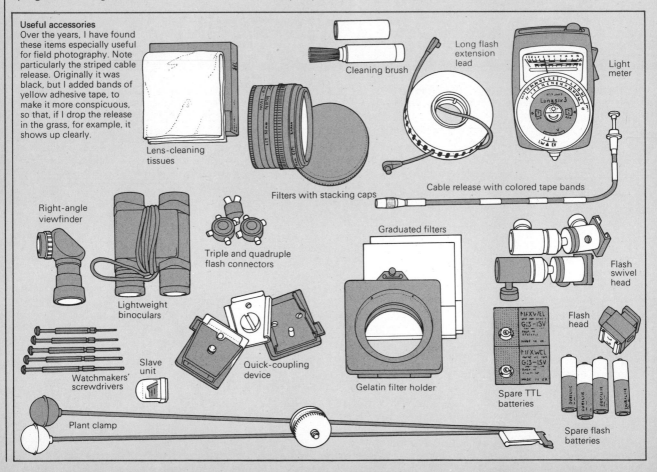

Useful accessories
Over the years, I have found these items especially useful for field photography. Note particularly the striped cable release. Originally it was black, but I added bands of yellow adhesive tape, to make it more conspicuous, so that, if I drop the release in the grass, for example, it shows up clearly.

Lens-cleaning tissues

Cleaning brush

Long flash extension lead

Light meter

Filters with stacking caps

Cable release with colored tape bands

Right-angle viewfinder

Lightweight binoculars

Triple and quadruple flash connectors

Graduated filters

Flash swivel head

Flash head

Watchmakers' screwdrivers

Slave unit

Quick-coupling device

Gelatin filter holder

Spare TTL batteries

Spare flash batteries

Plant clamp

does the Hasselblad Superwide camera. A special small level can be clipped onto the side of other Hasselblad cameras, while a small model with a standard flash-shoe base can be clipped onto the top of any 35mm camera with a flash socket.

You can mount your camera on a tripod very easily by using a quick coupling device, sometimes known as a "quick shoe"; this consists of two parts, one of which is screwed onto the camera and the other onto the tripod, so that one slides into the other and clicks into a locked position, which can be released only by depressing a lever. This device allows you to interchange quickly different makes of camera on a tripod, although it is not necessary for the Hasselblad, which has an interchangeable film back.

I find some special-purpose lenses invaluable in the field, particularly macro lenses, perspective-correcting lenses, and teleconverters. If you are interested in close-up photography of any subject, a macro lens is a wise investment. I use my 55mm micro-Nikkor lens more than any other lens in my 35mm system. When I need a larger working distance, as for example when stalking butterflies, I use the 105mm or the 200mm micro-Nikkor.

Reflectors are such lightweight accessories that they can be permanently retained in a backpack or a photographer's waistcoat. I use a thin, silver-coated survival blanket, which can be stowed into its 6 inch × 4½ inch pouch, and a 19 inch-diameter Lastolite white reflector, which doubles up as a diffuser. A small hand-mirror can be useful for reflecting a beam of sunlight onto a fungus or a flower in a dark woodland. To cast a shadow behind a flower or a grass spotlit by sun, use either a survival blanket or a heavy waterproof that does not flap around.

Keep your exposed films as cool as possible in hot weather. A double-layered cooler box, with a frozen freezer pack, will keep films cool all day, although it is too heavy to be practical unless you are working from a vehicle. In humid climates, film must be kept both cool and dry, so it is worth carrying an airtight sandwich box with a layer of dry (blue) silica gel crystals on the bottom.

◁ Macro lenses
The three macro lenses illustrated here are the 200mm f4, the 105mm f4 and the 55mm f2.8 micro-Nikkor. Each has an inbuilt extension, which allows for continuous focusing from infinity to half size. Because they are designed to produce high-quality close-up images, they do not produce such well-defined landscape pictures as conventional lenses of the same focal length.

◁ Perspective-correcting lenses
The unique shift mechanism of the lens optics enables converging verticals, obtained by tilting the camera, to be corrected without using an expensive and cumbersome view camera. Now available for many 35mm SLR systems, the first PC lens produced was the 35mm f2.8 PC-Nikkor lens.

◁ Teleconverters
Teleconverters are inserted between the prime lens and the camera to increase the focal length of the lens. Cheap teleconverters reduce the image quality of a good lens and they may also produce vignetting of all four corners of the frame. Converters designed to match lenses of specific focal length, however, produce high-quality images. Like all converters they reduce the amount of light reaching the film.

◁ Lastolite reflector
A circular reflector made in two sizes (19 inch and 40 inch diameter) which twists up to fit into a circular pouch. As soon as the outer wire is untwisted, it springs into a circle rigid enough to be held in one hand or propped up against a natural support.

Foil reflectors △
Aluminum cooking foil wrapped over hardboard makes a cheap reflector.

Ewa-cape rain cover △
A rain hood, made from transparent PVC, which covers the camera.

Dressing for the field

Before contemplating even a single day's trip into the field, spend some time thinking about what to wear and how to carry your gear. It is important to be comfortable, so that you can concentrate fully on finding subjects and photographing them. Very little clothing has been designed with the photographer specifically in mind, but much of the outdoor clothing sold for backpackers and mountaineers is equally suitable for photographers.

When you are working in cold weather, it is essential to be warm all over. It is no good putting on layers of sweaters, yet having frozen hands or feet. On your feet, tough walking boots are best for gripping wet rocks, but if you are wading through deep water, rubber boots or waders will keep your feet dry, albeit not very warm. For making short trips in snow along well-defined tracks, double-layered après-ski or "moon" boots will keep your feet warm. The only way to move around in deep snow, however, is by wearing snowshoes or skis. When working at altitude or on snow, I put glacier cream on my face to prevent it from burning.

When out on field trips in hot weather, however, you will find that cotton clothing is preferable to that containing man-made fibers because it absorbs sweat. Wear a wide-brimmed hat, to keep the sun off your face, and loose-fitting, long-sleeved shirts and long trousers as a protection against thorny shrubs and insects, as well as against the burning rays of the sun. In arid, open regions, desert boots are sensible footwear, and in rain forests, three-quarter-length jungle boots act as a barrier against snake bites.

When stalking animals in the open, you will find that an outer layer of camouflage clothing helps you to blend in with the natural surroundings and thereby move in closer to a wary subject. You will cover a wider terrain more easily if you restrict your equipment to the bare minimum. However, if you are a general nature photographer who, like me, tackles any subject, you may have occasion to regret leaving even one lens behind.

The weight of your equipment will dictate the means by which you carry it in the field, but remember that aluminum

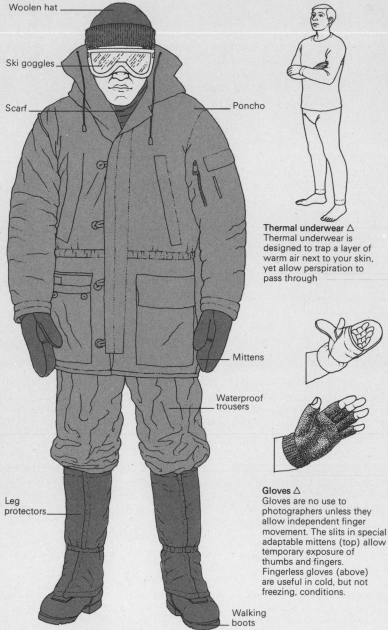

Woolen hat

Ski goggles

Scarf

Poncho

Mittens

Waterproof trousers

Leg protectors

Walking boots

Thermal underwear △
Thermal underwear is designed to trap a layer of warm air next to your skin, yet allow perspiration to pass through

Gloves △
Gloves are no use to photographers unless they allow independent finger movement. The slits in special adaptable mittens (top) allow temporary exposure of thumbs and fingers. Fingerless gloves (above) are useful in cold, but not freezing, conditions.

Cold-weather clothing △
When working in a cold location, always wear a hat or a woolen balaclava, a waterproof poncho over a quilted parka, a scarf, waterproof trousers, and boots with non-slip soles. Waterproof leg protectors over trousers and boots prevent snow, sand, or gravel from packing down into the boots. If you do not have a pair of adaptable mittens, wear a pair of fingerless gloves beneath ordinary mittens. Carrying your camera around your neck beneath your parka will help to keep the battery warm. When walking over snow, wear ski goggles to protect your eyes from the bright glare.

◁ **Photographer's vest**
Anglers' multi-pocketed vests have recently been adapted for photographers. Made in cotton, nylon, or quilted material, their advantage over a backpack is that equipment carried in them is more accessible. Larger pockets will take a motorized camera or lenses, while small pockets are useful for separating films, lens hoods, and a cable release.

Shoulder pack ▷
A shoulder bag with internal pockets, which can be adapted into a backpack, provides a flexible gadget bag for a limited range of items.

◁ **Backpack**
Most serious photographers use a strong backpack with padded inserts to cushion heavy items when carrying a wide range of equipment safely and comfortably over any type of terrain. Some have straps (shown left) for securing a tripod, as well as several small outside pockets for easy access to individual lenses and accessories.

Holster ▷
A pair of holster packs on a belt will allow you to change quickly from one complete camera or lens system to another when taking action pictures.

◁ **Kidney-shaped pouch**
The kidney-shaped pouch that is worn strapped around the hips by skiers is a convenient receptacle for a small range of photographic equipment, when you are climbing or cross-country ski-ing.

cases are quite impractical for carrying any distance. Below I have listed the basic 35mm outfit and accessories, which I carry to any location for speculative photography, together with the weight of each item. To save weight, I always remove films from their cardboard containers. If I am flying to a location, I even remove the films from their plastic containers so that I can carry four rolls of 35mm film in the plastic box in which slides are usually returned from processing; this system also makes it easy to identify the film type. I much prefer to use lenses with a fixed focal length, but you can cut down on weight by replacing two or three lenses with a zoom lens. You may well come across other ways of carrying equipment, for example, in a fisherman's vest or a gardener's belt. With any pack, you must know precisely where each item is stowed.

Basic field kit

Item	Weight
35mm SLR + 50mm f1.8 lens + lens hood	2lb 6oz
20mm f4 lens + lens hood	9oz
35mm f2 lens + lens hood	11oz
55mm micro-Nikkor lens + extension tube	15oz
135mm f3.5 lens	15oz
200mm f4 lens	1lb 4oz
400mm f5.6 lens + case	4lb 7oz
Right-angle viewfinder	2½oz
4 filters with pair of stacking caps	4oz
gelatin filter holder + filters	1½oz
Cable release	1oz
Miniature screwdrivers	1½oz
8 36-exposure films in 2 boxes	8oz
Silver reflector	3oz
Muslin diffuser	2oz
Benbo tripod + Gitzo head	8lb 8oz
Vivitar 283 flash + extension lead	1lb 3oz
Spare TTL batteries	1oz
Leitz Trinovid binoculars	7oz
Field notebook, pens, lens tissues, lens brush, and plastic bags	6½oz
Total weight	23lb 4oz

Supporting the camera

The majority of blurred images that have been focused correctly are the result of camera movement rather than subject movement; indeed a slow shutter speed can be used deliberately and creatively to blur an image (see pp. 46–7).

If you are using short-focal-length lenses, or there is plenty of available light allowing a fast shutter speed, a camera support is not essential and may even be a hindrance to the occasional "grab" shot. However, if a camera support is necessary, and you have not brought one into the field with you, you can always resort to bracing the camera with your body, by taking up one of the poses shown below.

The advantages of a sturdy tripod are many. Not only will it prevent camera shake, especially when you are making long exposures, using long lenses, or taking close-ups, but it can also help you to compose the picture. I have used the versatile Benbo tripod for 10 years and very much doubt that I shall ever come across a better tripod for working in any habitat or on any terrain. It is illustrated (right) standing in the conventional position on flat ground, but the drawings on pp. 38, 54, 91, and 97 show some of its other possible positions. When the single lever is unlocked, the telescopic legs can be moved freely into any position up to, and beyond, the horizontal. The center column can also be moved independently.

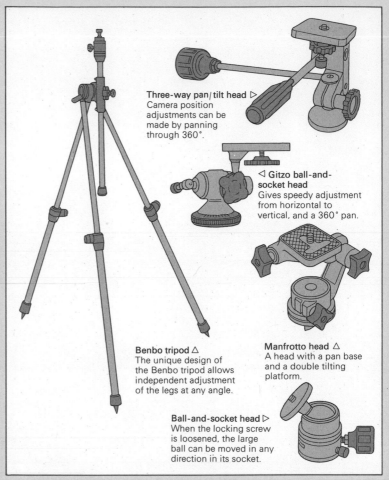

Three-way pan/tilt head ▷
Camera position adjustments can be made by panning through 360°.

◁ **Gitzo ball-and-socket head**
Gives speedy adjustment from horizontal to vertical, and a 360° pan.

Benbo tripod △
The unique design of the Benbo tripod allows independent adjustment of the legs at any angle.

Manfrotto head △
A head with a pan base and a double tilting platform.

Ball-and-socket head ▷
When the locking screw is loosened, the large ball can be moved in any direction in its socket.

Body supports ▷
When stalking an active animal, you are unlikely to have time to erect a tripod, but you can steady the camera using your body as a support. An upright position will give you less stability than if you squat, kneel, or lie prone like a rifleman. The latter works only if there are no plants or rocks impeding your view of the subject. With practice, you will be able to hand hold a camera with a long lens at a shutter speed slower than the reciprocal of the lens focal length; for example, 1/125sec or 1/60sec for a 300mm lens.

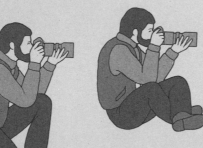

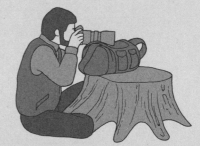

Using objects as camera supports △
You can support the camera on any nearby object that is a convenient height, such as a rock, a fence post, a tree trunk, or even the hood of an automobile. A soft gadget bag placed on any of these supports can be molded to fit the base of the lens in the same way that you can mold a bean bag on a window frame (p. 125). You can also help to support your body, when holding a camera with a long lens, by leaning against a tree trunk (p. 80).

Once you have found the desired position, you lock the legs and the center column into that position by tightening the lever. Even when the locking lever is tightened, the center column, with the camera attached, can still be slid backward or forward through a retaining collar without the position of the legs having to be altered. When the center column is arranged in a horizontal position, it can then be moved toward or away from the subject rather like a focusing slide. The sealed ends of the outer leg tubes safely allow you to push them into mud or water. Because the tripod can be used in even the most awkward positions, I tend to use it for a large proportion of my photographs, to produce as crisp an image as possible.

I use a Gitzo ball-and-socket head on all of my Benbos (when photographing birds from a hide, I also use one for each of my electronic flash heads) because it can be adjusted very quickly. I have always preferred to use a head without long lever controls, which are only a hindrance when one is bending over the tripod to focus the camera for low-level work.

Some tripods have a reversible center column which allows you to attach the camera to the bottom, instead of the top, of the column for low-level photography in the field, but it may be difficult to maneuver yourself into a position from which you can view easily through the camera.

In addition to tripods, there are many different kinds of camera support now available. Those illustrated on the right represent a good range of types, all of which I have tried myself. I rate the shoulder pod or rifle grip as most useful for long-lens work and the ground-spike and table-top tripods best for low-level close-up work. A variation on the ground spike is the spiky base illustrated on p. 87. The pistol grip and the hand grip provide more stability than is to be gained by simply holding the camera in the hand, especially if they have a built-in cable release. Before selecting a camera support, it is important to assess its capabilities and its limitations. A flimsy tripod can be a liability, but if you are prepared to carry a good, sturdy model, it will amply reward you by improving the quality of your pictures.

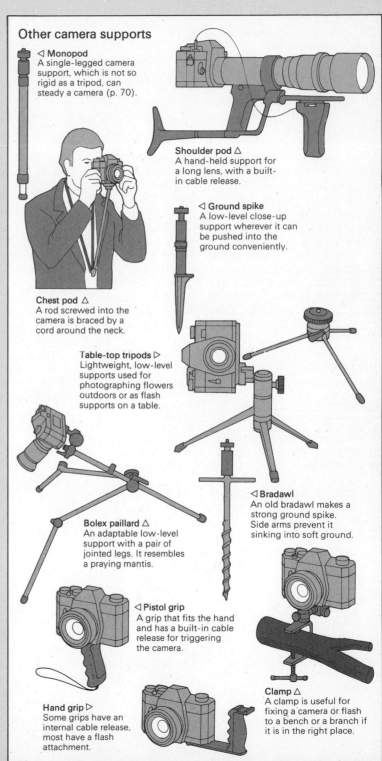

Other camera supports

◁ **Monopod**
A single-legged camera support, which is not so rigid as a tripod, can steady a camera (p. 70).

Shoulder pod △
A hand-held support for a long lens, with a built-in cable release.

◁ **Ground spike**
A low-level close-up support wherever it can be pushed into the ground conveniently.

Chest pod △
A rod screwed into the camera is braced by a cord around the neck.

Table-top tripods ▷
Lightweight, low-level supports used for photographing flowers outdoors or as flash supports on a table.

◁ **Bradawl**
An old bradawl makes a strong ground spike. Side arms prevent it sinking into soft ground.

Bolex paillard △
An adaptable low-level support with a pair of jointed legs. It resembles a praying mantis.

◁ **Pistol grip**
A grip that fits the hand and has a built-in cable release for triggering the camera.

Hand grip ▷
Some grips have an internal cable release, most have a flash attachment.

Clamp △
A clamp is useful for fixing a camera or flash to a bench or a branch if it is in the right place.

Using a hide

If you wish to photograph animals at close range — especially birds at their nests — you will have to work from within a hide. The size and the structure of hides vary considerably, but they are all designed to enable bird watchers and photographers to come much closer to wildlife.

Permanent hides
Permanent hides are now a feature of many nature reserves and parks, where they are accepted by wildlife as part of the landscape. The interiors of permanent hides vary from an empty shell with open slits in the walls for viewing the animals to centrally heated hides with double-glazed picture windows. Personally, I prefer hides that have viewing slits rather than glass windows (which are rarely spotlessly clean), a ledge beneath each slit (on which I can lay out my lenses), and a bench to make lengthy sessions comfortable.

Mobile hides
A vehicle, especially if it has four-wheel drive, makes a good mobile hide when you want to photograph game in parks or birds, in fields or on water, beside the road. If you use an automobile, you will not be restricted in the weight of equipment you can take into the field. I prefer to photograph from the back seat, with all my lenses spread out around me, so that I can work from either side of the vehicle, using a bean bag (see p. 125) to steady a hand-held camera, or setting up a Benbo tripod inside the vehicle. Always switch off the engine before taking photographs.

Birds that frequent areas adjacent to a road will accept the presence of a car without question but, if you have driven off the beaten track, it may be necessary to cover the car with a camouflage net. Strung up between a pair of saplings, a net also makes a very useful instant screen when you are stalking on foot. A camouflaged boat is an effective mobile hide in wetland areas; while a hot-air balloon allows you to obtain a bird's eye view as you drift silently above any kind of habitat.

Portable hides
Most bird photographers use a nest as the focal point when erecting a temporary hide, yet you can also position a hide away from a nest at a baited area (see p. 156) or on the shore above high-water mark, where waders will be pushed up by a rising tide. Ground hides should be lightweight (especially if they have to be carried some distance from an automobile) yet strong enough to withstand wind and rain.

Before erecting any hide, take great care to make sure that the hide itself does not draw attention to the nest. Set up on open ground, a hide will act like a signpost, directing a natural predator or an egg-collector to the nest. It is always best to work well away from public footpaths.

You may have to locate several nests before you find one suitable for photography. If you have had to tie back some branches for a clearer view, you must return them to their original positions afterwards. Birds will not accept an instant hide close to their nests, so you must either erect the hide some distance away and move it in toward the nest each day, or gradually increase its height on the final site. After each stage, retreat to check through binoculars that the birds have accepted the hide and are returning to the nest. If this is not the case, you should either move the hide farther back or dismantle it. Once the hide is completed, you may find that a bird will not accept external flash or even a lens. If so, dummy flash heads, and the end of an empty bottle simulating a lens, can be set up farther off and gradually moved in.

It is best to approach a hide for a photographic session with a companion who then departs. This will fool the birds into thinking that the intruders have left, and so they will then settle down more readily. Before entering the hide, make sure that you have all your equipment and films, as well as food and drink, because you should not emerge until your companion has returned at a predetermined time. Once in the hide, you will be able to view the birds by lifting up viewing flaps adjacent to the camera. Even when birds have accepted your presence in a hide, they may still be disturbed by the noise of the shutter release or a motor drive. You can reduce noise by using a padded cover or blimp, which is rather expensive.

Camouflage net
When stalking out in the open, or sitting in a tree, you can drape a camouflage net over your body and camera as an improvised and very portable hide. For the net to be fully effective, you will have to wear green or brown clothing which merges with the net and, if necessary, tie some branches to it. Make sure that the net does not flap in the wind and keep as still as you possibly can.

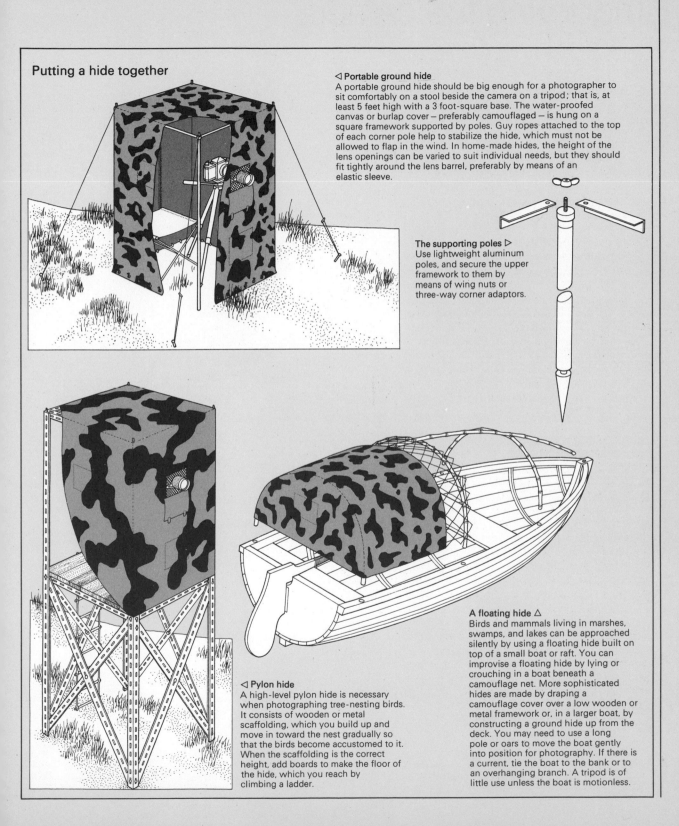

Putting a hide together

◁ Portable ground hide
A portable ground hide should be big enough for a photographer to sit comfortably on a stool beside the camera on a tripod; that is, at least 5 feet high with a 3 foot-square base. The water-proofed canvas or burlap cover — preferably camouflaged — is hung on a square framework supported by poles. Guy ropes attached to the top of each corner pole help to stabilize the hide, which must not be allowed to flap in the wind. In home-made hides, the height of the lens openings can be varied to suit individual needs, but they should fit tightly around the lens barrel, preferably by means of an elastic sleeve.

The supporting poles ▷
Use lightweight aluminum poles, and secure the upper framework to them by means of wing nuts or three-way corner adaptors.

◁ Pylon hide
A high-level pylon hide is necessary when photographing tree-nesting birds. It consists of wooden or metal scaffolding, which you build up and move in toward the nest gradually so that the birds become accustomed to it. When the scaffolding is the correct height, add boards to make the floor of the hide, which you reach by climbing a ladder.

A floating hide △
Birds and mammals living in marshes, swamps, and lakes can be approached silently by using a floating hide built on top of a small boat or raft. You can improvise a floating hide by lying or crouching in a boat beneath a camouflage net. More sophisticated hides are made by draping a camouflage cover over a low wooden or metal framework or, in a larger boat, by constructing a ground hide up from the deck. You may need to use a long pole or oars to move the boat gently into position for photography. If there is a current, tie the boat to the bank or to an overhanging branch. A tripod is of little use unless the boat is motionless.

Triggering the camera

You can photograph wild animals, which will not tolerate a close approach, from a hide (see pp. 154–5) or by triggering the camera by remote control. Many otherwise wary subjects will accept an unmanned camera on a tripod, especially those with a matte black finish or with all shiny parts masked by dark tape.

A motor drive or an auto winder is preferable for remote-control photography; otherwise you will cause unnecessary disturbance by returning to the camera to recock the shutter.

Prefocusing the camera

Whatever method you choose to fire the shutter by remote release, you must prefocus the camera on a spot to which the subject is likely to come. When birds are breeding, the nest is the point to which the adults return throughout the day. Similarly, mammals that live underground will emerge to forage above ground. You can attract both birds and mammals into a specific area by baiting with food or by providing a water supply during a drought.

Baiting

Baiting is more rewarding during times of food shortage than when food is plentiful. Indeed, during prolonged periods of snow and frost, it is possible to entice many birds to bait without the need to take cover. Before selecting an area to bait, look around for signs of activity, such as tracks or droppings, frayed saplings, or damaged shells or pine cones. You will then get some idea of what kinds of bird and animal naturally frequent the area and will therefore not waste time putting down unattractive bait. For example, grain attracts seed-eating birds and small mammals; nuts attract squirrels, an old fish head never fails to bring gulls to the seashore, and a road corpse, such as a rabbit that has been hit by a car, will tempt a magpie or any other scavenger. Place any artificial bait in such a way that it will be scarcely discernible in the photograph. For example, bait the crevices of an old weathered tree stump with fat or nuts.

Try to position the bait so that you can observe it through binoculars from behind a rock or a tree. If there are no convenient

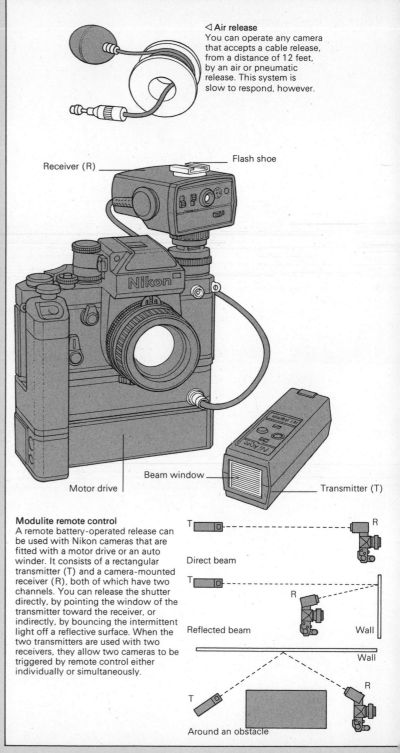

◁ **Air release**
You can operate any camera that accepts a cable release, from a distance of 12 feet, by an air or pneumatic release. This system is slow to respond, however.

Receiver (R) — Flash shoe

Nikon

Motor drive | Beam window — Transmitter (T)

Modulite remote control
A remote battery-operated release can be used with Nikon cameras that are fitted with a motor drive or an auto winder. It consists of a rectangular transmitter (T) and a camera-mounted receiver (R), both of which have two channels. You can release the shutter directly, by pointing the window of the transmitter toward the receiver, or indirectly, by bouncing the intermittent light off a reflective surface. When the two transmitters are used with two receivers, they allow two cameras to be triggered by remote control either individually or simultaneously.

Direct beam

Reflected beam — Wall

Wall

Around an obstacle

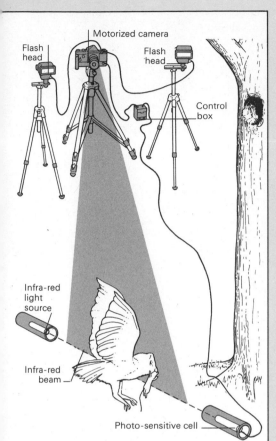

Photo-electric beam △
When a visible light beam or an infra-red light beam (for nocturnal animals) falling on a photo-detector is broken by a bird or bat flying, or a mammal walking, through it, an electronic circuit is activated which fires the camera shutter and the flashes.

◁ **Mechanical trips**
A trip wire (left) and a pressure plate (below) are devices by which the subject itself triggers the camera remotely. The animal pulls the wire taut or stands on the pressure plate, causing a pair of contacts to touch and complete the electrical circuit, which triggers the camera shutter and the flashes.

natural hides, erect a hide at some distance from the baited area or string up a camouflage net between two posts.

Triggering by the photographer

The simplest way of remotely triggering a prefocused camera is by using a long air release (right), although I prefer to use an 80-foot-long electronic release attached to a motor drive, because this responds much more quickly.

Motor-drive systems can also be triggered remotely using a modulated pulse system (up to 200 feet), an infra-red beam, or radio control (up to 800 yards in open areas). The main disadvantage of the pulsed-light trigger is that the hand transmitter must be very accurately aligned to ensure that the beam reaches the "eye" of the receiver.

A radio-control system, which also consists of a transmitter and receiver, requires no such alignment and can be used over much greater distances — even in built-up areas — than the pulsed-light system. However, the use of CB radios, which have become increasingly popular, can cause the camera to be fired prematurely. Before using a radio-control release, you should make sure it is legal.

Triggering by the subject

You can achieve pictures of a shy mammal, without going to much expense, if you set up a trip wire or a pressure plate, linked to a camera, at a baited area. A more sophisticated technique, and the only one that will give you high-quality photographs of animals in mid-flight, is a photo-electric trip beam set up across a known flight path or track. Because there is always a slight delay after the beam has been broken and before the camera shutter is activated, the camera has to be prefocused slightly beyond the beam to allow for the time-lapse. High-speed flash is essential for arresting all movement and boosting the light level, so that you can stop down the lens to increase the depth of field. If you use a pair of crossed light beams, the subject will be even more precisely in focus and framed within the field of view, because the camera is triggered only when the subject breaks the beam intersection.

Tele-flash △
A tele-flash attachment — a concave mirror positioned behind a backward-directed flash — is a very useful accessory for reflecting and concentrating the light beam of any basic flash unit onto nocturnal animals when photographing them with a long lens. Some electronic flash guns now have inbuilt variable zoom settings, including one for long lenses, which matches the beam of light with the angle of view of the lens.

Close-up equipment

The wide price range of 35mm single lens reflex (SLR) systems has brought close-up photography within the reach of most people. By simply adding a close-up lens, or inserting extension tubes between the lens and the camera, you can view the precise framing and focusing of a close-up directly through the camera itself. Yet close-up photography is often fraught with problems for the beginner. A moving subject or an unsteady camera, combined with a slow shutter speed, are likely to cause blurring with close-ups. Insufficient depth of field can result in the subject's being only partly in focus, and incorrect exposure is a common problem when extension tubes or bellows are used either on a camera that has no TTL metering or with flash. As with all aspects of photography, there is an initial trial-and-error period, which you can minimize by viewing each frame with a critical eye and keeping careful notes.

Using the equipment

Basic close-up techniques for nature photography in particular are outlined on p. 70. Close-up photography begins when the image size on the film is reproduced at a magnification of 1/10 (X0.1) life size, and extends through to life size reproduction (X1). Macrophotography covers magnifications from X1 to X10, although the maximum image of a so-called macro lens (see p. 149) used without any accessories is only X0.5.

When extension tubes or bellows are inserted between a lens and the camera body, the magnification is a function of the amount of extension (expressed in millimeters) and the focal length of the lens (also in millimeters), which means that you can increase the magnification with any lens by inserting more extension tubes, or by racking out the bellows extension. You can also increase the magnification by using a lens of a shorter length. For example, when 50mm of extension is used with a 50mm lens, the magnification is X1; whereas with a 28mm lens it is X1.5 but the lens-to-subject working distance is reduced. Therefore, when taking close-ups of active insects in the field, you would be better advised to use a lens with a longer focal length, which will give you a greater working distance.

For a given amount of extension, the longer the focal length of the lens, the smaller the magnification. The amount of inbuilt extension of a macro lens will therefore vary with the focal length of the lens. Both the 105mm and 200mm macro lenses have to be racked out much farther than does the 55mm macro lens in order to

Close-up lens △
A lens which is attached to the front of a camera lens to provide an even closer focusing range.

Extension tubes △
Positioned between the lens and the camera body, they can be used in combination or singly in order to enlarge the image.

Macro lens △
Specially designed for close-up work, with a built-in extension to which extra tubes can be added.

Reversal ring △
Used to connect a lens in its reverse position to the camera body, thereby allowing for greater magnification.

Bellows △
Positioned between the lens and body, a bellows unit provides a greater magnification than extension tubes.

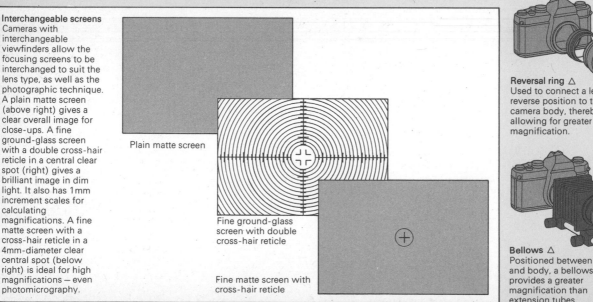

Interchangeable screens
Cameras with interchangeable viewfinders allow the focusing screens to be interchanged to suit the lens type, as well as the photographic technique. A plain matte screen (above right) gives a clear overall image for close-ups. A fine ground-glass screen with a double cross-hair reticle in a central clear spot (right) gives a brilliant image in dim light. It also has 1mm increment scales for calculating magnifications. A fine matte screen with a cross-hair reticle in a 4mm-diameter clear central spot (below right) is ideal for high magnifications — even photomicrography.

Plain matte screen

Fine ground-glass screen with double cross-hair reticle

Fine matte screen with cross-hair reticle

produce the same magnification at full lens extension (X0.5). Your choice of close-up accessory will depend on the magnification you require on film, which may itself be determined by the subject size.

Splitfield lens

If you wish to illustrate a flower's habitat and you do not have a wide-angle lens suitable for photographing a foreground flower in its setting, try using a splitfield lens. This consists of half a close-up lens inside a full lens mount. When used with a standard lens focused on infinity, the two lenses function as one bifocal lens, with the half lens magnifying a sharply focused foreground subject, and the lens focused on infinity keeping the background in focus in the upper half of the frame. At the same time, you will have to use a small aperture to blur the demarcation line between the two halves of the picture.

Reversing the lens

You can increase the magnification of a standard or a wide-angle lens by attaching it back to front to the end of extension tubes or bellows by means of a reversal ring. At magnifications of greater than XI, lens reversal will help to improve the definition of the image. When a lens is used in the reverse position, however, the automatic diaphragm and the meter coupling no longer function. The lens becomes automatic once more if you attach a special double cable release to the open rear end of the lens and to the shutter release on the camera.

Supporting the camera

A rigid camera support will improve the definition of any close-ups taken with available light. In addition to the Benbo tripod illustrated on p. 152, a variety of low-level supports are available (see p. 153). The versatile Swedish Combi-stat will enable you to maneuver the camera into a variety of positions fairly close to level ground, but you cannot compensate for uneven terrain by locking the legs into a variety of positions as you can with the Benbo. In the studio, an overhead copying stand makes a solid camera support for taking close-ups from above.

A Close-up lens

B 55mm macro lens

C Standard 50mm lens with extension tubes

D Standard 50mm lens with bellows

E Bellows with 35mm lens (X1 to X4.5)
Bellows with 24mm lens reversed (X4.5 to X10)

Magnification scale ▷
A variety of different magnification ranges that can be achieved with a 35mm SLR camera is shown on the scale on the right (key given above). Each of the five photographs of goat willow catkins (far right) was taken at a different magnification, indicated by a line linking it to the scale.

Vintec ▽
When a 35mm or a 6cm × 6cm camera is attached to a Vintec micro-drive platform, it can be shifted precisely by two separate 8cm-long, 1mm-graduated, traverses, one operating laterally and the other back and forth.

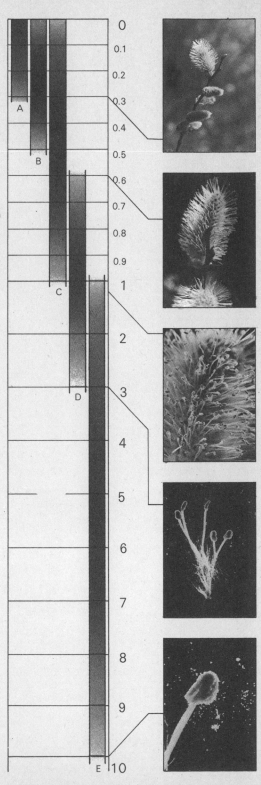

Planning a studio

Some purists may well argue that all nature photographs should be taken in the field by natural light, but such a dictum limits the time available for photography and reduces the number of potential subjects. Provided that you remove no rare animals or plants from their natural surroundings and look after all captive subjects before returning them to their own patch, studio sessions can usefully supplement field photography. I regard studio photography as an opportunity for revealing small features and hidden details, not immediately apparent in the field, by careful control of light sources and backgrounds. As I much prefer working outdoors, I do most of my studio work in the evenings or during bad weather.

A huge, expensively equipped studio is not essential for indoor work. Any room, or part of a room, will do. Because my studio is a separate building at the bottom of my garden, I tend to gravitate toward part of my large kitchen during the winter months. The illustration on the right shows my studio, which measures 12 feet by 16 feet. The design incorporates features gleaned from working in many much smaller areas as well as in large research laboratories. Because no two nature photographers use identical techniques or, indeed, enjoy taking the same subjects, it is unlikely that my studio will satisfy everyone's needs. Hopefully, it will provide a basis, which you can modify to suit your individual requirements. My studio is quite separate from my darkroom, but you may prefer to have one leading into the other.

The way you equip your studio will depend on what subjects you intend to photograph there. Relatively small subjects, such as flowers, fruits, shells, fossils, insects, amphibians, reptiles, fishes, aquatic life, and small mammals, are most suitable for studio photography. If you want to do aquarium work, one of the first essentials is a solid table on which to stand the aquarium. The weight of the water alone in a tank measuring 8 × 8 × 12 inches is 23lb. My own studio resembles a small laboratory with 36-inch-high benches permanently fixed around most of the outer walls. These allow me plenty of room for maneuvering aquaria and lights, and I am able to position the tripod legs beneath them, which means that I can bring the camera right up to a subject at the edge of the bench when taking close-ups. If there is enough room, it is a good idea to set a sink into a bench, because a ready supply of water is essential for cleaning glassware and preventing cut plant specimens from wilting. In addition to the benches, I have a free-standing table which I can move about in front of background colored paper rolls, depending on the size of the subject and the lighting required. I always keep a few other background props such as rocks and

Insect breeding cage △
A clear, flexible, plastic sleeve – with an aluminum base and perforated lid – allows you to keep a constant check on the insects and their food.

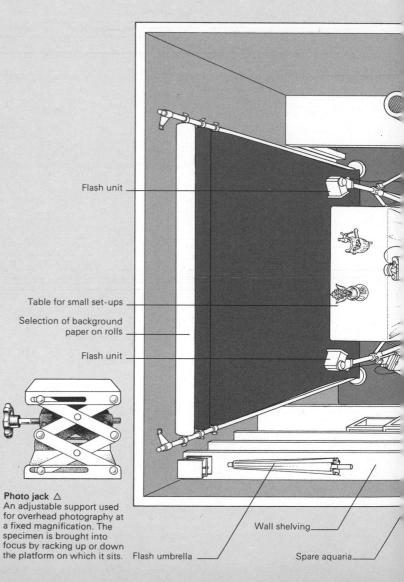

Flash unit

Table for small set-ups

Selection of background paper on rolls

Flash unit

Photo jack △
An adjustable support used for overhead photography at a fixed magnification. The specimen is brought into focus by racking up or down the platform on which it sits.

Flash umbrella

Wall shelving

Spare aquaria

branches for vivaria, and a supply of washed sand and gravel for aquaria, which I store in plastic garbage cans. A pegboard is useful for hanging up beakers and funnels, and I also have a trolley on which stand a number of plastic containers, holding films, small flash guns, spare flash heads, spotlights, reflectors, and filters and which can be moved quickly from one part of the studio to another.

When setting up a cold-water aquarium in the studio, be sure not to position it where direct sunlight can reach it. Many marine invertebrates in particular behave abnormally when the water temperature is raised more than a few degrees above that of sea water. For the same reason, when any animals that live in cold climates are housed in a studio, you must take care not to heat it above the temperature of their natural surroundings. Conversely, tropical fishes, amphibians, and reptiles must always be kept warm.

The most useful light sources for nature photography tend to be much smaller than those used by portrait or commercial photographers and they are described in some detail on pp. 162–3.

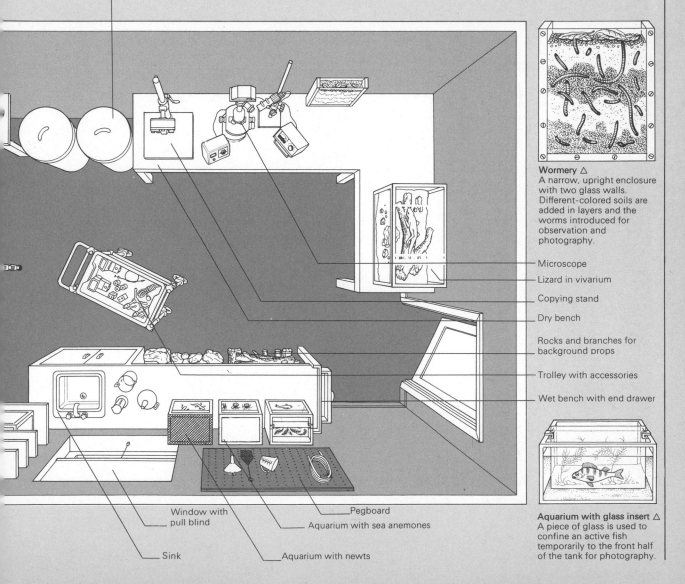

Garbage cans with sand and gravel

Wormery △
A narrow, upright enclosure with two glass walls. Different-colored soils are added in layers and the worms introduced for observation and photography.

Microscope

Lizard in vivarium

Copying stand

Dry bench

Rocks and branches for background props

Trolley with accessories

Wet bench with end drawer

Window with pull blind

Pegboard

Aquarium with sea anemones

Sink

Aquarium with newts

Aquarium with glass insert △
A piece of glass is used to confine an active fish temporarily to the front half of the tank for photography.

Special lighting

Within a studio you have the opportunity of selecting the lighting and the background for each subject. This means that photographs of plants or animals taken under such controlled conditions should be technically superior to field shots. Otherwise it is not worth the trouble of arranging a set and lighting, because studio portraits can never attempt to match the authentic setting of a location shot.

Large floodlights are generally unsuitable for a nature photographer's studio; they generate too much heat for delicate specimens and, because they provide a continuous light source, they cannot be used to freeze action. For these reasons I favor using electronic flash in the studio; the heat it generates is negligible and the duration of the flash — 1/1000 sec or less — is brief enough to arrest most, though not all, movements of aquatic life, insects, amphibians, reptiles, and mammals. If you are alternating short studio sessions, using electronic flash, with fieldwork, you can use daylight color film in both cases. When using flashes, it can be useful to exchange them temporarily for flexi-armed bench lights to boost the light while you focus the camera and preview the lighting effect.

When you buy a flash system, bear in mind that it may have to double up for use in the field as well as in the studio, and so it will be more economical in the long run to buy a model which can be recharged. If you are working in an improvised studio that has no electricity, you will have to resort to either disposable alkaline or rechargeable nickel cadmium (nicad) batteries. You will, of course, need electricity for recharging the nicads, which are more expensive than disposables, but the additional expense, including the cost of the battery charger, will be a long-term saving.

Manual flash guns are cheaper than automatic models, but they are also much less versatile. Most auto guns have heads that allow you to adjust the angle of tilt; some vary the angle of the beam depending on the focal length and angle of view of the lens. Auto flash guns adjust the light output either by varying the flash duration or by varying the power of the flash. Some automatic guns are too powerful for close-up work, unless you can reduce their light

Fiber optics ▷
For precise spotlighting of small static specimens, such as plants, fossils, or shells, fiber optics are ideal. They provide an intense but totally cold light, which does not damage delicate live plant material. Exact positioning of the concentrated light source is possible because of the flexible arms surrounding the fiber bundles. I photographed the portion of paua shell reproduced on p. 28 using a single fiber optic. As with all continuous light sources, you can view the effect of the light and shadows directly through the camera.

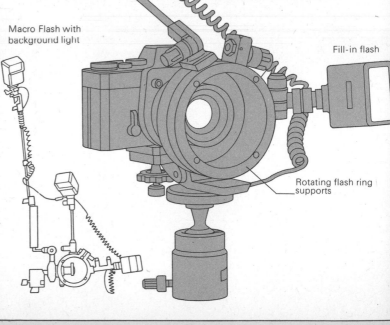

Main flash

◁ **Macro Flash**
The Macro Flash is a versatile piece of equipment, consisting of two or three flashes, for close-up photography using a 35mm single lens reflex camera and a macro lens, or a standard lens with extension tubes. Two flashes are mounted independently on adjustable arms clipped to lockable rings which can be rotated around the lens axis, allowing you to change the direction and angle of each flash quickly. A third flash can be added if you want to illuminate the background.

Macro Flash with background light

Fill-in flash

Rotating flash ring supports

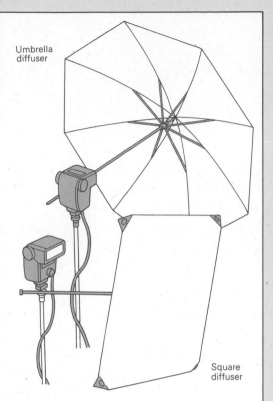

Umbrella diffuser

Square diffuser

Diffusing the light ▷
A soft diffuse light can be produced by bouncing a flash or a photoflood off a white or silvered umbrella, or by directing light through a muslin diffuser. You can light small subjects by enclosing them in a white, translucent, faceted Balcar diffuser (top right) or a white plexiglass cone (bottom right) and shining a direct light source through from outside. A cone diffuser is particularly useful when photographing shells or fruits with a high gloss.

◁ A continuous spot
A tungsten halogen spotlight provides a bright narrow-beamed continuous light useful for photographing shells and fossils. For color work, you will have to use artificial-light color film.

output. You should also check the recycling time of the flash, which may be 10 seconds on a manual gun and 2 seconds on an auto gun, and make sure that it has a synchronization cord connection, which allows you to use the flash detached from the camera.

To light large aquaria or vivaria, I use two or three large flash guns, whereas for close-ups I prefer to use small guns to which I attach black paper collars so that I can direct the light precisely. The Macro Flash has its own bracket, to which the camera is attached, and the whole set-up can then be supported on a tripod and the individual flash positions adjusted to suit each subject. Some alternative means will have to be found for securing other flash guns. I use either lighting stands or Benbo tripods, each topped with a ball-and-socket head with a flash shoe.

You can fire two or more flashes simultaneously by plugging their flash synchronization leads into a multiple flash adaptor on the camera. A much neater method involves using a slave unit for triggering several cordless flash guns. As it reacts to the light of the main flash, the slave unit fires the other guns.

When trying out a new lighting set in the studio, I check the exposure by making an instant color print, using the Polaroid back on my Hasselblad. If you intend doing much work with flash in the studio, however, it is probably worth investing in a flash meter.

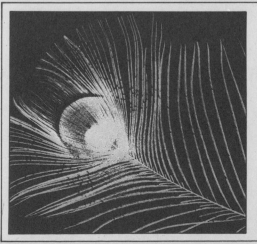

Photograms
It is possible to make a simple photographic image, known as a photogram, without using a camera by shining a light onto an object resting on photographic print paper in a dark room. You can use an enlarger light, or any rigid-point light source above the paper for this purpose. Leaves, cones, and feathers are the most suitable subjects for nature photograms, because they are shown in greater detail than they would be in a normal photograph. When you develop the print, the image appears white on a black background.

Organizing a slide collection

If you take nature photography seriously, you will gradually build up a large collection of slides, possibly varying widely in subject matter. Sooner or later, you will have to come to a decision on how to catalog and store these slides.

Viewing your slides

Before you decide which storage method will suit you best, it is essential to have some means of viewing your processed transparencies critically. Film that is returned in cardboard or plastic mounts can be projected, and then you can reject any transparencies that are not sharp or have been incorrectly exposed. Using a projector, however, you will not be able to make direct comparisons between two or more frames when viewing each slide individually, whereas a light box will allow you to view and quickly compare exposures with the naked eye.

You can make your own light box from an old drawer or by cutting a hole in a bench top, as long as you make sure to ventilate the box. Use only fluorescent light tubes that have the correct color temperature for daylight viewing and cover the hole in white opaline glass or plexiglass to diffuse the light.

I use a light box when examining both my mounted Kodachrome 35mm slides and my unmounted Ektachrome $2\frac{1}{4}$ square transparencies. To detect any scratches on the film emulsion caused either in the camera or during processing, however, I have to view each frame critically with a X12 magnifier.

Before mailing films for processing, I mark the address labels with the film's reference numbers. As soon as they are returned, I go through each film very quickly on the light box and transfer each reference number from the address labels to the containers, marking also a brief outline of the film contents so that, if necessary, I can trace a film quickly before I have cataloged the slides. All the transparencies in this book have been viewed critically many times on a light box.

Choosing a storage system

The permanent storage system you choose for your slides will depend on how you intend to use them and how often you will want to retrieve them. The most important criteria of any system are that your slides are protected and can be found quickly.

The most simple system, which will involve you in no additional expense, is to keep the slides in the film box in which they were returned from processing. Many people who do just this house the film boxes in a metal or wooden cabinet with

Abodia cabinet

Hand viewer

Linen tester

Light box

Circular projector

◁ **Viewers**
The simplest way of viewing individual slides – through a hand viewer or a linen tester – is not practical when you want to compare the quality of several slides. You can view a complete film quickly by loading it into a slide tray and projecting it slide by slide. I view all of my slides – both when they are returned from processing and before I use them – on a light box with a magnifier. I store my slides in an Abodia cabinet, which houses a total of 5,000 35mm slides on 50 metal racks and contains its own light source. As the central doors are opened, they activate the light behind the rear opaline screen. You can view a complete rack of 100 slides at any one time by pulling it across to the center of the cabinet in front of the screen.

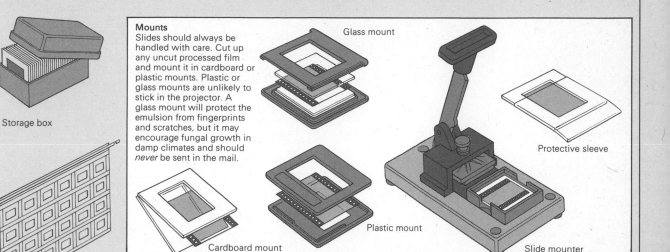

Storage box

Hanging sheet

Circular slide tray

Mounts
Slides should always be handled with care. Cut up any uncut processed film and mount it in cardboard or plastic mounts. Plastic or glass mounts are unlikely to stick in the projector. A glass mount will protect the emulsion from fingerprints and scratches, but it may encourage fungal growth in damp climates and should *never* be sent in the mail.

Glass mount

Protective sleeve

Plastic mount

Cardboard mount

Slide mounter

Storage △
Slide-processing boxes make the least expensive containers. Plastic sheets, which can be hung in a filing cabinet by means of a metal bar, or are ready punched for filing conveniently, allow you to handle, store, and view slides of all sizes. If you are going to project your slides frequently, you will save time by sorting and storing them ready for projection in a slide tray, preferably one that has a plastic dust cover.

shallow drawers, which allow them to see at a glance the contents of each box. You will be able to see immediately whether an entire film is present, or a box is full if you have previously drawn a diagonal line, with a colored felt pen, across the top of the mounts. Any break or irregularities in the line will show that slides are missing or in the wrong order.

You may wish to keep the slides filed consecutively as they were taken, and simply list each frame in a book or file under date. Or you may decide to store all pictures of a single group together, for example, flowers in one drawer, insects in another. If you aim to use your slides primarily to illustrate lectures, you can sort them into separate lecture sets and store them in film magazines. However, this method requires a large amount of storage space, and is quite expensive.

Plastic sheets, known as viewpacks, are available with individual slide pockets. These can be hung in a filing cabinet or stored in a ring binder, and have the advantage of allowing you to view quickly several 35mm slides at a time. They also require less storage space than do slide trays or grooved boxes. I can fit 210 sheets, or a total of 5040 35mm slides, in one drawer of a filing cabinet. Because 35mm slides fit tightly into the viewpack pockets, it is possible to scratch slides as you insert or remove them. A wise precaution therefore is always to cover each

slide with a clear protective sleeve before putting it into the pocket of the viewpack.

The most professional method of storing slides is in a special cabinet with its own light box, which either pulls out as a sliding drawer or is contained at the back of the cabinet, as in the Abodia cabinet.

Classifying and cross-referencing
As well as deciding how to sort your slides, you must also devise some means of classifying and cross-referencing them. Most simply, you could file the slides alphabetically under the subjects' common names. Or you could classify them under their scientific names, not in alphabetical order, but grouped into their natural classifications. By using a recognized flower or bird check list for a particular region or country, you can mark up each genus in numerical order and then enumerate each species within the genus, so that you have a two-number reference, say 67/4, which is unique for that species. Separate frames can then be designated a number or a letter — for example, 67/4/1, 67/4/2 . . . or 67/4/a, 67/4/b . . . Before a slide is filed away, I make sure that it is fully captioned with the subject's common name, its scientific name, the location, and any interesting biological behavior noted. I then cross-reference it under each name and subject category so that anyone, at any time, will be able to locate a particular slide.

Index

Acknowledgments

Many people have helped in the production of this book and I would especially like to thank the Dorling Kindersley team, who made the whole project so enjoyable. In addition, thanks go to the many people who attended my photographic field courses armed with a variety of novel gadgets, some of which are illustrated in this book. I would particularly like to thank Gordon Dickson for his plant clamp and Ed Slater for his boomerang-shaped flash unit all the way from Australia.

I also extend special thanks to Alistair Maxwell for producing the black and white prints; Express Design Service for processing the Ektachrome material; Peter Hobson for designing and building the photo-trip; Julie Burchett, Mary Stafford Smith, and Kate West for their speedy typing; Jan McLachlan for her careful proof-reading of the copy; and Martin Angel for his constant encouragement and support.

Dorling Kindersley would like to thank the following people for their help in producing this book:
Ron Bagley
Juliet Johns
Mike Smith
For design and illustrations:
David Ashby
John Bishop
Hayward & Martin Ltd
Les Smith
Steven Wooster